'Only what we could carry' was the rule; so we carried Strength, Dignity, and Soul.

—Lawson Fusao Inada

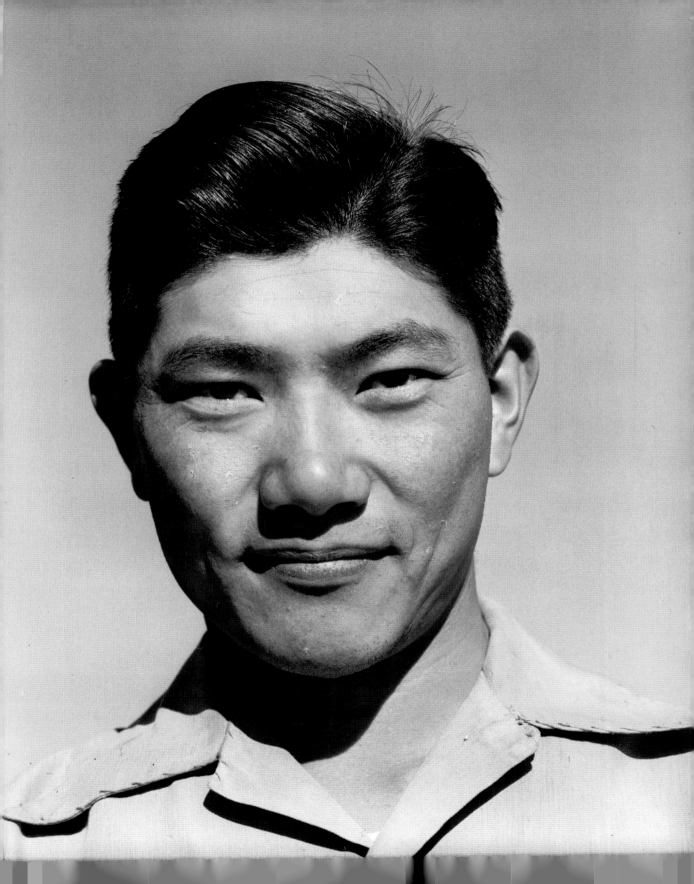

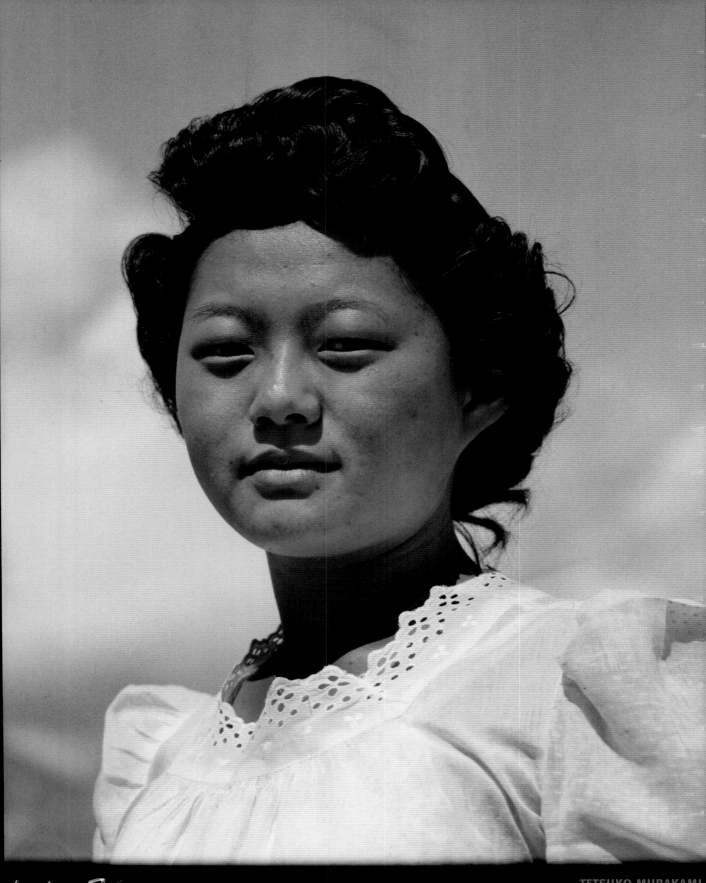

TETSUKO MURAKAMI

4-M-51

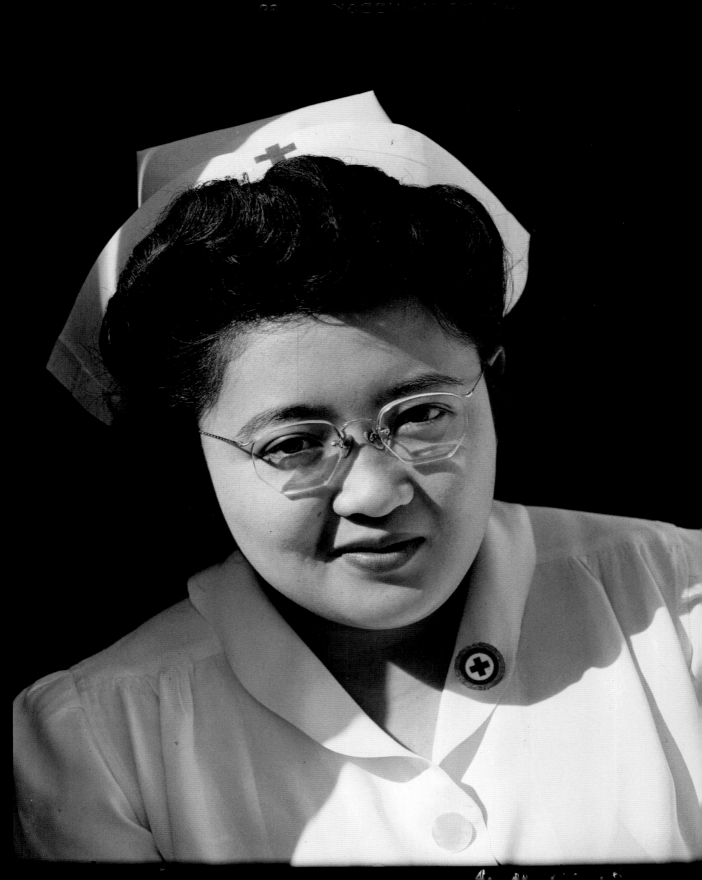

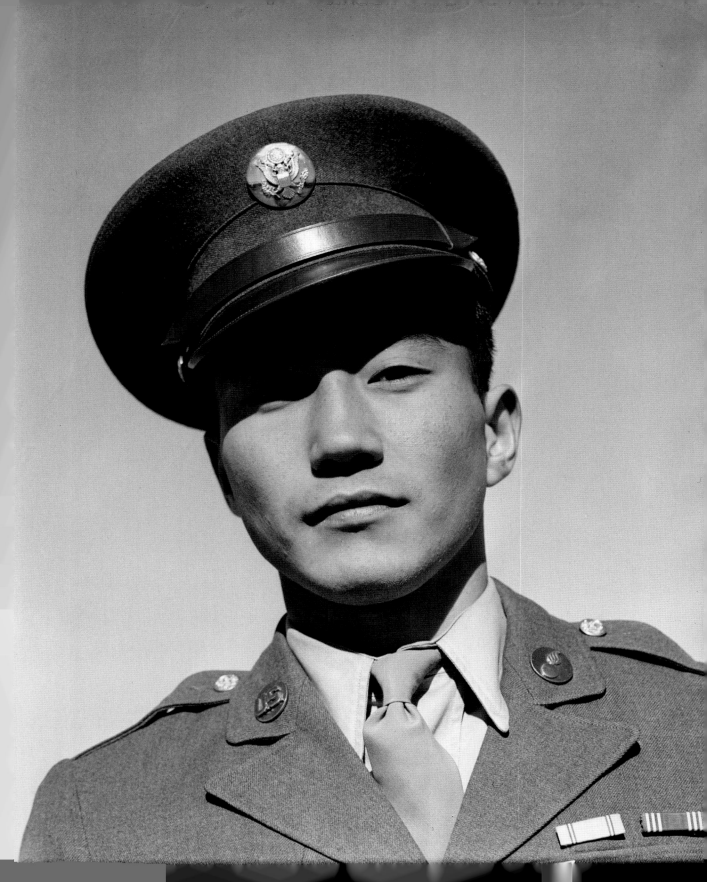

UN-AMERICAN

IMAGES BY
DOROTHEA LANGE,
ANSEL ADAMS,
AND OTHER
GOVERNMENT
PHOTOGRAPHERS

RICHARD CAHAN
AND MICHAEL WILLIAMS

CITYFILES
PRESS

THE INCARCERATION OF JAPANESE AMERICANS
DURING WORLD WAR II

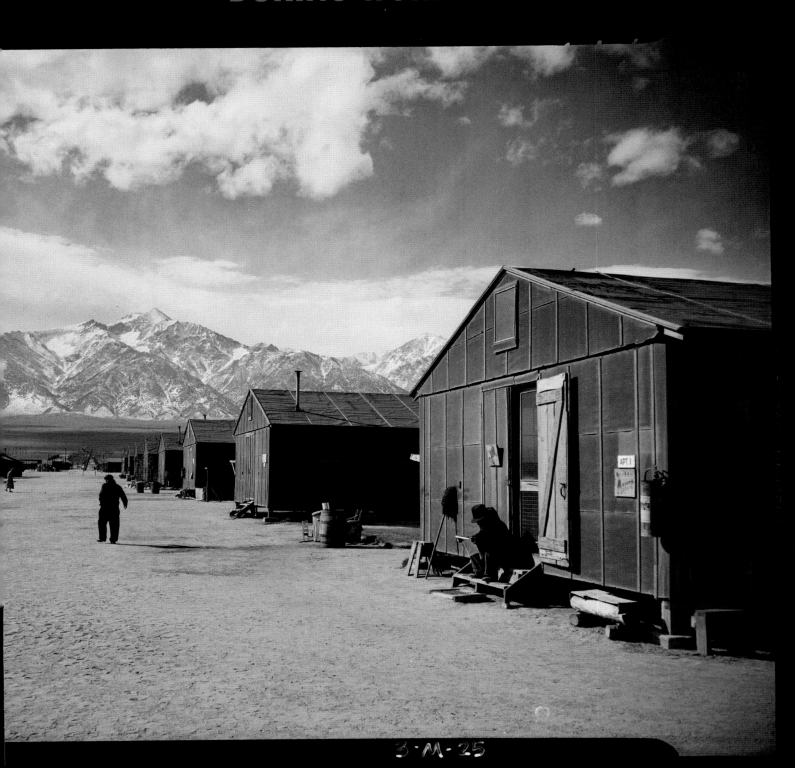

3-M-25

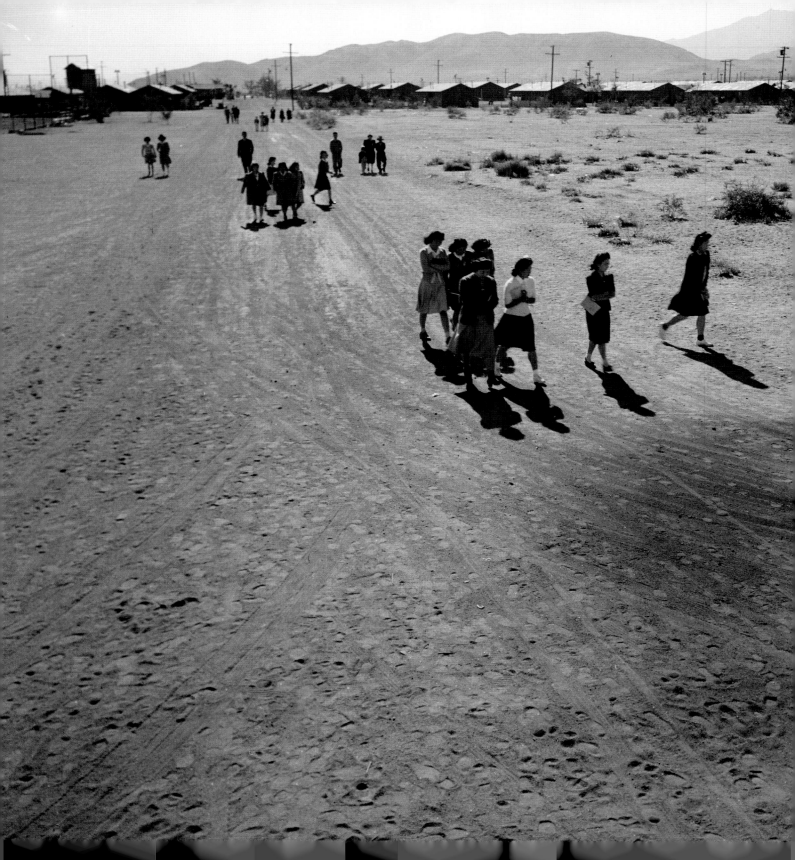

CONTENTS

A Note to the Reader

About the Words

The precise use of words is essential when discussing this chapter of U.S. history. We are influenced by *Power of Words Handbook: A Guide to Language About Japanese Americans in World War II,* published in 2013 by the Japanese American Citizens League and available online. Misleading words shroud the reality of what actually happened during the war. Japanese Americans on the West Coast were not "evacuated," which connotes that they were taken away for their own good. They did not go to an "assembly center," which sounds like a place to gather for a parade.

When referring to people of Japanese ancestry, we generally use the term "Japanese Americans." Some were immigrants; others were U.S. citizens. Issei (meaning "first generation") emigrated from Japan and were ineligible for citizenship until the passage of immigration laws in 1952. Nisei ("second generation") were their children, who were citizens because they were born in the United States. Both groups had abiding stakes in America, making them Japanese Americans.

We prefer "incarceration" to "internment," which has been used improperly for decades. Because Issei were born in a country with which the United States was at war, they were classified as enemy aliens. The term for the confinement of enemy aliens is "internment." That term does not apply when citizens are confined. Many Japanese Americans prefer the term "incarceration" for the confinement of both groups.

The government used the term "evacuation"; we prefer "forced removal." The government used "relocation"; we prefer "incarceration." The government used "assembly center"; we use this term in the proper names of camps but otherwise prefer "temporary detention center," or "temporary incarceration center." The same holds for "relocation center," which we use in proper names of camps but prefer "permanent detention center," or "permanent incarceration center." Some Japanese Americans prefer "concentration camps." That is exactly what these camps were, but we do not use that term because of its association with European concentration camps in World War II, which are more aptly described as "death camps."

About the Photographs

We consider the pictures in this book to be historical artifacts, so we have taken care to present them in as exact a way as possible.

This is the first time these images have been published full frame, just as the camera exposed them. There is no cropping. The negatives are shown in their entirety, usually including the edges.

There is writing on some of the photographs, particularly those by Clem Albers. Adding caption information—the date and location—directly on a negative was a common practice among newspaper photographers of the day. Using a stylus or a pen, they would scratch right on the emulsion at the time the photograph was made. (Sometimes they would accidentally mark on the wrong side of the negatives, resulting in backward writing.) Albers often added additional facts and also used a letter-and-number code.

We have cleaned dust and spots from the images but have not corrected darkroom flaws or signs of age, wear, or deterioration. The shape of each picture indicates the type of camera used. Most of the photographs were taken with large-format cameras, which could be rotated to produce horizontal or vertical negatives of four by five inches. Dorothea Lange and Hikaru Carl Iwasaki also made square pictures taken with medium-format cameras.

Most of these pictures were taken by well-trained professional photographers. Their work looks better than ever with the help of modern scanners. Occasionally, however, the War Relocation Authority depended on photographs by camp administrators to supplement its archive. The Tule Lake images by bureaucrat Robert H. Ross are among the most dramatic of these, but they suffer technical deficiencies.

Along the bottom of each picture, we have credited the photographer and given the location and date. We believe in the power of the camera, and we believe that these 170 photographs tell a crucial story of a time that should not be forgotten.

Introduction

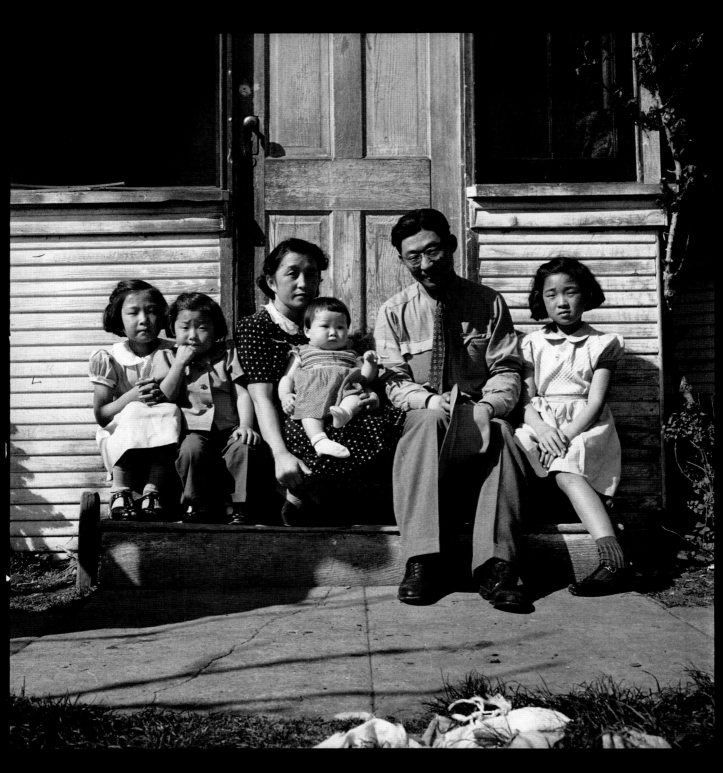

The Mitarai family poses for Dorothea Lange. From left are: Shirley, Patricia, Helen holding Elaine, Henry, and Jean, now known as Jeanette

JEANETTE MISAKA STILL REMEMBERS the day in 1942 when Dorothea Lange came to take her family's photo.

Lange was a curious-looking woman. She wore an embroidered beret and slacks, a bit avant-garde for that era. Short and slight, she walked with a modest limp and toted a large camera that she used without hesitation. Her lined face had elfin features—merry, magical, and mischievous. Her soft voice drew people toward her.

At the time, Jeanette was known as Jean. She was 10, the oldest of the four daughters of Henry and Helen Mitarai. All were of Japanese ancestry and American citizens by birth. Lange had met Henry a few days before. He was a prosperous farmer, working three parcels of land south of San Francisco with several tractors and a large crew of helpers.

Lange was not a commercial photographer. She was a documentarian, hired by the federal government at the start of World War II to photograph its outlandish plan to move 109,000 men, women, and children of Japanese descent from their homes to detention camps.

"She told him she wanted to photograph an average Japanese family," Jeanette recalled. So her parents gathered the family for one last picture on the farm.

Getting the right shot was tricky. Lange took more than a dozen pictures of Jeanette and her family at their Sunnyvale, California, home. She posed them in front of a flowering cherry tree, but a telephone pole interfered with the composition. She placed Helen, in her polka-dot dress, and her four girls on the front step of their farmhouse with Henry looking on. She tried all five on the step. She took pictures of the girls together, and she photographed Henry alone, appearing, in his broad-brimmed hat and stylish tie, like the successful farmer he was. She shot him standing amid long rows of sugar beets, leaning against a tractor, pondering his next crop or, perhaps, the future.

"Those pictures represent what could have been," said Jeanette seventy-five years later. "That's when Dad was in his prime."

Soon, the Mitarai family was forced to leave their farm, shipped by train to a temporary detention camp and later to a permanent detention center in northern Wyoming. They were given only a few days to pack and store their property. They were told they could bring only what they could carry, so they filled suitcases and duffle bags, and reported to authorities. They left the family dog, Dixie, behind.

Dorothea Lange's photographs of the Mitarai family are part of an extensive collection of photographs that document the incarceration of Japanese Americans during World War II. They tell an essential story—from the first to the last days—of how Americans responded to a hysteria that infected the country. It was a panic that swept the country following the Japanese raid on Pearl Harbor on December 7, 1941. Within eight months, the United States government forced nearly every Japanese American living in California and parts of Oregon, Washington, and Arizona to leave their homes, banishing them to ramshackle prisons on the fringes of the country.

The internment of Japanese Americans—now more accurately described as the incarceration— included more than seventy

thousand natural-born American citizens of Japanese ancestry. Their constitutional rights were ignored as they were hauled off without charges or trials. Most lost their homes, their land, their privacy, and their freedom. Despair and humiliation tore families apart and shredded the lives of many.

It is a shame of America—and it was documented on film.

IN MARCH 1942, the government started hiring a small but determined group of photographers to record what was then called the evacuation of the West Coast. Among them was Dorothea Lange. They would show the painful final weeks of freedom for Japanese Americans, the turmoil of "Evacuation Day," the shock of arriving at temporary camps, and the determination to endure the desolate years in permanent camps. Their pictures show people congregating in big cities and working farm fields; they describe what they wore, where they waved goodbye, and how they felt. They offer an unsettling portrait of a nation more concerned with security than human rights. And they show the toll of such a choice.

These photographers left behind more than seven thousand pictures, which are now stored at the National Archives at College Park, Maryland, and the Library of Congress in Washington, D.C. Their explanatory captions are generally brief and incomplete. The photographers were on the run; they were overworked and overwhelmed, going from city to city, camp to camp. Time and circumstance often prevented them from gathering the identities of their subjects.

Some of the 170 photographs selected from the collection for this book have been published before, but few have been researched as thoroughly. The photos themselves left behind clues. Identification tags and street addresses were matched with government records to identify the people in many of the shots. Those people or their relatives were contacted, often for the first time. Their accounts make the pictures more personal and more powerful than ever.

When the subjects could not be found, local newspaper accounts, diaries, memoirs, and primary-source government documents have been used to put the photographs in context.

Some Japanese Americans dismiss the collection as propaganda because it comes from the government that incarcerated them. They do not see in these photographs the painful feelings and memories that still haunt them. But camp inmates were not allowed to possess cameras or take pictures until the late stages of World War II, so these pictures form our only comprehensive look at camp life. This collection, which details what happened when the government targeted one ethnic group as a security threat, is historically important. It's all we have.

"You are kidding yourself if you think the same thing will not happen again," Supreme Court Justice Antonin Scalia told a group of law students in 2014. He warned that camps similar to those opened in World War II might be built again. The government was wrong to force U.S. citizens into detention centers based only on suspicion, Scalia said, but he pointed to Roman philosopher Cicero, who cautioned: "In times of war, the laws fall silent."

THE GOVERNMENT'S PHOTOGRAPHIC documentation of the incarceration started slowly and haphazardly. Russell Lee, working for the Office of War Information, photographed newsboys selling extra editions of the *Searchlight* in Redding, California, on the night of the Japanese strike on Pearl Harbor. The next morning, Lee's colleague at the agency, John Collier Jr., awoke early to take pictures of San Francisco residents picking up the morning papers. The *San Francisco Call-Bulletin* banner headline blared, "Enemy Planes Near N.Y. from Atlantic!" The *San Francisco News* reported, "Navy Hunts Japs off Pacific Coast." The frenzy had begun.

The same day, December 8, 1941, President

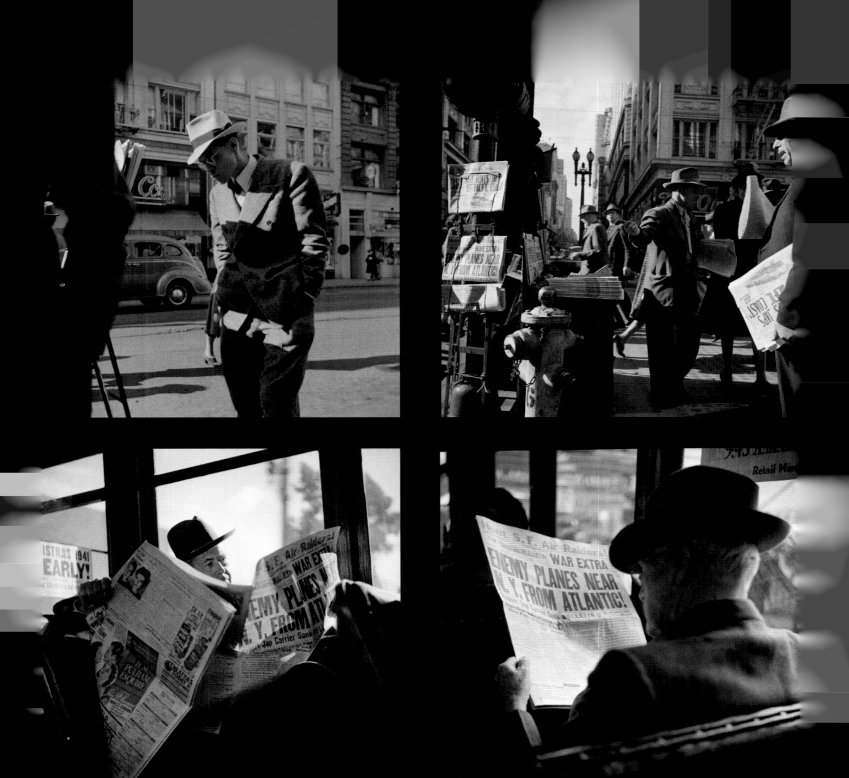

SAN FRANCISCO RESIDENTS READ NEWSPAPERS ON THE DAY AFTER PEARL HARBOR.

Photographer John Collier Jr., of the Office of War Information, understood on December 8, 1942, that the war would have an immediate impact on the Japanese American community. After taking these pictures, Collier photographed Japanese neighborhoods. That night, he

Franklin D. Roosevelt formally declared war against the Empire of Japan. In his speech before Congress, Roosevelt called December 7 "a date which will live in infamy." That was true for the entire nation, but the date had additional significance for Japanese immigrants and their descendants: It put the machinery of the incarceration in motion.

Within twenty-four hours of Pearl Harbor, the FBI broke into homes and took into custody 1,212 Japanese immigrants who had lived in the United States for decades. The raids were based on FBI lists of religious leaders, Japanese-language teachers, and those who had any known connection to their native land.

Detaining enemy aliens—citizens of nations at conflict—was the way of war. By mid-1942, about twenty-two hundred Japanese, fourteen hundred German, and three hundred Italian enemy aliens were picked up by the Department of Justice. The Japanese aliens, however, were a special class. Most had lived in the United States for decades but were unable to become citizens because of laws designed to prevent their naturalization. The arrests of these elders cut off the leadership of the Japanese American community and the means of support for their families. And when the government moved to freeze the banking assets and businesses of Japanese immigrants, day-to-day existence became difficult for thousands.

The raids proved to be ineffective. The FBI did not uncover any spy or saboteur. But they did demonstrate the muscle of the federal government, prompting many Americans to feel safer and Japanese Americans to feel fear.

Panic increased as the forces of imperial Japan made advances across the Pacific Ocean and Southeast Asia. Japan invaded Thailand, Burma, Malaya, the Philippines, Wake Island, and Midway and captured Manila, Hong Kong, and Singapore. Three days after Pearl Harbor, the western United States was declared a theater of war, with Lieutenant General John L. DeWitt

serving as commander. His Fourth Army was now in control.

Day by day, U.S. residents transferred their virulence against imperial Japan to those of Japanese ancestry living in the United States: the first-generation immigrants (called Issei) and their children (called Nisei), who were citizens by virtue of being born in the United States. Tamotsu Shibutani, a sociology student at the University of California, Berkeley, watched the enmity spread. At first it was confined to "the super-patriots, the pressure groups, and those with an axe to grind," he wrote in a 1942 report. "Churches, clubs, and newspapers were allowed to continue their activities as usual, and with a few exceptions students in schools were treated with courtesy and respect. On the whole, the American population has been admirably tolerant, in spite of the reports carried in Jap-baiting newspapers, and many have bent over backwards to treat the victims of circumstances fairly and justly."

The calm continued through January 1942. "All this lulled the Japanese community, especially the American-born element, into a false sense of security," Shibutani noted. "There seemed to be every confidence in the minds of the younger generation as to the justice and fair-mindedness of the American people." But then, in early February 1942, things began to change as the number of FBI raids increased and letters to the editor and editorials became more pernicious. Wrote Shibutani: "Various state officials began to make public pronouncements against the 'yellow peril' in their midst, instances of outright discrimination became apparent, and the newspapers began to publish glaring headlines."

In mid-February 1942, General DeWitt recommended that every man, woman, and child of Japanese ancestry be removed from the far western part of the country and sent to its interior. With the Pacific fleet crippled, the West Coast was exposed to attack. The Japanese "at large" were potential enemies, he said, and their

loyalty was impossible to determine. They might assist an invading army and join advance troops. "A Jap is a Jap," DeWitt later said, repeating a common expression of the time. "The Japanese race is an enemy race, and while second and third generation Japanese born on United States soil, possessed of United States citizenship, have become 'Americanized,' the racial strains are undiluted."

President Roosevelt acted on DeWitt's recommendation by signing Executive Order 9066 on February 19, 1942. It gave the secretary of war and his military commanders the power to expel "any or all persons"—aliens and citizens—from "prescribed military areas" without a hearing or trial. It formally started the incarceration program.

Though it seems remarkable, seventy-five years later, that a president would cede such a decision to a military official—whose job was to guard America rather than defend the civil liberties of Americans—that decision was immediately left to DeWitt, whose antipathy toward Japanese Americans was clear.

He based his decision on "military necessity." It was a lie.

No proof had ever been shown that any U.S. resident of Japanese ancestry planned to aid imperial Japan. DeWitt pointed to the seizure of thousands of guns, rounds of ammunition, sticks of dynamite, radio receivers, and cameras as evidence of clandestine plots. But the Justice Department declared: "We have not found among all the sticks of dynamite and gun powder any evidence that any of it was to be used in bombs. We have not found a single machine gun nor have we found any gun in any circumstances indicating that it was to be used in a manner helpful to our enemies. We have not found a camera which we have reason to believe was for use in espionage."

The general also cited hundreds of nightly reports of signal lights visible from the coast, as well as intercepts of unidentified radio transmissions. But the FBI and the Federal Communications Commission later looked into the allegations and found no ship-to-shore signaling or any evidence of sabotage.

DeWitt painted a sinister picture of the Japanese American community, saying that more than one hundred Japanese organizations along the Pacific coast were involved in "pro-Japanese purposes" and that thousands of American-born Japanese who had traveled to Japan for education returned "rabidly pro-Japanese." He also suggested that there was a "vast conspiracy" involving Japanese Americans who had moved near strategic areas. "Whether by design or accident," he wrote, "virtually always their communities were adjacent to very vital shore installations, war plants, etc." In Santa Barbara County, for instance, they lived adjacent to oil fields, a lighthouse, the harbor entrance, and an open beach "ideally suited for landing purposes."

The conspiracy theory was unfounded. Like most immigrant groups, Japanese Americans preferred to live together and found homes in the few communities where they were welcomed. Wrote the FBI's director, J. Edgar Hoover, to the U.S. attorney general in February 1942: "The necessity for mass evacuation is based primarily upon public and political pressure rather than on factual data." The FBI had investigated all allegations of espionage and found no evidence to support such claims.

Japanese Americans decided not to challenge Executive Order 9066. Almost all complied with the government's plan because they were loyal U.S. citizens and felt that making sacrifices was essential to the war effort. Following orders, particularly from institutions of higher authority such as the government, was part of the Japanese cultural tradition. On March 2, 1942, DeWitt issued Public Proclamation 1, which created Military Area 1 (the western halves of Washington, Oregon, and California as well as the southern half of Arizona) and Military Area 2 (the rest of these states), from which all people of

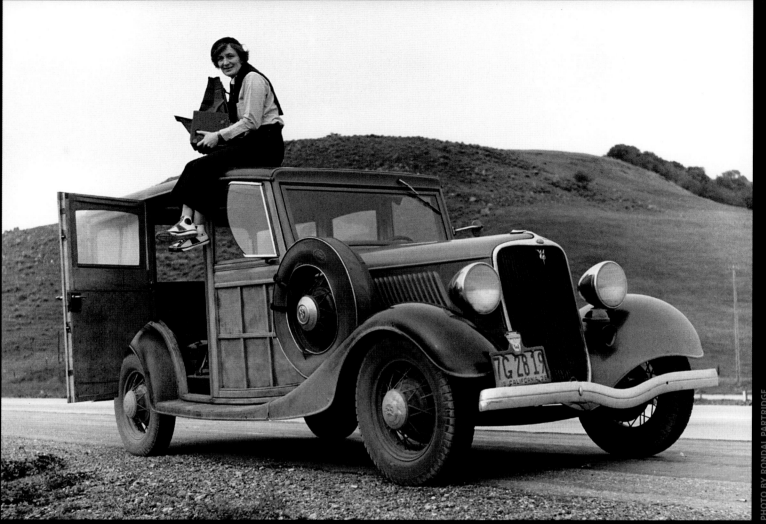

PHOTO BY RONDAL PARTRIDGE

PHOTOGRAPHER DOROTHEA LANGE AND HER *MIGRANT MOTHER* PHOTO.

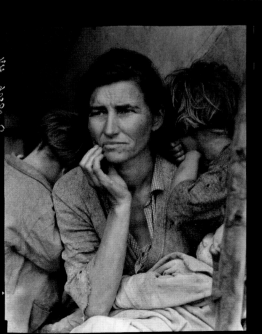

Taken in Nipomo, California, Dorothea Lange's *Migrant Mother* demonstrates why she was such a singular photographer. Driving on a rainy highway back to her home in Berkeley, California, after days of shooting, Lange saw a tiny hand-lettered sign that read "Pea-Pickers Camp." She passed it without thinking and drove another twenty miles before making a U-turn.

"I was following instinct, not reason," she wrote years later. "I drove into that wet and soggy camp and parked my car like a homing pigeon. I saw and approached the hungry and desperate mother, as if drawn by a magnet. I do not remember how I explained my presence or my camera to her, but I do remember she asked me no questions. I made five exposures, working closer and closer from the same direction. I did not ask her name or her history."

It was this extraordinary sense of how to approach people and the comfort she fostered in her subjects that marked Lange's work. It was as if she produced a pheromone that put people at ease in front of her camera.

Japanese ancestry were either banned or restricted to certain areas.

During the next few weeks, nearly 5,000 Japanese Americans who still had access to money headed inland to find new homes on their own. But late in March, the option of "voluntary migration" was revoked by military order. Almost all those who were left in Military Area 1 and the rest of California—more than 109,000—were picked up and sent to one of fifteen temporary incarceration centers or to one of the permanent camps that had opened early.

IN MID-MARCH, the government established the War Relocation Authority, an agency to oversee the removal of Japanese Americans from the western states. One of its first hires was photographer Dorothea Lange, who took the earliest photographs in the WRA archive. She must have been valued, because she met with WRA director Milton Eisenhower (brother of future president Dwight D. Eisenhower) during the agency's first days.

When asked years later, Lange could not recall how the documentation project came to be. By 1942, on the strength of the striking images she'd created while working for the Farm Security Administration, she had a reputation as an empathetic and talented photographer. Lange was already famous for her 1936 photograph of a destitute woman huddled with her children in a lean-to tent. The photo, known as *Migrant Mother,* is the *Mona Lisa* of photography.

Though linked to California and the West, Lange grew up in and around New York City. Born Dorothea Nutzhorn in 1895, she shed her father's name when he abandoned the family, adopting her mother's maiden name. Her compassion came early. Stricken by polio at the age of 7, she walked with a limp. "No one who hasn't lived the life of a semi-cripple knows how much that means," she wrote. "I think it was perhaps the most important thing that happened to me. [It] formed me, guided me, instructed me, helped me, and humiliated me." It also, she thought, helped her connect with the down-and-out and the oppressed: "Cripples know about each other."

Lange learned about other crippling effects from her mother, Joan, a court investigator who would climb the steps of New York City tenements to interview families for her probation reports. "I found myself later sometimes having to knock at a door when I was working," recalled the photographer, "and I used to remind myself of my own mother many a time."

Lange enrolled in a teacher-training school but soon dropped out. "It just came to me that photography would be a good thing for me to do," wrote Lange, who did not even own a camera at the time. She took a job as a photographer's apprentice and a photography course at Columbia University taught by Clarence White, a leading pictoralist. "He knew when something was beautiful," she wrote.

She left home to travel the world but ran out of money in the San Francisco area, where she would spend the rest of her life. She set up a portrait studio and became a successful society photographer by producing unconventional, unglamorized portraits. Her cardinal rule of photography was established in that studio: "First—hands off! Whatever I photograph, I do not molest or tamper with or arrange."

By all accounts, the studio offered Lange a prosperous future, but she became intrigued by what was happening outside her window. During breaks, she wandered the streets of San Francisco, photographing the homeless and unemployed, focusing on the labor strikes in a city roiling with angst. She enjoyed the role of witness and found that her camera gave her a "cloak of invisibility." It became indispensable, she said: "You put your camera around your neck in the morning along with putting on your shoes, and there it is, an appendage of the body that shares your life with you."

Lange made her mark with the Farm

Security Administration, where she joined a group of accomplished photographers including Walker Evans and Gordon Parks. She left in 1939, worked for other government agencies for a short while and returned when the War Relocation Authority was formed. Neither Lange nor her husband and work partner, Paul Schuster Taylor, was sure why the WRA wanted its work documented. "To have a photographer in a government agency was becoming a little more acceptable than it had been only a few years earlier," he noted. "Probably there were some who said, 'We want to show that we are handling these people all right.' There were possibly some others who saw it another way."

It was not until late March 1942 that Lange took to the road, photographing Japanese American farmers in central California. On April 1, she signed a three-month contract. She worked almost every day, driving thousands of miles to create a remarkable record of about 850 photographs that forms the heart of the WRA archive. Lange's intimate photographs provide the most dramatic evidence of what happened during the early days of the incarceration. They speak of grace and grit.

Lange set the scene with her first photographs. She sought to document the "normal life" of Japanese Americans and show what she called the "performance" of rounding them up. "I photographed, for instance, the Japanese quarter of San Francisco, the businesses as they were operating, and the people as they were going to their YWCAs and YMCAs and churches and in their Nisei headquarters—all the baffled, bewildered people," she said.

From the first days, Lange was beset by challenges. "It was very difficult work," she said. Watching the gathering of families filled her with dread. "The stress of it was that she thought that we were entering a period of fascism, and she thought that she was viewing the end of democracy as we know it," recalled her assistant Christina Gardner. Lange complained of stomachaches. "Sometimes she was hardly able to function," Gardner said.

The stress surfaced when Lange traveled to Yolo County in central California in May 1942 to photograph the exodus. "I can remember in Woodland in particular, one night when we had to stay overnight," Gardner said. "I went down to the lobby to type a letter or something and when I came back she was just in a paroxysm of worry about what was going to happen to these people. What was going to happen? Our government was doing this. She saw the greater fabric . . . in a way that very few people did at the time. I mean most people I know said, 'Oh yeah I don't think it's very fair, but this is wartime, we're not going to cause a big ruckus now, this is wartime.' Even people that I normally would have thought of as being fairly liberal-minded and decent to other people. It was dismissed as a minor factor in the whole picture of what was going on and in a way it was minor in that sense."

The challenges increased when Lange arrived to photograph the intake centers where Japanese Americans were told to report. It was at these centers that instructions and identification tags were given out. The soon-to-be inmates returned to their homes for the next few days, but they were told to wear the tags on the day they were picked up and affix them on their baggage.

Next she showed their arrival at the incarceration camps and their settling into a routine there. Lange photographed at four camps, chronicling "the process of processing" and the "oceans of desks and oceans of people." Her photographs were more than literal depictions. They were symbolic of what was happening during one of the nation's darkest days, according to her biographer Linda Gordon: "We see now that what is being stolen is not only farms and education and businesses and jobs but also personal identity. Individuals are registered, numbered, inoculated, tagged, categorized and assigned."

The WRA valued Lange's skills, but army

officials did not trust her, perhaps because of her blatant sympathies. "We have also had considerable criticism from the Army and the information center workers with reference to Miss Lange, but I am not inclined to give this a great deal of attention," wrote Edwin Bates, a WRA information official. Two army colonels had accused Lange of "interfering with registration and removal of the evacuees," he noted. "Miss Lange was rather shocked to hear this criticism and there the subject was dropped with an admonition from Col. Cress to be quite certain not to interfere with activities at the information center."

Lange was also instructed to account for every negative she produced and every cent she spent. She was constantly asked for her credentials, told what she could not shoot, and prohibited from talking to people at the detention centers by army escorts, according to her assistant Gardner. "I had a lot of trouble, too, with the Army," Lange later said. "I had a man following me all the time." The man was Major Norman Beasley, whom Lange referred to as Bozo Beasley. He decided that the army could censor photographs showing the "evacuative process" inside temporary incarceration centers, and he made sure Lange's film never left the army's control.

JOINING LANGE IN MARCH 1942 was veteran newspaper photographer Clem Albers. Born in Michigan and raised in Berkeley, Albers went to work for the *San Francisco Bulletin* as a teenager in 1921. He photographed the construction of the Golden Gate Bridge and the San Francisco–Oakland Bay Bridge in the 1930s for the *San Francisco Call-Bulletin* and covered the Golden Gate International Exposition on Treasure Island in 1939 and 1940 after joining the staff of the *San Francisco Chronicle.*

Albers was employed for only a month by the WRA, but he took more than three hundred pictures in that time. He photographed

Japanese Americans' last days in Los Angeles, San Francisco, and San Pedro, California, and documented the temporary camps at the Santa Anita racetrack in Arcadia, California, and at the rodeo grounds in Salinas, California. Albers also shot in three permanent camps: Manzanar and Tule Lake in California, and Colorado River, usually called Poston, in Arizona. His photo of Issei being marched through Sharp Park near San Francisco is one of the few that depict enemy aliens at a Department of Justice facility.

Like Lange, Albers knew how to get close. "He had great rapport with the subjects he worked with, and being an avid reader he brought a depth of understanding as well as experience to his work," said Joe Rosenthal, a contemporary who won a Pulitzer Prize for his famous photograph of marines raising the U.S. flag on Iwo Jima during World War II. Unlike Lange, Albers never displayed his sympathies or political leanings, said Jerry Telfer, a photographer who worked with Albers at the *Chronicle* years after his short WRA stint. Even in the 1960s, Albers embraced the old-fashioned large-format press camera he had used so efficiently with the WRA. "He really loved that 4x5," said Telfer. "He thought the square [medium-format camera] was a toy, and the 35-mm not worth shooting." The large negatives captured subtle detail and gave Albers enough room to take notes on.

Working for a government agency under the oversight of the army, Lange and Albers encountered a culture that conflicted with their documentary and photojournalism backgrounds. The government wanted control over what should and should not be photographed, and the army went well beyond national security concerns in dictating ground rules for photographers, as a transcript found by biographer Linda Gordon of an undated conference call between army brass shows: "One thing that is absolutely taboo, pictures of machine guns in the towers. . . . Pictures of forts that bring out our military police in a favorable light, show them to be strong,

healthful men, but not Gestapo and that sort of thing. . . . It is a matter of holding down publicity and letting out only that which would be in aid to inform the public of what is happening to bring us the favorable light."

Also restricted were photos of barbed wire, armed guards, and any signs of resistance, according to Gordon. And once photographs were taken, the army reserved the right of censorship. Prints made of every photograph by Lange and Albers were submitted to the army for review. Those of images deemed inappropriate were marked "Impounded" on their white edges, and the negatives were embargoed—though, amazingly, not destroyed.

It has long been assumed that Major Beasley impounded the photographs, but the job apparently went—at least once—to Captain Clyde H. C. Braden. A recently discovered memo from June 6, 1942, indicates that Braden impounded eighteen photographs taken at incarceration centers. "A copy of this memorandum will go to Miss Bauman who will make suitable arrangements for locking up these negatives, prints and captions," the memo stated. It may have been Elinor Bauman who carefully wrote in cursive the word "impounded" on the borders of the prints.

Like Lange, Captain Braden was in full sympathy with the Japanese Americans' situation. Braden was a humanist; he'd earned a bachelor's degree in Romance languages and started postgraduate work at Harvard in English. According to family lore, he would come home at night and cry about what he was witnessing at the camps. "But my father was a very matter-of-fact person who would follow all the rules to a T," said Braden's son, Chris. "He was duty bound, and it didn't matter if the duty stunk." Perhaps that is why Braden approved 141 photographs that were placed before him for inspection and why the ones he did impound were so carefully preserved for the future.

Contrary to popular belief, the confiscated prints and negatives were reunited with the War Relocation Authority collection of seven thousand photographs and sent to the National Archives after the war. They have been available to the public since then.

It's not clear why Lange and Albers lasted for such a short time at the WRA—but they were obviously not a good fit for government work. Even the end was demeaning for Lange. "I had to sign when I was finished, under oath, before a notary," she said. She was dismissed by the agency "without prejudice" on July 30, 1942—her papers simply marked "completion of work"—but spent the next several days photographing at Manzanar.

THE THIRD PHOTOGRAPHER hired by the WRA, Francis Stewart, was very much in the mold of Lange and Albers. "Stewart is not alone a photographer, he is a fine artist," wrote WRA administrator Edwin Bates about the 32-year-old new hire. He had an impressive background, having studied at the finest art schools in Los Angeles, including Otis and Chouinard, and received a commercial art diploma from the Frank Wiggins Trade School. He then turned to journalism, working first for the *Los Angeles Express* and next the *San Francisco Call Bulletin,* where he intermittently ran the photo and art departments and served as the head photographer.

Stewart left the paper in May 1942 to join the WRA as an "information specialist." He was expected to take photos, make movies (the photo unit took part in the production of five 16 mm shorts), and run the picture desk. He worked briefly with Lange but spent much of the next year on his own, documenting the permanent camps—Manzanar and Tule Lake, Poston and Gila River in Arizona, Minidoka in Idaho, and Topaz in Utah.

Like Lange and Albers, Stewart encountered an army that demanded to see what he was doing. Four photographs that he took in June 1942 at the incarceration camp at Poston were impounded. They showed a group of Issei men

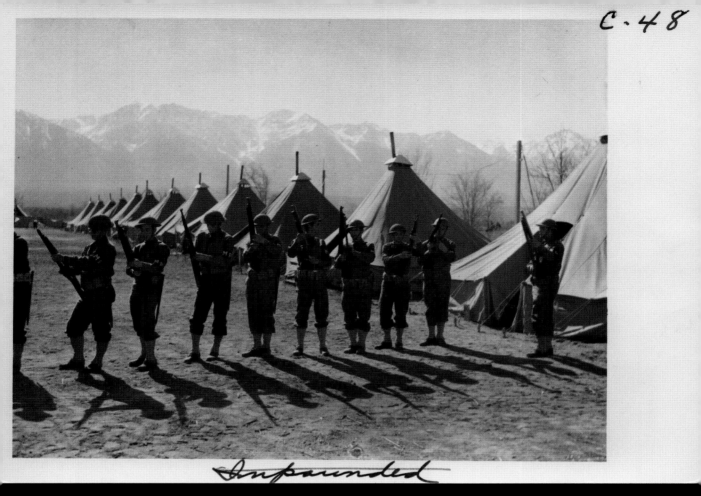

Impounded

The National Archives collection of War Relocation Authority photographs contains at least twenty-six photographs that are marked impounded. The top photo shows military police checking their weapons at the Manzanar Relocation Center. The bottom shows a veteran talking to a staff member at the Santa Anita Assembly Center. Each was taken in early April 1942 by photographer Clem Albers.

Most of the banned photographs are aerials or overalls of the camps, views showing armed military personnel, or shots of squalid conditions. Twelve by Albers were impounded, four by Dorothea Lange, four by Francis Stewart, and six by Fred Clark, an administrator at the Poston incarceration center.

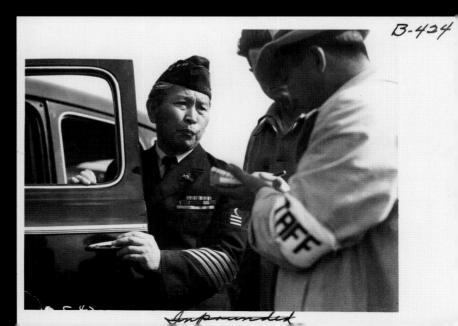

Impounded

filling out paperwork requesting to return to Japan. After arriving at Tule Lake in September 1942, he questioned the authority of a military police commander who wanted to look over his film. Stewart asked WRA administrators if the army had a right to censor his work. The answer was a surprising no. A WRA attorney said that it was permissible to take pictures "of evacuees, of their homes, of the lands they cultivate, of community activities within the Relocation Center" without the permission or approval of the army. Off-limits, of course, were areas classified by the military as "secret," "confidential," or "restricted." The days of military censorship were over.

Named acting head of the WRA Photographic Section in late 1942, Stewart oversaw the establishment of its new headquarters in the Midland Savings Building in downtown Denver. But he left abruptly in mid-1943, having taken more than a thousand pictures for the agency. "There is some mystery as to why he quit," said his son Gene, speculating that his father, too, may have become distressed by what he was witnessing. "My father had a liberal—even progressive—political outlook and was always troubled by what he perceived as injustice."

THE FINAL THREE photographers hired full-time—Tom Parker, Charles Mace, and Hikaru Carl Iwasaki—were of a different mold. They were working photographers, not artists.

Tom Parker, a lifelong government photographer, came to the WRA from the Roosevelt-era Works Progress Administration and Federal Works Agency. He was hired in August 1942 and sent to the Merced Assembly Center in eastern California.

During his three years off and on with the WRA, Parker traveled to almost all of the ten permanent camps. He crossed the country in 1944 to photograph former inmates who had been released to start new lives in the Midwest and East, and he shot the government trailer camps opened in the Los Angeles area after the war. Parker, who took over as head of the photographic section after Stewart, produced nine hundred photos. By looking at his work, it seems like he didn't have the heart of Dorothea Lange, Clem Albers, or Francis Stewart. Few did.

Charles Mace was hired by Parker in 1943 to work in the photo lab in Denver but soon became a full-time photographer. An established pro, he had worked for the Associated Press, *Rocky Mountain News,* and *Denver Post.* He had made a name for himself during World War I in the Army Signal Corps, where he served as General John J. Pershing's personal photographer and in the trenches, sending back a reported fifteen hundred battle scene images.

In the field for the WRA, Mace tirelessly documented the controversial 1943 program to transport all inmates deemed "disloyal" from nine camps to the camp at Tule Lake. Mace rode the trains there and back with them, capturing the effects of yet another move. He had an eye for detail, and his captions provided cryptic humor and insight into the traumatic trips. Photographing a dog named Tojo in a wooden crate at Tule Lake, Mace wrote, "The many canine pets of the center residents were not questioned as to their loyalty, it being universally taken for granted that a dog goes where his master goes."

In 1943, Mace was replaced in the darkroom by 19-year-old Hikaru Carl Iwasaki, the only Japanese American inmate released to work full-time for the WRA Photographic Section. Born in 1923 in San Jose, California, Iwasaki learned photography while in junior high school. He worked on the high school newspaper and yearbook and took a job at a portrait studio, where he picked up lighting and darkroom techniques. In 1940, his father, Seizo, a tailor, passed away. Two years later, Hikaru was picked up and taken to Santa Anita with his mother, Hisako, and younger sister, Akiko. "Some of people were put in horse stalls," he said. "I was lucky. We lived in barracks that were just built."

Iwasaki and his family were sent by train to a permanent camp in Wyoming in September 1942. "When we headed to Heart Mountain we did not know the destination," he said. "We arrived in the cold and we were issued Army pea coats." Iwasaki found work as an X-ray technician because it was the closest work he could find to photography. There he met Parker and Mace, who were looking for a new lab man at the Denver office.

Impressed by his darkroom work, Parker and Mace assigned Iwasaki to photograph former camp inmates who had relocated to Denver. His subjects—a file clerk, a stenographer, an accountant, and produce workers—were prosaic, but his photographs were dramatically lit and proficient, and his captions were always complete. For two years, he traveled the United States by train to tell the relocation story. It was tinged with Americana: former camp inmates looking over the Revolutionary War battlefield in Concord, Massachusetts; standing in front of a statue of Abraham Lincoln in Madison, Wisconsin; posing in front of a Girl Scout poster in St. Louis. Iwasaki showed that Japanese Americans were fitting into mainstream America, working as soda fountain clerks, bellhops, waiters, gardeners, doctors, and farmers.

The cross-country trips must have been surreal for a young government employee who had just a year before been in an incarceration camp. Photographing in the South, he watched as black men and women were prohibited from using whites-only water fountains and movie theater entrances and saw how blacks knew they must sit in the back of the bus. Iwasaki didn't know where to sit at first, but he soon learned: "I was able to sit anywhere."

STARTING IN 1943, the primary job for Parker, Mace, and Iwasaki was to document life in the camps. The WRA oversaw ten permanent incarceration centers: two in California, two in Arizona, two in Arkansas, and one each in

Idaho, Utah, Wyoming, and Colorado. The camps ranged in size. The smallest, built to accommodate eight thousand, was Granada (also known as Amache) in Colorado; the largest, Colorado River (known as Poston) in Arizona, was built in three sections for twenty thousand. With watchtowers, barbed-wire fences, and rows and rows of barracks, the camps looked like sprawling army bases, but security was often informal. Inmates were given passes to leave for the day, often to go hiking. Fishermen allegedly sneaked away for days, and Boy Scouts were taken on overnight trips. But most everyone returned. In the remote and desolate surroundings of the camps, there was no way to escape.

Like small cities, the camps were constructed in blocks. Each contained twelve or twenty-four barracks. For every twelve barracks, there was one mess hall and one laundry-toilet-shower facility. "Each barrack was subdivided into six rooms," recalled Sam Mihara, a former prisoner at two of the camps who now speaks about the incarceration. "Each had military cots, a coal fired stove, one light, and nothing else." Inmates cleverly revamped the rooms, fashioning curtains, piecing together shelves and furniture from scrap lumber, and adding wallboard. They tried to make homes.

In addition, separate buildings were constructed in each camp for administrative offices, dormitories for outside employees, a hospital and dental clinic, warehouses, and a general store.

The photographers documented how camp life evolved. Inmates set up PTAs, garden clubs, and American Legion posts and played all sorts of sports. In their memoir *Farewell to Manzanar,* Jeanne Wakatsuki Houston and James D. Houston described the camp as "a totally equipped American small town, complete with schools, churches, Boy Scouts, beauty parlors, neighborhood gossip, fire and police departments, glee clubs, softball leagues, Abbott and Costello movies, tennis courts, and traveling shows."

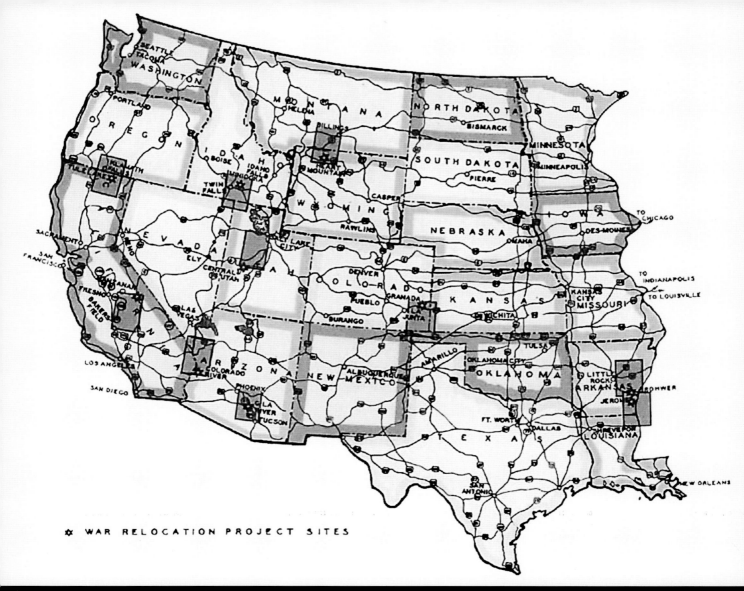

☆ WAR RELOCATION PROJECT SITES

War Relocation Authority Camps

Gila River Relocation Center, Rivers, Arizona (capacity 15,000)
Granada Relocation Center, Amache, Colorado (capacity 8,000)
Heart Mountain Relocation Center, Cody, Wyoming (capacity 11,000)
Jerome Relocation Center, Denson, Arkansas (capacity 10,000)
Manzanar Relocation Center, Owens Valley, California (capacity 10,000)
Minidoka Relocation Center, Hunt, Idaho (capacity 10,000)
Poston Relocation Center, Poston, Arizona, officially named Colorado River (capacity 20,000)
Rohwer Relocation Center, McGehee, Arkansas (capacity 10,000)
Topaz Relocation Center, Delta, Utah, officially named Central Utah (capacity 10,000)
Tule Lake Relocation Center, Newell, California (capacity 16,000)

Construction of the centers began in late March 1942. Sites were chosen that were far from cities and towns but close to railroad lines for easy transportation. The paucity of building materials and building-trades craftsmen caused delays.

In addition, the Department of Justice operated nine internment camps primarily for enemy aliens, including large-scale camps in Santa Fe, New Mexico; Bismarck, North Dakota; Crystal City, Texas; and Kooskia, Idaho.

In December 1942, WRA administrators in Washington, D.C., sent a shooting script to the photographers in Denver. Marked "Suggested outline of topics to be covered in photographic documentation of WRA program," the nine-page document served as a blueprint for future camp photography. It was an explicit outline of what the government wanted, and it explains many of the pictures in the archive. Most of its suggestions emphasized the positive aspects of camp life: bands and parades; sketching, painting, carving, and flower-arranging classes; go and shogi games; garment making and cotton picking. Photographers were also asked to show camp improvements: fishponds, miniature gardens, sewage disposal plants, altars and other religious structures.

By taking on this checklist and sticking to the script, photographers created an anthropological record of the camps but overlooked the most crucial aspects. They missed telling what everyday life was like. Inmates later talked about the dust and sand that blew through knotholes of the shabbily built barracks, about the breakup of families, the rift between Issei and Nisei, and the general challenge of unwarranted incarceration. Images that even hint at these issues are rare—despite Washington's request for "character studies." And the most important camp happenings—the distribution of loyalty questionnaires in 1943 and the decision by Tule Lake inmates to renounce their U.S. citizenship—are barely acknowledged on film.

Missed, too, are historical moments such as the fracas at Santa Anita in August 1942, the Poston strike in November 1942, the riot that left two dead at Manzanar in December 1942, and the Heart Mountain draft resistance movement in 1944. Notably, local camp officials who were sent cameras by the WRA did photograph the somber funeral of James Hatsuki Wakasa, who was shot and killed after wandering near the fence at Topaz; the grisly suicide of 23-year-old John Yoshida at the Jerome Relocation Center

in Arkansas; and the far-reaching disturbances at Tule Lake in 1944 and 1945. But photographs like this are atypical.

ANSEL ADAMS NEVER WORKED for the War Relocation Authority, but in 1943 he received special authorization to photograph the Manzanar Relocation Center in eastern California. He coordinated closely with camp officials, and provided his photographs to the Office of War Information. After completing the work in 1944, he donated his negatives, prints, and copyright to the Library of Congress. So like the work of Dorothea Lange, Clem Albers, and other WRA photographers, Adams's work is in the public domain.

Adams is probably the best-known and most loved American photographer of the twentieth century. His photographs of the Sierra Nevada, Grand Canyon, Yosemite Valley, and other western beacons fill books and museum exhibitions and appear on posters, note cards, and screen savers. Though his pictures look so simple and effortless, they were often produced only after weeks or months of preparation. Each was pre-visualized, carefully planned, and executed with formidable technical skill.

"You don't take a picture, you make a picture," he said.

Adams was more than a nature photographer. For much of his career, he did serious portraiture, and he was long interested in documentary work. He helped Dorothea Lange develop her negatives for the Farm Security Administration during the 1930s and collaborated with her on assignments for the Office of War Information, photographing Italian Americans in San Francisco and shipyard workers in Richmond, California. They later worked on magazine pieces together.

But Adams would never have classified himself as a social documentarian, so it might seem that he was slightly out place at Manzanar. Adams turned 40 the day after President

Roosevelt signed Executive Order 9066 calling for the incarceration of Japanese Americans in 1942. He craved a chance to contribute to the war effort but turned down an offer from esteemed photographer Edward Steichen, a friend, to set up and run the navy's darkroom.

During the late summer of 1943, Adams met another friend, Ralph P. Merritt, the director of Manzanar, who asked if Adams might be interested in photographing those at the camp. "We've been able to get these people in all their destitute, terrible condition to build a new life for themselves. A whole new culture," said Merritt, who was well liked by the inmates. Merritt could not pay Adams, but he promised to reimburse him for gas, procure him tires (a perk during the war years), and give him free rein at the camp. Adams accepted. Together they decided that he would focus on the Japanese Americans who had affirmed their allegiance to the United States in the series of loyalty questions in early 1943.

Adams arrived at Manzanar with no agenda. He did not have a government agency looking over his shoulder or dictating suggestions. In his own way, he searched for the perfect light and compositions to celebrate what he and his camera saw. It was a style that had worked for him in the wild, and he was unwilling to change when he arrived at the camp. "So I went down to Manzanar and photographed hundreds of people," Adams wrote. "And practically everyone was positive. They'd rejected the tragedy because they couldn't do anything about it. The next step was a positive one. And I had them smiling and cheerful and happy."

That turned out to be problematic, because when Adams exhibited and published his photographs of the smiling and cheerful and happy captives, critics questioned their authenticity. "The photojournalists raked me up and down over the coals; you have no idea," Adams said years later. "'Why do you have these people smiling? That's all fake. They were oppressed, prisoners.' And so I tried to explain what really happened."

Affable Adams, who resembled Santa Claus with his billowing beard and bedazzling eyes, knew from the start he should show his subjects downtrodden, unhappy, and dirty, he said. But that's not what he found. He found only grins.

"The smiles should not be taken at face value," wrote Gerald H. Robinson in *Elusive Truth: Four Photographers at Manzanar*. "First, Adams was a warm, ebullient figure with an expressive and engaging manner. I always felt that he could coax a smile from a boulder! Second, to the camp inmates he was a stranger, and smiles are often used to allay hostility and avoid confrontation."

Adams's primary goal was to portray the grace and beauty of the Japanese Americans at Manzanar. Instead of showing much of camp life, he focused on the inmates themselves, photographing them looking right into the lens of his large-format Graflex press camera or his medium-format Kodak Medalist. Outside, he shot in direct sunlight with no screens or reflectors. Inside, he used a small flash to add to room light. The trickier the setup, the more time it took, leading to the "posed" feeling, he explained. He often shot from a low angle, making his subjects look heroic.

"In this undertaking I felt that the individual was of greater importance than the group; in a sense each individual represents the group in a most revealing way," he said. In addition to the portraits, Adams was particularly interested in showing people at work: harvesting cabbage, butchering beef, repairing and riding tractors, even editing the camp newspaper. "Communal life undoubtedly has bolstered morale; everyone seems interested in some form of work, service, sport, or other activity," he wrote.

Dorothea Lange applauded Adams's resolution to create lavish portraits of camp inmates. "I fear the intolerance and prejudice is constantly growing," she wrote Adams in late 1943. "We have a disease. It's Jap-baiting and

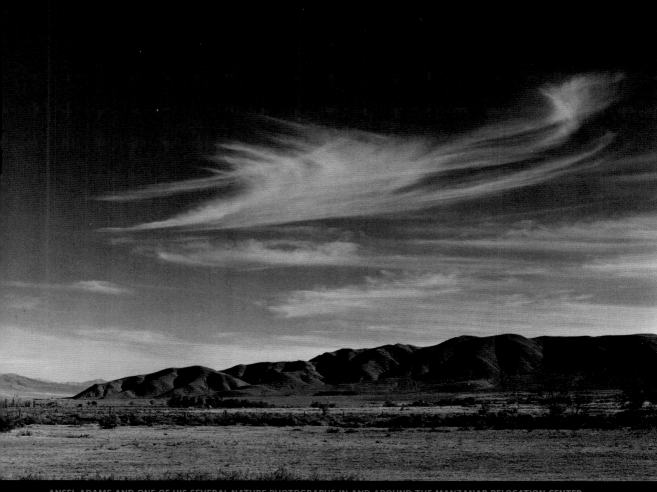

that the acrid splendor of the desert, ringed with towering
s, has strengthened the spirit of the people of Manzanar," Ansel
rote in his 1944 book *Born Free and Equal.* "I do not say all are
s of this influence, but I am sure most have responded, in one way or
to the resonances of their environment."

riticism for photographing the surrounding landscape, he repeated
 forty years later in *Ansel Adams: An Autobiography.* "I have been
of sentimental conjecture when I suggest that the beauty of the
cene stimulated the people in the camp," he wrote. "No other
n center could match Manzanar in this respect, and many of the
oke to me of these qualities and their thankfulness for them."

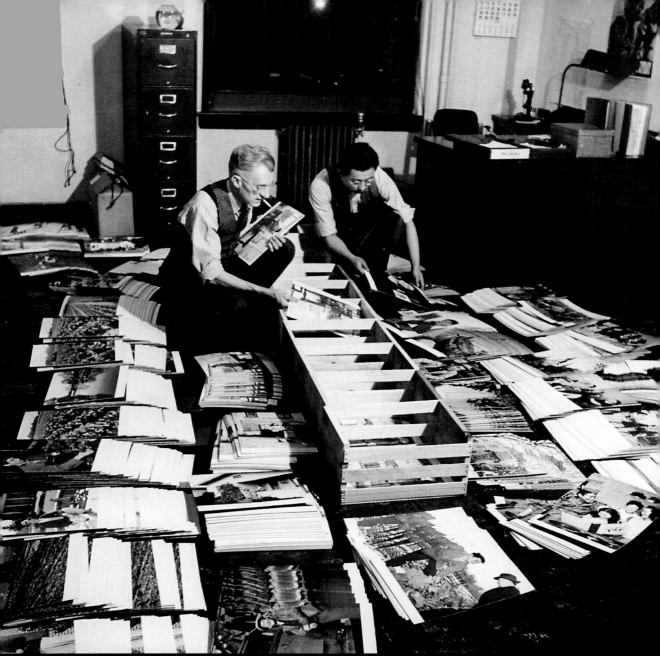

PHOTOGRAPHERS CHARLES MACE (LEFT) AND HIKARU CARL IWASKI LOOK OVER PRINTS AT THE WRA HEADQUARTERS IN DENVER.

War Relocation Authority Photographers:

Dorothea Lange (1942)
Clem Albers (1942)
Francis Stewart (1942-1943)
Tom Parker (1942-1945)
Charles Mace (1943-1945)
Hikaru Carl Iwasaki (1943-1945)

In addition, administrators took photos to supplement work of the professional staff. Major contributors included:

Gretchen Van Tassel, based in Washington, D.C.
Fred Clark and Pauline Bates Brown, at Poston
Richard H. Ross and John D. Cook at Tule Lake
Joe McClelland and Pat Coffey at Granada
Takashi Bud Aoyama at Heart Mountain
Charles Lynn and Tom Okano at Jerome

hatred. You have a job on your hands to do to make a dent in it—but I don't know a more challenging nor more important one. I went through an experience I'll never forget when I was working on it and learned a lot, even if I accomplished nothing."

Lange and Adams were close friends, but they were each critical of the other's work during World War II. Adams said Lange and other WRA photographers were making "a very grim sociological picture of this event, which was a very grim event, no question about that." Lange questioned whether Adams ever understood the deep injustice he was documenting. "He doesn't have much sense about these things," she said. To Adams, the incarceration was "only a rocky wartime detour on the road of American citizenship." He later wrote, "In light of retrospection and true evaluation the evacuation may have been unnecessary, but the fact remains that we, as a nation, were in the most potentially precarious moment of our history—stunned, seriously hurt, unorganized for actual war."

Adams, whose address at the time was simply "Ansel Adams, Yosemite National Park, California," could not resist photographing the majestic scenery of Owens Valley. "Manzanar had a beautiful setting," he said. "I always tried to bring in the environment of the mountains. I knew a great many of the people would look up at the Sierra Nevada. It was a beautiful place."

Lange, who admired the beauty of Adams's photographs, dismissed his notion that the environment helped mollify the inmates. "They had the meanest dust storms there and not a blade of grass," she said. "And the springs are so cruel. When those people arrived there they couldn't keep the tarpaper on the shacks."

Adams showed his work to camp inmates in 1944 and later exhibited it at the prestigious Museum of Modern Art in New York, but the show was relegated to the museum's basement. Each of the sixty-nine prints was checked and cleared by the War Relocation Authority. As expected, he and the museum were criticized for the sympathetic portrayal of Japanese Americans. "Even some of my liberal friends said, 'You made a mistake that time. You just got yourself in hot water,'" Adams recounted years later. "We were talking about it. They said, 'It's not the thing to do. Japan is the enemy and you shouldn't have done it.'"

It's hard to imagine now, but Adams was considered brave for casting Japanese Americans in a favorable light. "I really stuck my neck out on it, and I'm very glad I did it," he later said. "But it was awfully hard to explain at the time."

Adams's bold book *Born Free and Equal* opens with the Fourteenth Amendment—which prohibits states from restricting the basic rights of citizens—and continues with a series of dramatic photographs that show the physical beauty of Manzanar, its surroundings, and its people. "Throughout this book I want the reader to feel he has been with me in Manzanar, has met some of the people, and has known the mood of the Center and its environment—thereby drawing his own conclusions—rather than impose upon him any doctrine or advocate any sociological action," he wrote in the foreword.

The book's production standards were far below what Adams had expected. Few copies of the first printing exist today. According to a long-standing rumor, the U.S. Army purchased and destroyed thousands of them because of the book's pro–Japanese American stance. That has never been confirmed.

IN EARLY 1945, critic Gerald W. Johnson wrote in the *New York Herald Tribune* that the photographs in *Born Free and Equal*—"Mr. Ansel's evidence"—proved that the Manzanar prisoners were loyal and that "no just charge of unnecessary brutality or negligence lies against the guards."

The photographs proved nothing of the sort. Sometimes—but not always—photographs offer proof. Adams's nature photography goes a

long way in showing the majesty of the American landscape. Images of the My Lai massacre in Vietnam and the Abu Ghraib prison in Iraq prove the abuses of war. In one of the first studies of Adams's and the WRA's photos, published in the National Archives' *Prologue* magazine in 1980, Sylvia E. Danovitch wrote: "These photographs thus document decent treatment in carrying out an unjust policy." That, of course, raises the question: Can treatment be decent if the policy is unjust?

Once again, it was Dorothea Lange who best understood the message of the incarceration.

"The American people generally, I think, are willing to concede we made a hell of a mistake," she said late in life. "And I see it in print, over and over again, from unexpected sources. In the *Congressional Record* it comes up every once in a while as an example of what happens to us if we lose our heads. It's the example they point to. I think it's rather encouraging, as a sign of our mental health, that we admit a mistake.

"What was, of course, horrifying was to do this thing entirely on the basis of what blood may be coursing through a person's veins. Nothing else."

In 1943, Eleanor Roosevelt visited the Gila River Relocation Center and started a crusade for the release of the inmates. "To undo a mistake is always harder than not to create one originally," the First Lady said, "but we seldom have the foresight."

Others, later, felt similarly.

Tom C. Clark, who helped orchestrate the incarceration as a Department of Justice attorney advising General DeWitt, later wrote, "There was little strategic justification for the evacuation; these people of Japanese descent, many of them American citizens, did not pose a substantial military threat."

But at congressional hearings in early 1942, Clark testified, "If the military authorities, in whom I have the utmost confidence, tell me it is necessary to remove from any area the citizens as well as the aliens of a certain nationality or of all nationalities I would say the best thing to do would be to follow the advice of the doctor. Whenever you go to a doctor if he tells you to take aspirin you take aspirin."

Clark was named U.S. attorney general after the war and later appointed to the Supreme Court.

One of the most vehement politicians at the hearings pushing for the expulsion of Japanese Americans from the West Coast was California Attorney General Earl Warren, who showed maps depicting nearly every piece of land owned by Japanese Americans in thirty-five counties across the state. The maps and an accompanying list with more than a hundred entries were extensive: "Japs adjacent to new Livermore Military Airport . . . Many Japs along Western Pacific and Southern Pacific Railroad rights-of-way . . . Heavy sprinkling of Japs in west Oakland in the vicinity of industries and the United States naval depot . . . Jap within 2 miles of East Park Reservoir Dam." It all sounded so ominous.

After the war, Warren, too, was appointed to the Supreme Court, serving as chief justice from 1953 to 1969. Following his retirement, he wrote, "I have since deeply regretted the removal order and my own testimony advocating it, because it was not in keeping with our American concept of freedom and the rights of citizens."

Only one month after the 1942 congressional hearings, Civilian Exclusion Order 1 was issued and 257 Japanese Americans were forced from their homes on Bainbridge Island, off the coast of Washington in the Puget Sound. "Any person affected by this order who fails to comply with any of its provisions or who is found on Bainbridge Island after 12 o'clock noon, P.W.T., [Pacific War Time] of March 30, 1942, will be subject to the criminal penalties," the order warned. That same day, several states away, Dorothea Lange took photographs of Jean Mitarai and her family.

The incarceration had begun.

Civilian Exclusion Order No. 1

1. Pursuant to the provisions of Public Proclamations Nos. 1 and 2, this headquarters, dated March 2, 1942, and March 16, 1942, respectively, it is hereby ordered that all persons of Japanese ancestry, including aliens and non-aliens, be excluded from that portion of Military Area No. 1, described as "Bainbridge Island," in the State of Washington, on or before 12 o'clock noon, P. W. T., of the 30th day of March, 1942.

2. Such exclusion will be accomplished in the following manner:

(a) Such persons may, with permission, on or prior to March 29, 1942, proceed to any approved place of their choosing beyond the limits of Military Area No. 1 and the prohibited zones established by said proclamations or hereafter similarly established, subject only to such regulations as to travel and change of residence as are now or may hereafter be prescribed by this headquarters and by the United States Attorney General. Persons affected hereby will not be permitted to take up residence or remain within the region designated as Military Area No. 1 or the prohibited zones heretofore or hereafter established. Persons affected hereby are required on leaving or entering Bainbridge Island to register and obtain a permit at the Civil Control Office to be established on said Island at or near the ferryboat landing.

(b) On March 30, 1942, all such persons who have not removed themselves from Bainbridge Island in accordance with Paragraph 1 hereof shall, in accordance with instructions of the Commanding General, Northwestern Sector, report to the Civil Control Office referred to above on Bainbridge Island for evacuation in such manner and to such place or places as shall then be prescribed.

(c) A responsible member of each family affected by this order and each individual living alone so affected will report to the Civil Control Office described above between 8 a. m. and 5 p. m. Wednesday, March 25, 1942.

3. Any person affected by this order who fails to comply with any of its provisions or who is found on Bainbridge Island after 12 o'clock noon, P. W. T., of March 30, 1942, will be subject to the criminal penalties provided by Public Law No. 503, 77th Congress approved March 21, 1942, entitled "An Act to Provide a Penalty for Violation of Restrictions or Orders with Respect to Persons Entering, Remaining in, Leaving, or Committing Any Act in Military Areas or Zone", and alien Japanese will be subject to immediate apprehension and internment.

J. L. DeWitt
Lieutenant General, U. S. Army
Commanding

What Life Was Like

It is not until Monday morning [December 8, 1941] that I sense that something terribly wrong has happened over the weekend. Walking down the main hallway to my class at Sacramento Junior College, I notice that there is not the usual "Hi, Kiyo." Like the parting of the Red Sea, students turn their backs and walk to the side, leaving me the wide, dingy hallway.

—Kiyo Sato

In early 1942, the federal government's War Relocation Authority hired two photographers to document its incarceration of Japanese Americans. From the start, Dorothea Lange and Clem Albers were determined to show what life was like for Japanese Americans. Setting out from her home in Berkeley, California, Lange traveled the area around San Francisco Bay; Albers focused mostly on Los Angeles. Their early work—which captured proud families in rural towns and the well-to-do in cities, schoolchildren and church groups, shopkeepers and farmers—is a photographic census, an unexpected record of a tight-knit group of Americans uncertain about their future.

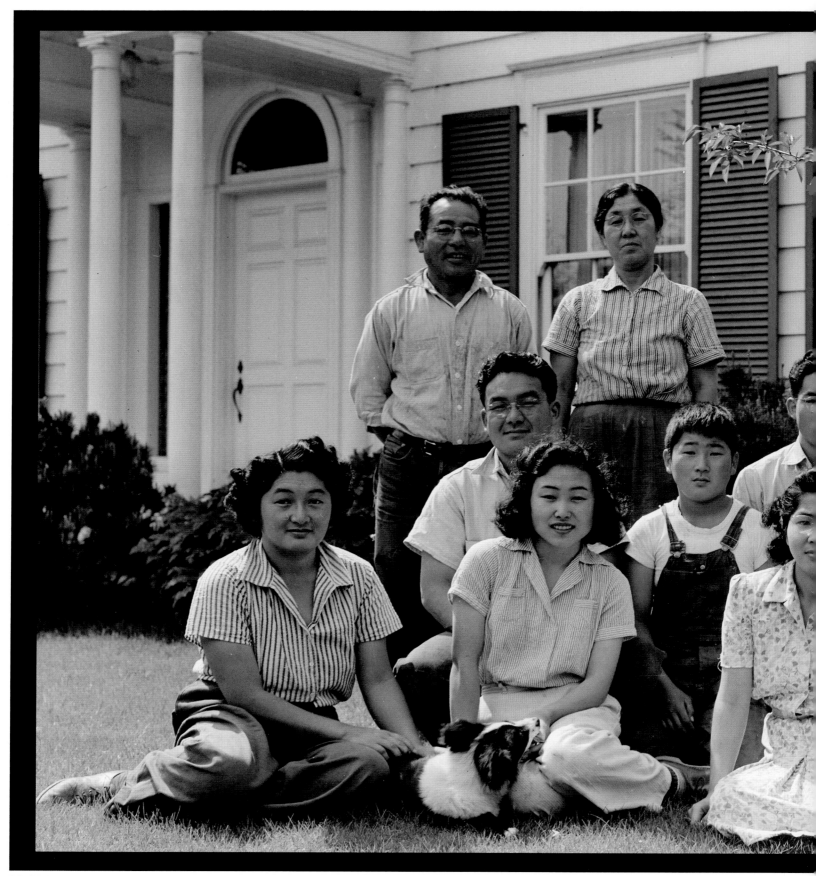

DOROTHEA LANGE MOUNTAIN VIEW, CALIFORNIA **APRIL 18, 1942**

"We lost so much during the war," recalled Maremaro Shibuya, who as a boy was photographed with his family in front of their home in Mountain View, California, by Dorothea Lange. A short time afterward, they were taken to the Santa Anita Assembly Center near Los Angeles, a temporary incarceration facility to hold Japanese Americans, and then to the Heart Mountain Relocation Center in Wyoming, one of ten permanent camps.

Before the war, Maremaro's father, Ryohitsu Shibuya (back row, left), who was called the King of Chrysanthemums, had taught himself genetics and developed more than ten varieties of the flower, including the bronze-colored single chrysanthemum, which he patented.

Maremaro's mother, Tora (back row, right), died less than a year after this photograph was taken. "The first winter in Heart Mountain was so cold, we thought she was freezing to death," Maremaro said. She was eventually admitted to a hospital but soon died—of stomach cancer, the family later learned.

The Shibuyas left Heart Mountain in 1943 after the government started a program that allowed for the release of those who found jobs or went to college in the East or Midwest. The family returned to Mountain View in 1945, but Ryohitsu had to start over. The chrysanthemums he'd planted had been lost, so he had to buy back his own patented mums from other nurseries. He also began creating new varieties of carnations.

In the front row are the Shibuyas' daughter Masago, daughter-in-law Ellen, and daughter Madoka (from left). In the middle row are sons Takeshi, Maremaro, and Yoshimaro. Youngest daughter Manabu was not pictured because she was at Girl Scouts. They all graduated from college before, during, or after the war.

Lange kept in touch with the Shibuyas and helped arrange a travel permit to Denver so they could search for jobs. Masago wrote to her: "We can never forget your kindness in our time of need."

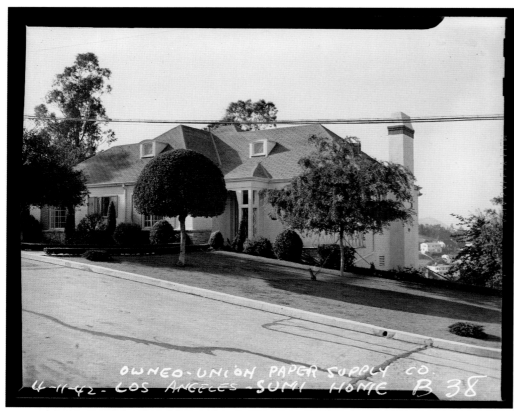

OWNED-UNION PAPER SUPPLY CO.
4-11-42 - LOS ANGELES - SUMI HOME B 38

CLEM ALBERS LOS ANGELES, CALIFORNIA **APRIL 11, 1942**

4-11-42 -

Akiko Sumi is shown at 21 in the living room of her family's home in Los Angeles before their removal to Heart Mountain in 1942. Before the war, FBI agents had arrested her father, Toraichi Sumi, a Japanese-born businessman who had donated to Japanese charities. "I may be gone a long time," Akiko recalled him telling her as he was taken away to a Department of Justice internment camp for "dangerous aliens." In 1943, he was returned to the incarcerated family in Wyoming.

The Sumis stored their possessions and rented out their home. A man named Henry Dierker, who had built the house, watched over it until the family returned in 1945. Many Japanese Americans lost their houses, farms, and businesses because they couldn't pay taxes, rents, or mortgages. "Our family was fortunate," said Kazuko Anderson, Akiko's niece, who was born just before the family was forced to leave. "We had a house to come back to."

After the war, Akiko Sumi became Akiko Honda, marrying into a family that grew the trademark gardenias that garnished the Scorpion, a drink served at the legendary Polynesian-themed restaurant Trader Vic's.

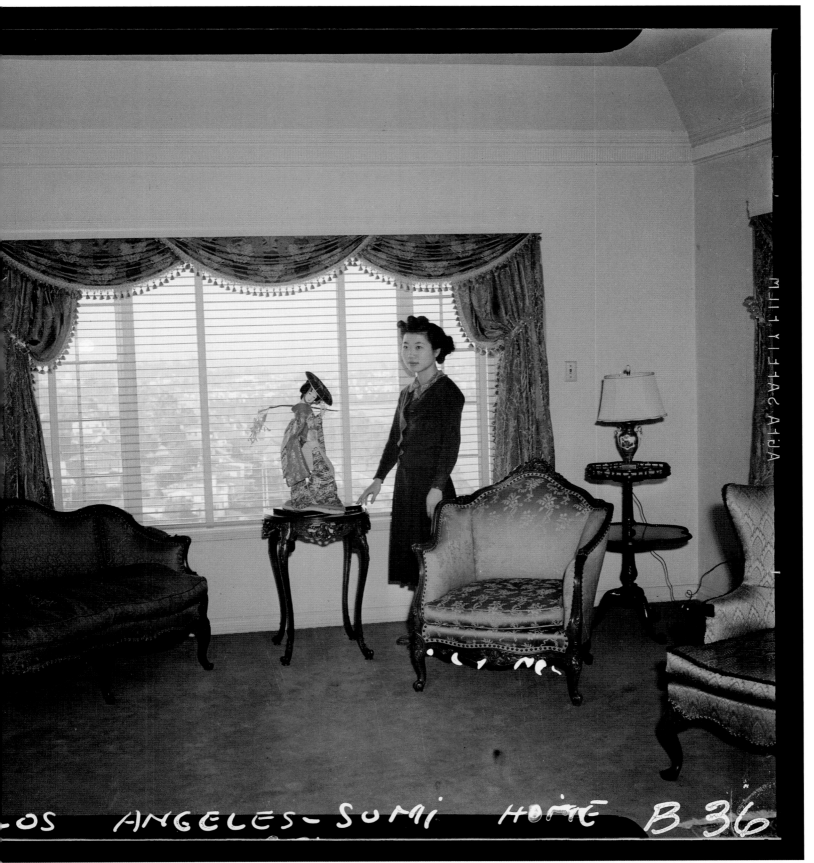

LOS ANGELES – SUMI HOME B 36

CLEM ALBERS LOS ANGELES, CALIFORNIA **APRIL 11, 1942**

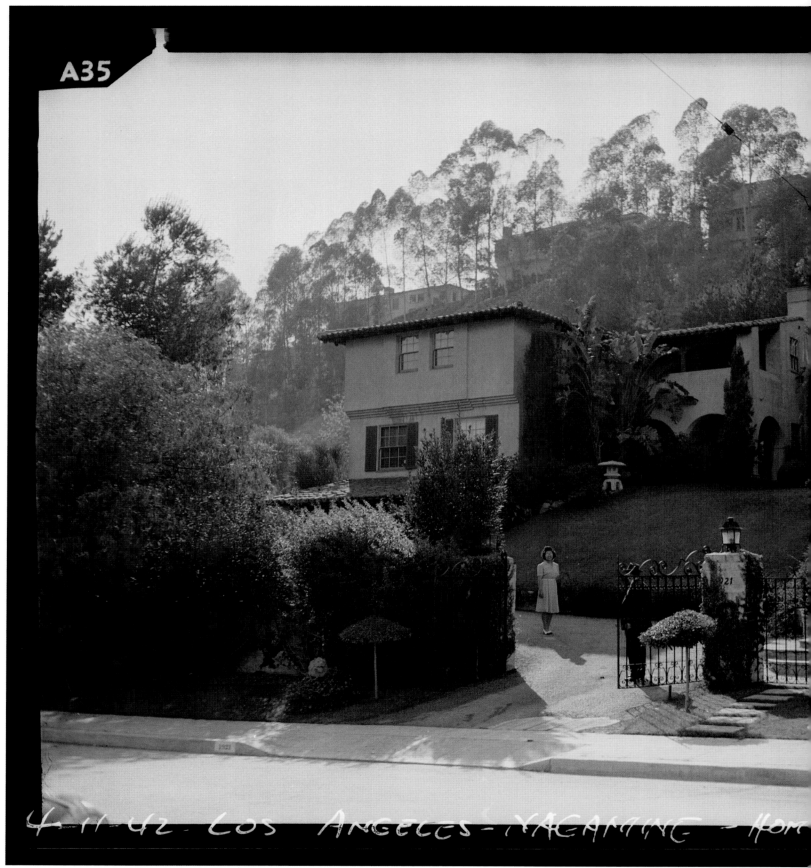

A35

4-11-42 LOS ANGELES - YAGANING - HOM

CLEM ALBERS LOS ANGELES, CALIFORNIA **APRIL 11, 1942**

On December 7, 1941, FBI agents went to the Los Angeles home of 62-year-old Haruyuki Nagamine and took him into custody—one of more than twelve hundred Japanese-born nationals picked up within forty-eight hours of the attack on Pearl Harbor. He would spend the war years in at least five Department of Justice internment camps before being released in 1946.

Haruyuki had come to the United States in 1908. His wife, Yone, whom he had married three years earlier, arrived in 1914. Because the Nagamines were Issei, or first-generation immigrants from Japan, they were prohibited under California law from becoming citizens of the United States. Now, with the two countries at war, the Nagamines were classified as enemy aliens.

The FBI targeted men such as Haruyuki, who owned the American Produce Company and was the director of a Japanese veterans' group. The bureau focused on business, religious, and civic leaders, as well as administrators and teachers at Japanese-language schools. Taking away the male elders crippled many Japanese American families.

Haruyuki's wife was not taken to a camp. When the war started, Yone, 58, was visiting the couple's daughter, Chiye, who was living in Tokyo. Yone was reunited with her husband when she returned to Los Angeles in 1947.

Mary Ogawa is shown on the driveway of the Nagamines' house, which she took care of during their absence. A Nisei, or second-generation Japanese American, Ogawa was a U.S. citizen but was forced to move to the Santa Anita temporary camp and then to the Rohwer Relocation Center, a permanent incarceration camp in Arkansas.

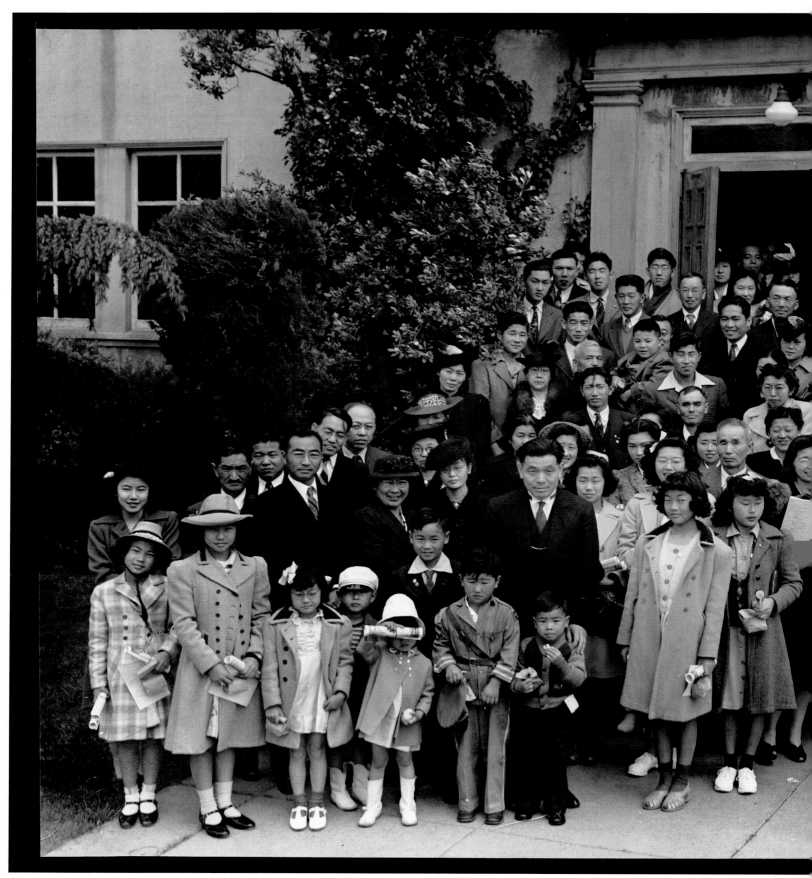

DOROTHEA LANGE OAKLAND, CALIFORNIA **APRIL 5, 1942**

Easter 1942 was the last day of services at the Japanese Independent Congregational Church in Oakland, California, because its members were soon after sent to detention facilities.

In her 1982 memoir, *Desert Exile: The Uprooting of a Japanese American Family,* Yoshiko Uchida, a member of the church who would become a beloved children's book author, recalled the days following Pearl Harbor: "We tried to go on living as normally as possible, behaving as other American citizens. Most Nisei had never been to Japan. The United States of America was our only country and we were totally loyal to it." To prove that loyalty, church members bought defense bonds, signed up for civilian defense, and dutifully obeyed the many rules and curfews directed toward Japanese Americans. "Still the doubts existed," she noted.

Yoshiko was a senior at the University of California, Berkeley, in February 1942, when President Franklin Roosevelt signed Executive Order 9066. She was convinced that it violated the Constitution's Fifth Amendment, which provides for "due process of law," and the Fourteenth Amendment, which provides "equal protection of the laws" for all U.S. citizens. Yoshiko and her sister, Keiko, were both born in and therefore citizens of the United States.

 "My sister and I were angry that our country could deprive us of our civil rights in so cavalier a manner," Yoshiko wrote, "but we had been raised to respect and trust those in authority. To us resistance or confrontation, such as we know them today, was unthinkable and of course would have had no support from the American public. We naively believed at the time that cooperating with the government edict was the best way to help our country."

Students at the Raphael Weill Elementary School in San Francisco began the day by reciting the Pledge of Allegiance. About a third of them were Japanese American, said Sam Mihara, who attended the school (now called Rosa Parks Elementary School, at 1501 O'Farrell Street) during the war. Its diverse student body included Asians, Caucasians, and African Americans, many of whose parents were drawn to the Bay Area for jobs in the burgeoning shipbuilding industry.

Before World War II, second-generation Japanese American children in San Francisco lived bicultural lives. They were tied to Japan through their immigrant parents and connected to the American culture around them. Many were sent to public schools during the day and to Japanese-language classes afterward. They celebrated Japanese and American holidays.

"These months [after Pearl Harbor] were very difficult," Mihara recalled. "There was a lot of hysteria. Newspaper headlines urged us to move. A full-size billboard in the neighborhood, which said 'Bye-Bye Japs,' told us to get out. We saw lots of political cartoons accusing us of being spies. We lived with strict curfew hours and experienced FBI searches for contraband without search warrants." Japanese men and women in the West were now not permitted to possess firearms, cameras, or shortwave radios.

The forced removal of San Francisco's Japanese residents began in early April. In late May, the government used Weill's auditorium to hold the last of them to be picked up; the nearly three hundred people were then put on six Greyhound buses and transferred, under armed military guard, to the nearby Tanforan Assembly Center. "For the first time in 81 years," the *San Francisco Chronicle* reported, "not a single Japanese is walking the streets of San Francisco."

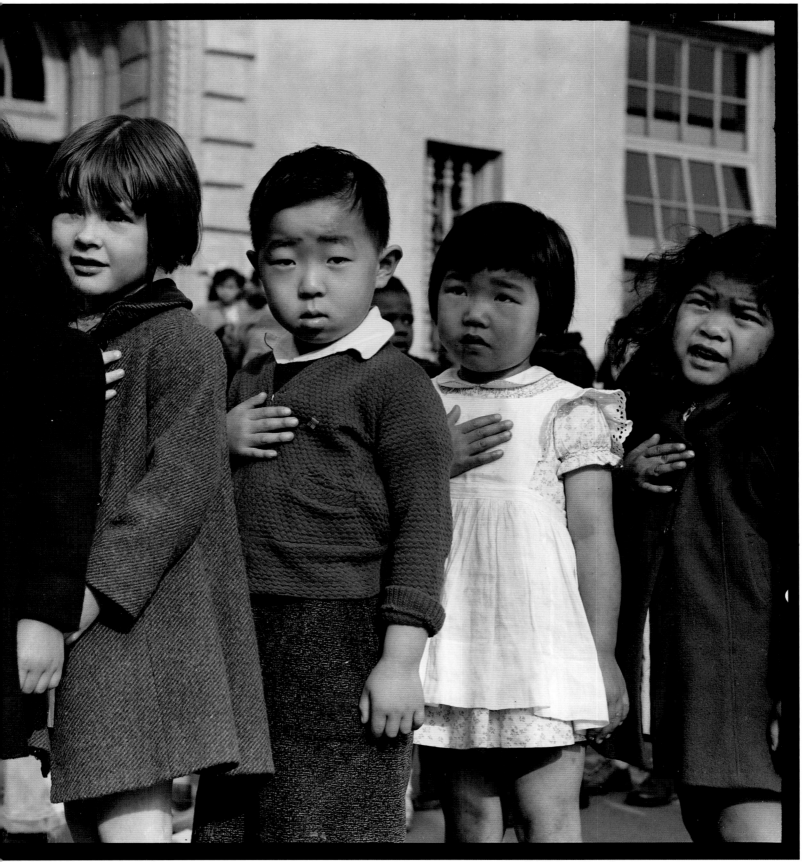

DOROTHEA LANGE SAN FRANCISCO, CALIFORNIA **APRIL 20, 1942**

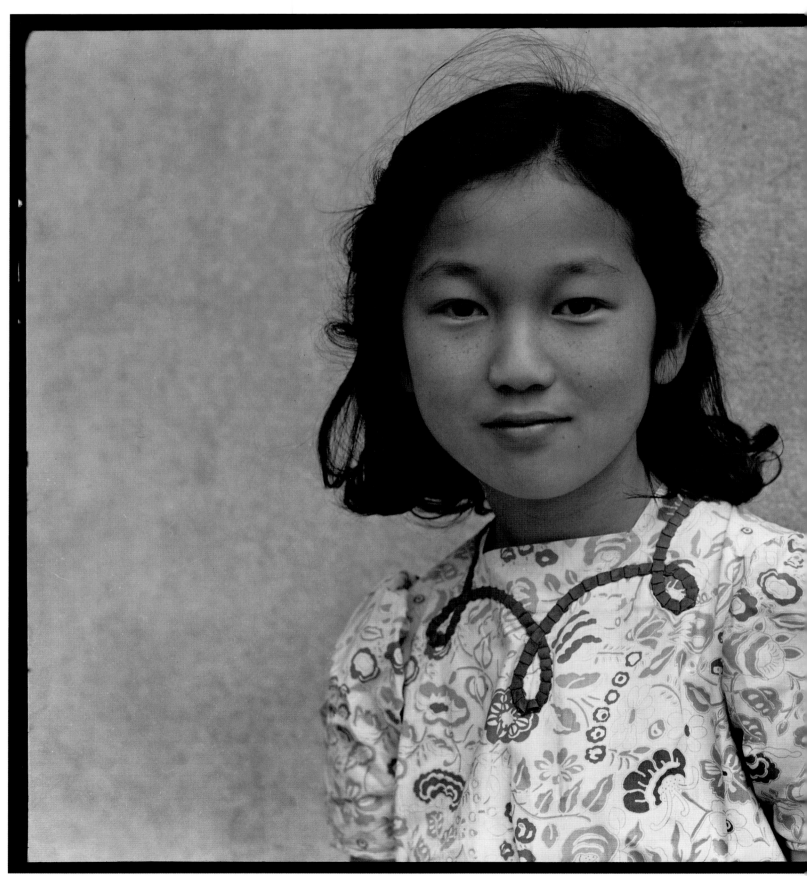

DOROTHEA LANGE SAN FRANCISCO, CALIFORNIA **APRIL 20, 1942**

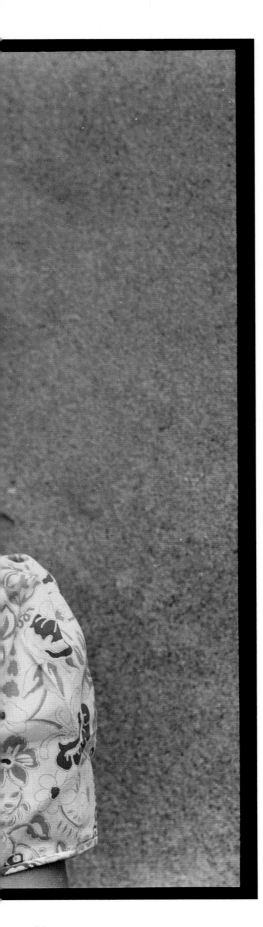

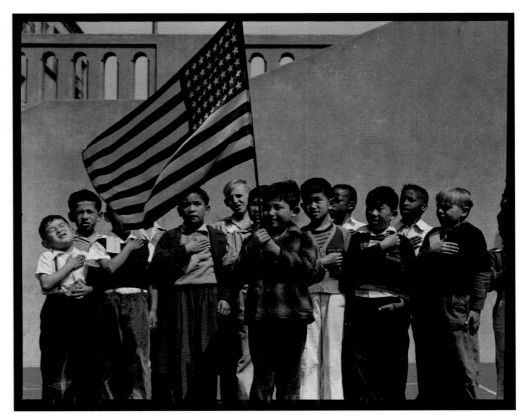

DOROTHEA LANGE SAN FRANCISCO, CALIFORNIA **APRIL 20, 1942**

Saluting the flag at Weill just days before the government banished him from his city didn't seem strange to nine-year-old Hisashi John Kobayashi (pictured, in a striped shirt, to the right of the flag holder). "It's just something that happened," Kobayashi recalled. He and his family were taken from San Francisco to the Topaz Relocation Center in Utah, where his father, Harutoyo, died of a heart attack. Seventy-five years later, Kobayashi still worried that minorities could be severely persecuted again: "Things like this can happen. You need to be vigilant. You need political power."

Left: For 11-year-old Rachel Kuruma, being sent to Topaz with her family was initially an adventure: sleeping in horse stalls, taking her first train ride, and witnessing her first snowfall. But the experience turned bitter when her father, Saichero, died in camp. "I was his baby," she said. When, at 85, she saw for the first time Dorothea Lange's portrait of her in the Weill courtyard, she smiled. "I was quite presentable then."

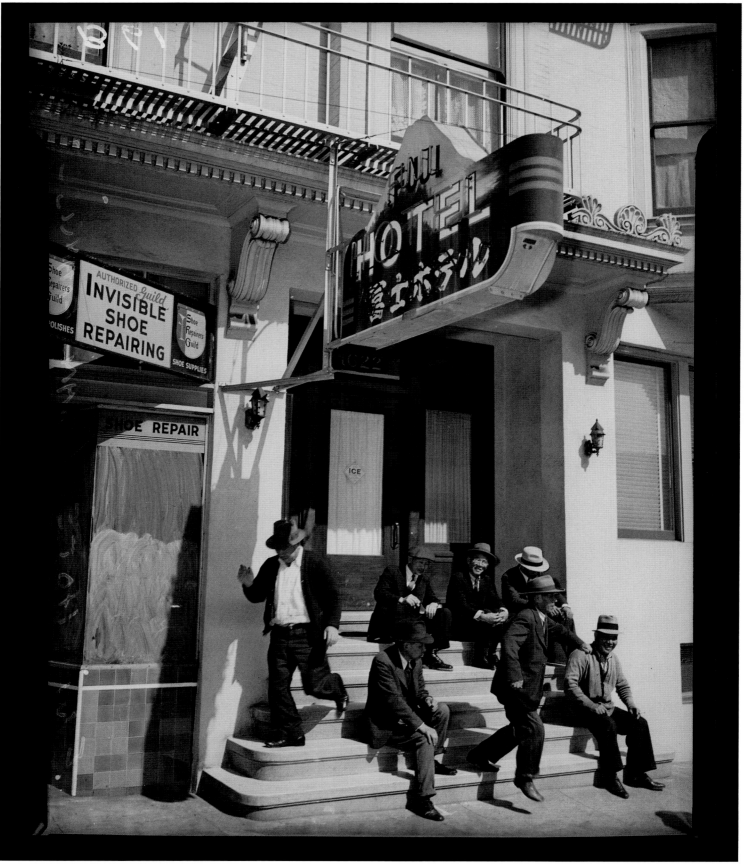

CLEM ALBERS SAN FRANCISCO, CALIFORNIA **APRIL 1942**

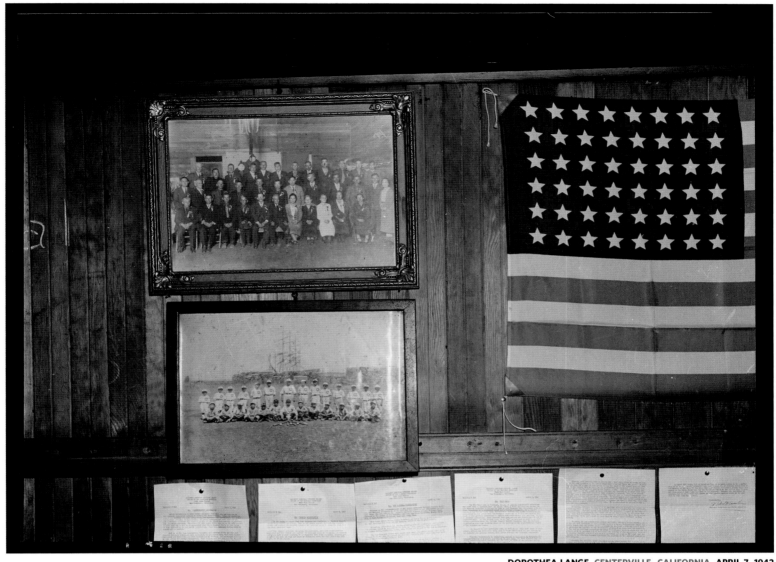

The Japanese American Citizens League headquarters in Centerville, California, were photographed one month before area residents were forced to leave their homes. The league was later criticized for urging its members to cooperate with the government before and during the war and for not challenging constitutional violations against Japanese Americans. About a hundred residents filled out the league's oath of allegiance to the United States in early 1942. The formal documents—which included photographs and fingerprints of each signatory—were signed in front of a notary public and are now stored at the Fremont Main Library in California.

Opposite: Unmarried Japanese men loiter outside the Fuji Hotel. Families were generally kept together during their incarceration, but bachelors lived in large unpartitioned barracks at the temporary detention facilities and incarceration centers.

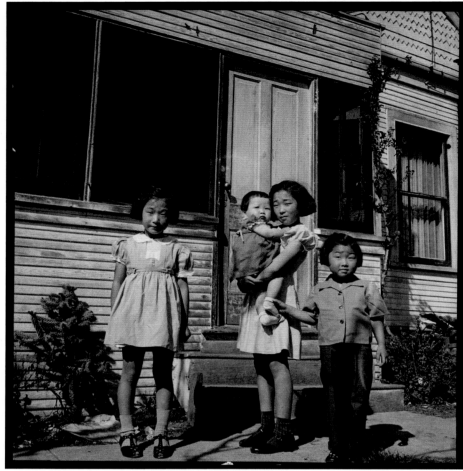

DOROTHEA LANGE SUNNYVALE, CALIFORNIA **MARCH 30, 1942**

Jean Mitarai, 10, holds her infant sister, Elaine, at the family farm with her sisters Shirley (left), 8, and Patricia, 5. Janet (now Jeanette Misaka) remembered that her mother, Helen, looked all over the farm for the baby's shoes on the day Dorothea Lange took this photograph: "Dad wanted us to look nice. We never could find those shoes."

The family was incarcerated at Heart Mountain and released in 1943. On Jean's first day back at junior high school in Richfield, Utah, the principal, a man named Alma Edwards, called the class together and said, "Jean is an American just like you and me. If anybody has a problem with that, see me." She never had a problem.

Right: Days before being forced to leave, members of a Japanese American farm family work the strawberry fields near the Coast Ranges in what is now Fremont, California.

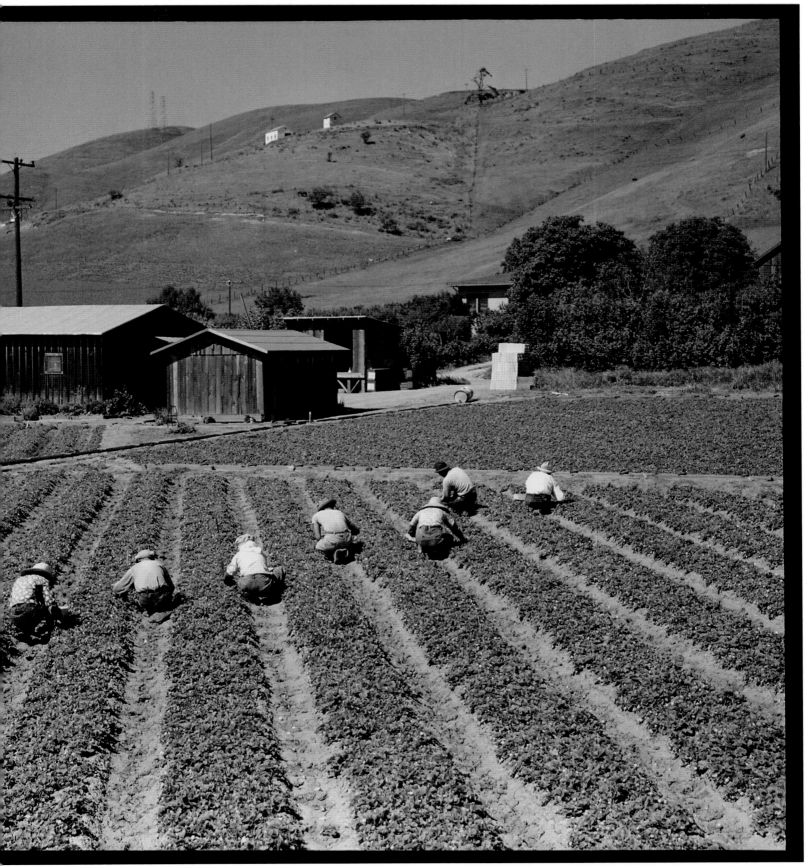

DOROTHEA LANGE NEAR MISSION SAN JOSE, CALIFORNIA APRIL 5, 1942

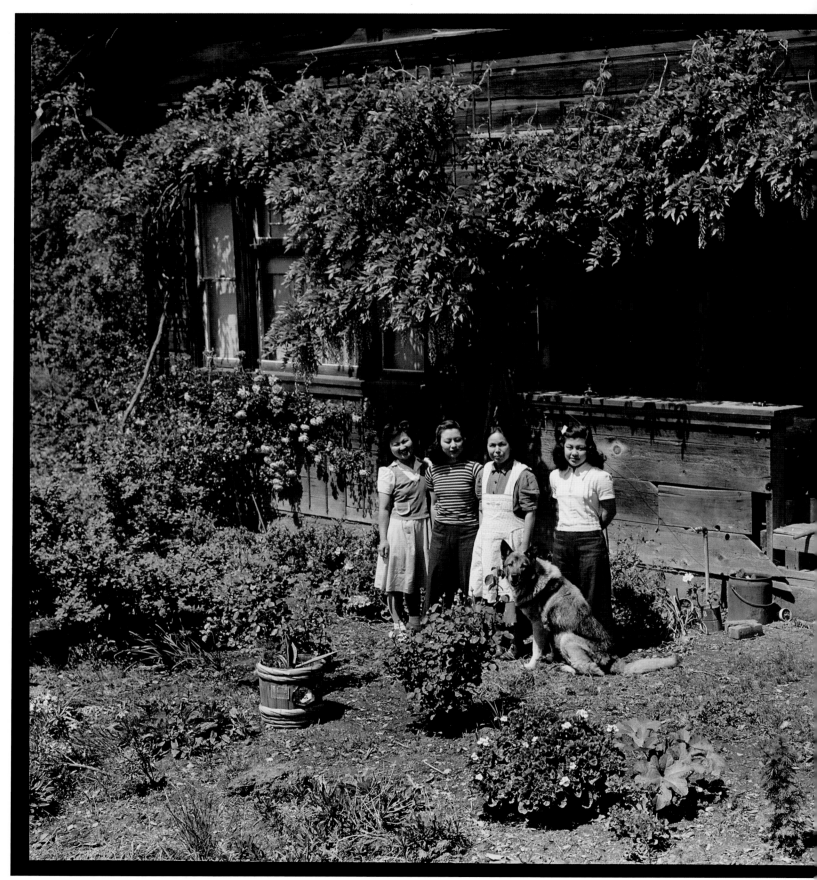

DOROTHEA LANGE MOUNTAIN VIEW, CALIFORNIA **APRIL 18, 1942**

Shun Kubota (in an apron) and her daughters (from left) Barbara Miyeko, Kimiko, and Sumiko were taken to Santa Anita and then to Heart Mountain. They were allowed to leave the incarceration camp in Wyoming to work in Chicago in 1943, according to camp records. The women helped run a twenty-acre farm, raising berries, broccoli, peas, and garlic.

Almost half of the men and women of Japanese ancestry along the West Coast were engaged in agriculture before the war. Their farms were tiny—less than one-fifth the size of typical California farms—and were often on land that was considered substandard. But their yield was astonishing. Japanese American farm families like the Kubotas worked hard and were exceedingly frugal, using little water. Their farms were admired—and coveted—by their neighbors. So coveted, in fact, that some say the plan to remove the families was a not-so-covert attempt to acquire their land. "We're charged with wanting to get rid of the Japanese for selfish reasons," said a representative of a California growers' association. "We might as well be honest. We do. It's a question of whether the white man lives on the Pacific Coast or the brown man."

To ensure that wartime food production would not be harmed, the federal government demanded that Japanese American farmers remain on their land until the day they were taken away. They were warned in March 1942 that they risked being charged with sedition if they left. "Foodstuffs are vital in prosecution of the war," the army proclaimed, "and for Japanese ranchers professing loyalty to the United States there is no better way of showing sincerity than by continuing to raise crops. On the other hand, willful destruction of crops demonstrates disloyalty and unwillingness to cooperate."

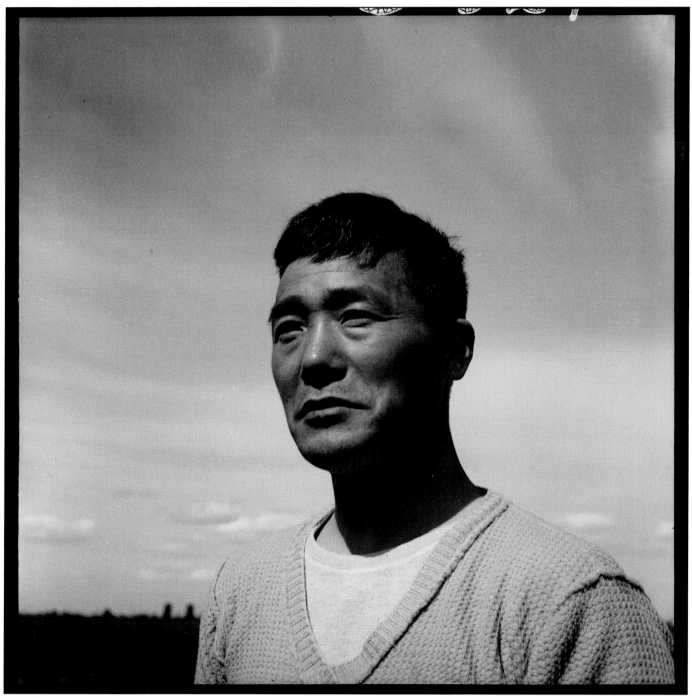

DOROTHEA LANGE NEAR FLORIN, CALIFORNIA **MAY 11, 1942**

"This Issei," Dorothea Lange wrote, "the father of seven children, came to the United States from Japan when he was a boy." Formerly in the wholesale grocery business in Los Angeles, he moved to Florin in eastern California just before the detention order was issued.

Right: A farmer in Centerville, in what is now Fremont, California, prepares the soil to transplant tomato plants before the forced removal of residents there. Japanese Americans were master farmers, using techniques handed down for generations.

DOROTHEA LANGE CENTERVILLE, CALIFORNIA MARCH 27, 1942

Bewildering and Sorrowful Days

I still have nightmares. I have nightmares quite often trying to decide 'What am I going to take?' 'What am I going to do with everything?' and 'What's going to happen to us?'

—Peggie Nishimura Bain

Just over two months after the attack on Pearl Harbor, President Franklin Roosevelt signed Executive Order 9066. It gave the military the power to exclude "any or all persons" from designated military areas without a hearing or a trial. The "any or all persons" were Japanese Americans. The designated military areas were southern Arizona, parts of Oregon and Washington, and all of California. Japanese Americans were given less than a week to register with authorities and get instructions on where they should go. In a breathtakingly short time, possessions were sold or stored and businesses and churches were closed. Crops were left in fields. Laundry was left hanging on clotheslines. These were bewildering and sorrowful days.

Civilian Exclusion Order 5, issued in early April 1942, directed Japanese Americans in downtown San Francisco to report within three days to an Army-run "control station" for instructions about their forced removal. "All these proclamations, all over town, on the telephone poles," Dorothea Lange recalled years later. "I have some of them—big proclamations telling people where to go, announcing the fact. And then when the day of removal came they all had to be at a certain place."

Like all of the 107 other orders, detention Order 5 commanded Japanese Americans to bring bedding, linens, toilet articles, clothing, knives, forks, spoons, plates, bowls, and cups sufficient for each member of the family. "The size and number of packages is limited to that which can be carried by the individual or family group," it declared.

Nearly 5,000 Japanese Americans were removed from San Francisco on four separate dates. Six days after the order was posted, ten buses moved 650 of them to the Southern Pacific Railroad Yards, where they were directed onto trains and transported to the Santa Anita Assembly Center in Arcadia, California.

San Francisco newspapers made light of the removal. A headline in the *News* read: "Alien Exodus Like an Outing." A reporter for the *Examiner* observed: "Everybody wore a grin; everybody had a wisecrack for his neighbor; nobody complained and nobody shed a tear." He wrote about games of gin rummy and bridge being played on the trains and the jitterbug being danced in their aisles. He inventoried the scene: gray-haired men, tottering old women, girls in slacks, and men in collegiate garb. "All had a place in this procession which should have been like a funeral march but wasn't," he noted. "It was a festival—a gigantic picnic—a holiday tour—a trip to nowhere—at least on the surface."

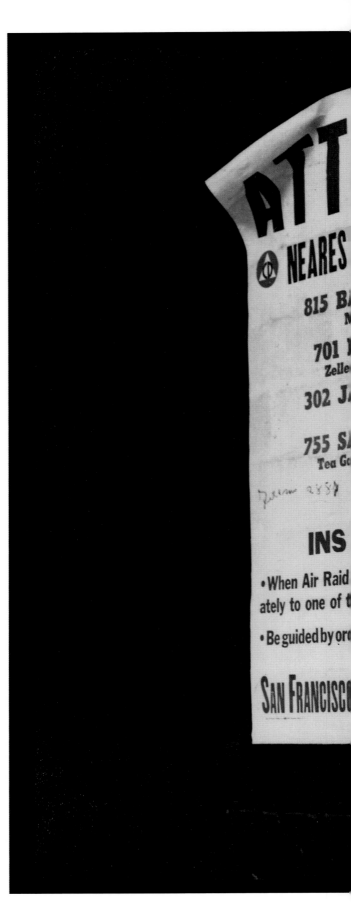

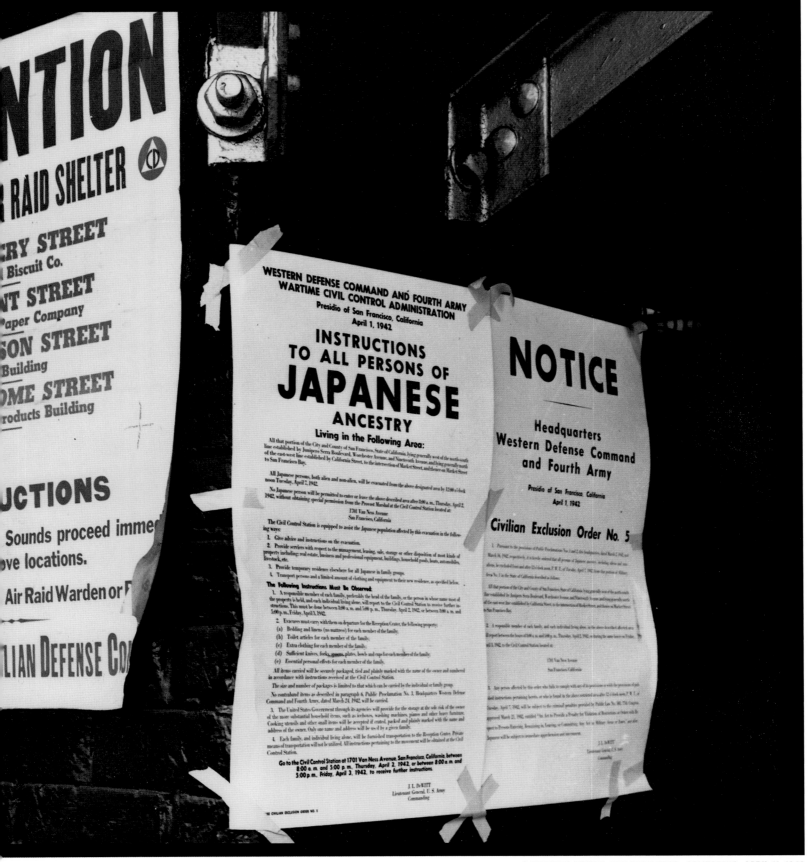

DOROTHEA LANGE SAN FRANCISCO, CALIFORNIA **APRIL 11, 1942**

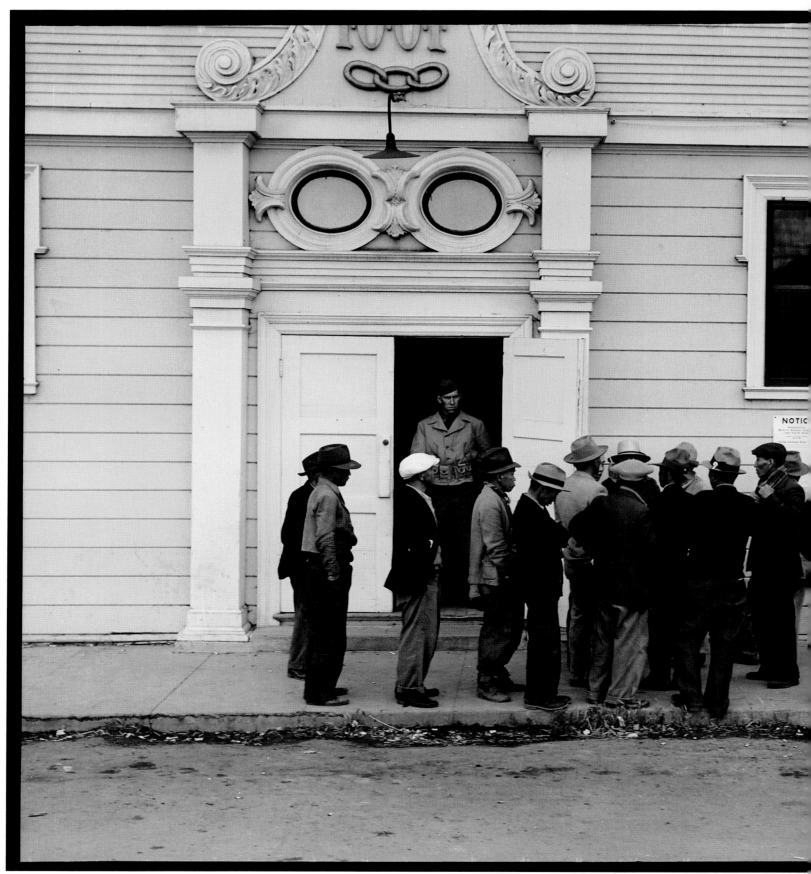

DOROTHEA LANGE BYRON, CALIFORNIA APRIL 28, 1942

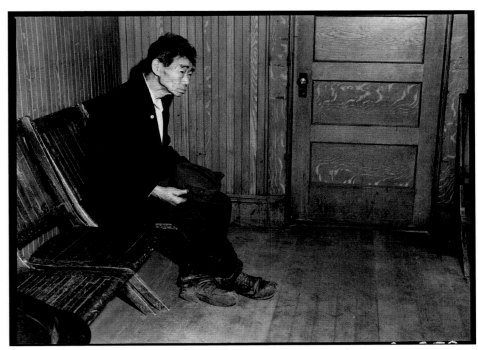

DOROTHEA LANGE BYRON, CALIFORNIA APRIL 28, 1942

Like all Issei, Toshi Mizoguchi, a 66-year-old bachelor who emigrated in 1892, was not allowed to become a U.S. citizen, but he wore an American flag button on his jacket the day he reported to the Wartime Civil Control Administration, which registered and transported people to incarceration camps. He was sent to the Colorado River Relocation Center, known as Poston, in Arizona. When the war ended, he returned to Visalia, California, where he died in 1951.

Left: Farmworkers receive instructions in front of an Independent Order of Odd Fellows lodge in Byron. "A Caucasian farmer representing a company was trying to get his workers to continue working the asparagus fields until Saturday, when they were scheduled to leave," Dorothea Lange wrote about the Tuesday meeting. "The workers want to quit tonight in order to have time to get cleaned up, wash their clothes, etc."

CLEM ALBERS SAN PEDRO, CALIFORNIA APRIL 5, 1942

Lieutenants James Glatt (left) and Cal Ferris look over maps of Redondo Beach, California, as they organize Civilian Exclusion Order 2, which forced 2,497 Japanese American from Los Angeles County. They were taken to the Santa Anita Racetrack, which was converted into a temporary detention center. A total of 39,258 residents of Los Angeles County and five surrounding counties were rounded up. The army's new Western Defense Command oversaw the removal process.

Right: Civilian Exclusion Order 51 was posted in a Japanese neighborhood just west of the California state capitol in Sacramento. Occupants of the house on the corner placed crated furniture on the porch in anticipation of their removal. Sacramento County had the fastest-growing population of Japanese Americans just before the start of the war. Twenty-one thousand people were removed from the city and fifteen surrounding counties.

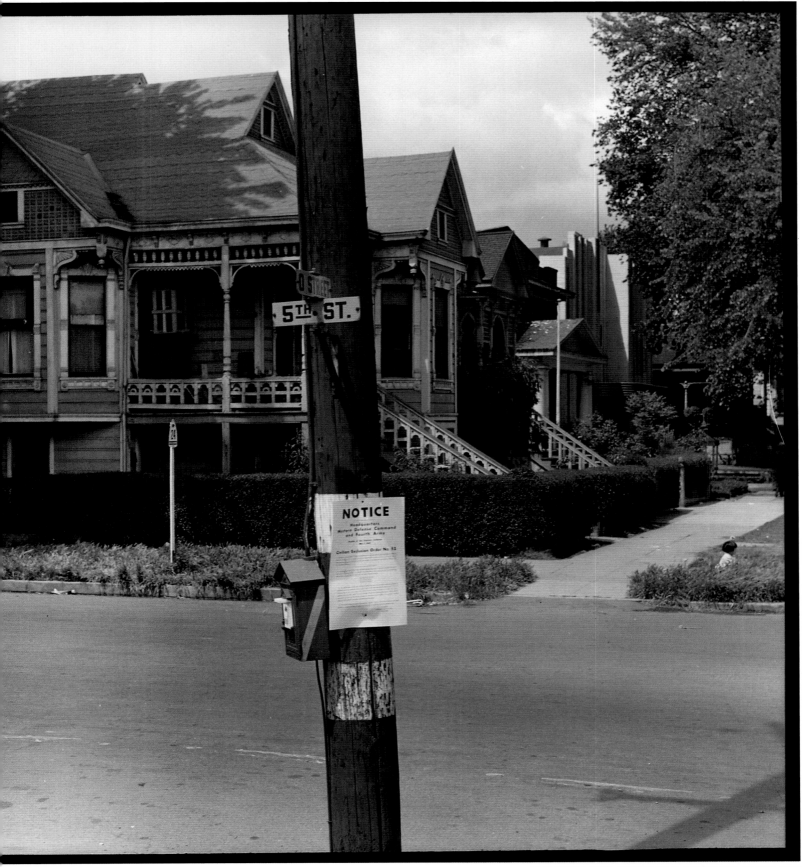

DOROTHEA LANGE SACRAMENTO, CALIFORNIA **MAY 11, 1942**

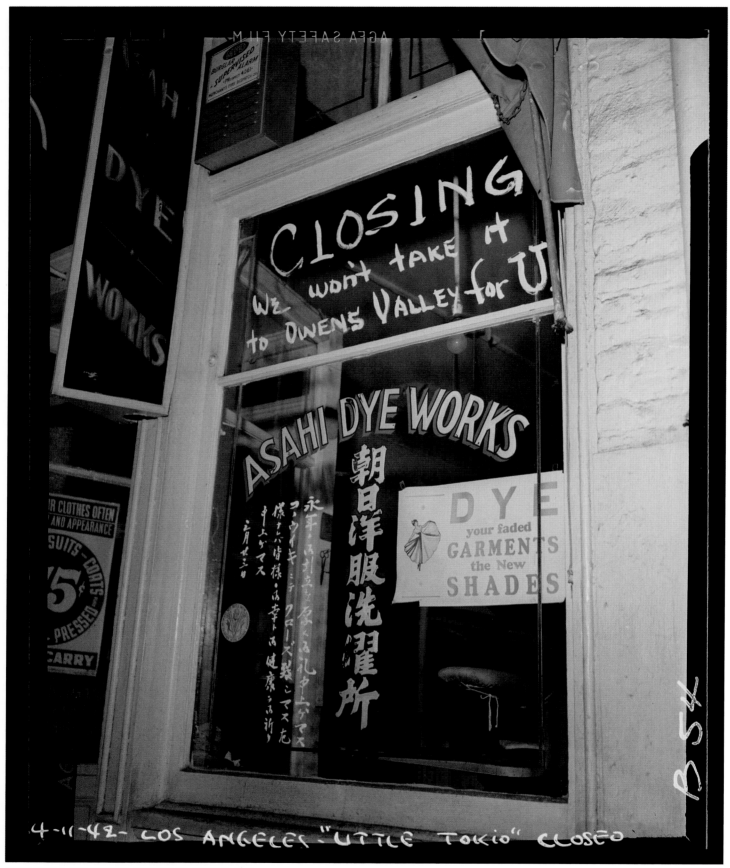

CLEM ALBERS LOS ANGELES, CALIFORNIA APRIL 11, 1942

The last days of Los Angeles's Little Tokyo neighborhood as storeowners prepare for the expulsion. The proprietors of Asahi Dye Works lightheartedly reminded customers that unclaimed items would not be taken to the Manzanar Relocation Center in Owens Valley, California. The shop was run by Soji Tanahashi and his wife, Kin, and their 23-year-old American-born son, Kei. The family was removed to Heart Mountain Relocation Center. Kei volunteered for the army and served as a second lieutenant in the 442nd Regimental Combat Team, an all–Japanese American unit. Shot four times in combat in Italy on July 4, 1944, he ordered medics to attend to other wounded men first and died before he could be treated. More than 33,000 Japanese Americans served in the military during World War II. An estimated 800 were killed in action.

THE PACIFIC DRY GOODS CO.

PHONES GARfield 0771
0772

CABLE ADDRESS
"PACIFICDRY" SAN FRANCISCO

CODES USED
BENTLEY'S PHRASE
A. B. C. 5TH EDITION IMPROVED

IMPORTERS AND WHOLESALERS OF
ORIENTAL DRY GOODS, CHINAWARES AND
ART NOVELTIES

434-440 GRANT AVE.
SAN FRANCISCO, CALIFORNIA

YOKOHAMA BRANCH
61-5 CHOME,
BENTEN DORI, YOKOHAMA
JAPAN

In reply refer to file

TO SAN FRANCISCAN'S AND OUR CUSTOMERS:

We take this opportunity of expressing to each of
you our heartfelt appreciation and "thank you" for
your patronage and for the many courtesies and
opportunities extended to us in the past.

We regret that circumstances beyond our control
compel us to leave this city, however, we hope
that you will continue to patronize and keep San
Francisco's Chinatown something to be proud of.

We hope that someday in the future, we may have
the opportunity of serving our friends again.

THANK YOU!

THE PACIFIC DRY GOODS CO.

DOROTHEA LANGE SAN FRANCISCO, CALIFORNIA **APRIL 1942**

Dave Tatsuno and his father, Shojiro, pose in front of the family's department store. Shojiro opened Nichi Bei Bussan in 1902 and rebuilt it after the 1906 San Francisco earthquake. Dave, a devoted amateur filmmaker, smuggled his Bell & Howell 8 mm camera into Topaz and took the only known color movies of life in an incarceration camp. He created a forty-eight-minute film that is now included in the National Film Registry of the Library of Congress, only the second home movie so honored.

Dorothea Lange, who also photographed Dave's wife, Alice, making the family's final dinner before their removal, recalled Dave running into his high school teacher on the street during that last week: "He greeted her, and they stopped and spoke. And I remember seeing a look go over her face, and she said, 'Oh, but not you, Dave, they don't mean you, Dave!' She didn't realize that he was going, too."

Left: Another San Francisco store, the Pacific Dry Goods Company in Chinatown, thanks customers for their loyalty.

DOROTHEA LANGE **FLORIN, CALIFORNIA MAY 12, 1942**

Reverend Shozen Naito locks the Buddhist Church of Florin. The majority of Issei were Buddhists; most Nisei were Christians. The military encouraged the practice of both religions, but it prohibited the use of the Japanese language at religious ceremonies and banned the practice of Shinto, the state religion of Japan, which fostered loyalty to the emperor.

Right: Ted Miyata, 23, is shown at the church. He returned to Florin on furlough to help his family. The incarcerated depended on their servicemen relatives for errands, Dorothea Lange noted: "They are the only ones allowed to travel into town, nine miles away, which others cannot under military orders."

DOROTHEA LANGE FLORIN, CALIFORNIA MAY 12, 1942

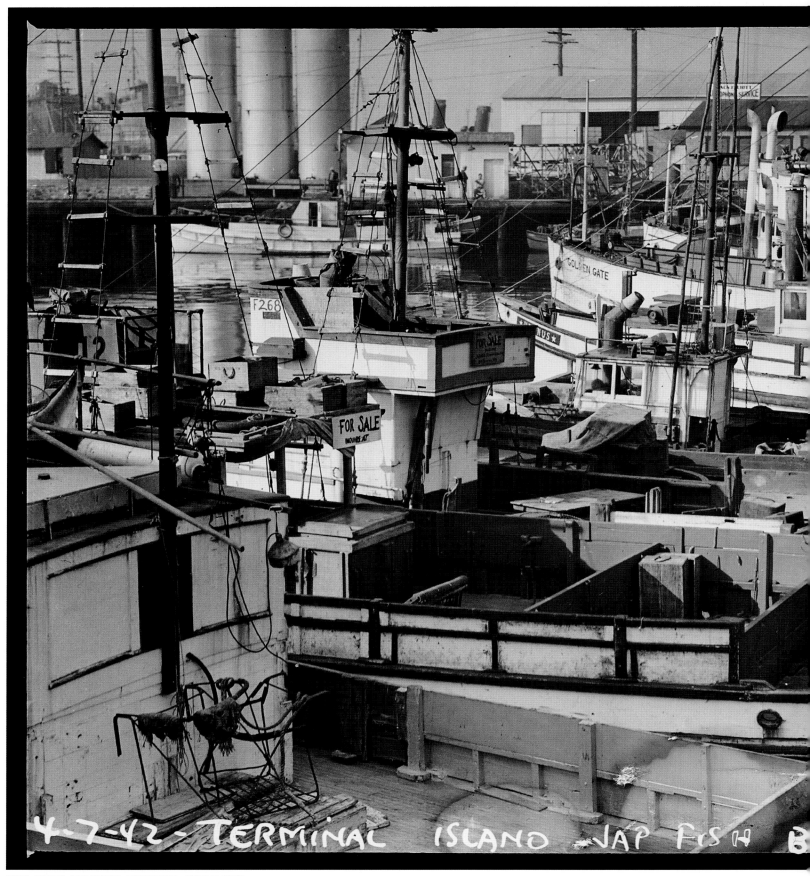

CLEM ALBERS SAN PEDRO, CALIFORNIA APRIL 7, 1942

Abandoned homes of Japanese Americans line the fishing village of Terminal Island in Los Angeles Harbor.

Left: Because Terminal Island was near a naval base, an airstrip, and the Port of Los Angeles shipyards, the FBI made it a top security priority. Suspected of making contact with the Japanese navy, hundreds of commercial fishermen were rounded up and held without trial in early December and again in February 1942. They were never charged.

"The Terminal Islanders as a group were perhaps more thoroughly victimized than any other group of Japanese Americans," reported the Department of the Interior in 1945. Residents were at first given a thirty-day evacuation notice but were then told to leave within forty-eight hours. "It was really cruel and harsh," wrote Joseph Yoshisuke Kurihara, who was incarcerated at Manzanar. "To pack and evacuate in forty-eight hours was an impossibility."

Their houses were soon condemned and bulldozed. The navy requisitioned their fishing boats, some of which were converted into patrol vessels and used as far away as the Panama Canal.

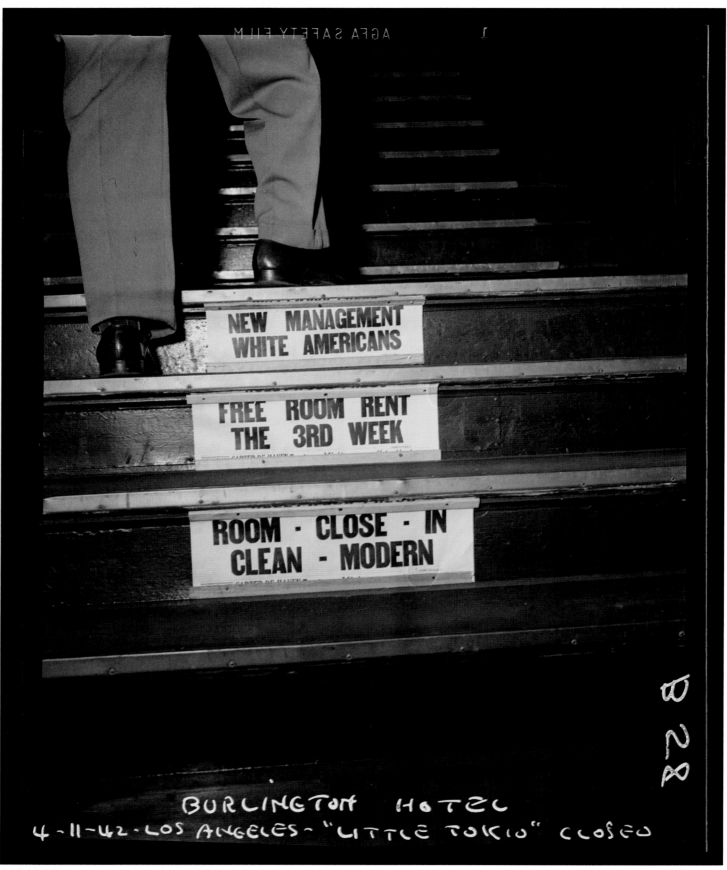

CLEM ALBERS LOS ANGELES, CALIFORNIA APRIL 11, 1942

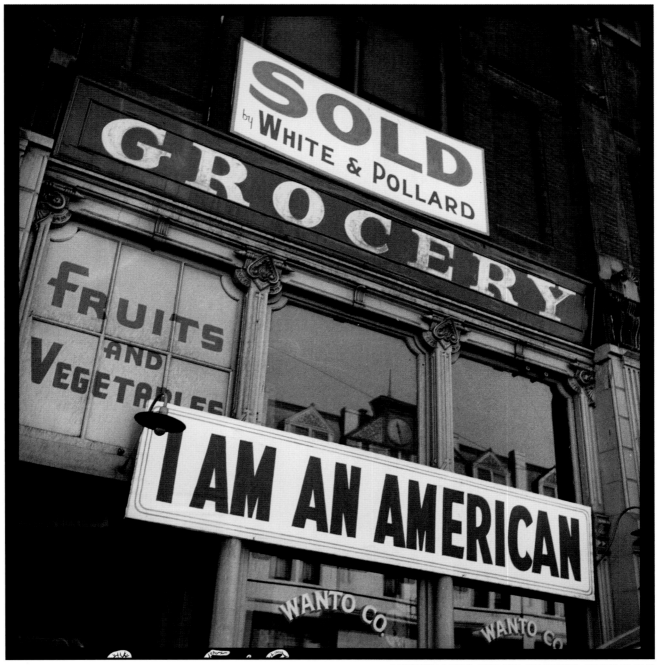

DOROTHEA LANGE OAKLAND, CALIFORNIA MARCH 13, 1942

Tatsuro Masuda had a sign declaring that he was an American put up at the grocery store, Wanto Company, he owned in Oakland, where he was born. "I paid for it the day after Pearl Harbor," he told Dorothea Lange. Newly married, Masuda and his wife were incarcerated at the Gila River Relocation Center in Arizona. They never returned to the store.

Opposite: The Burlington Hotel came under new management after residents of Little Tokyo were ordered to leave. The area soon changed to an African American neighborhood known as Bronzeville.

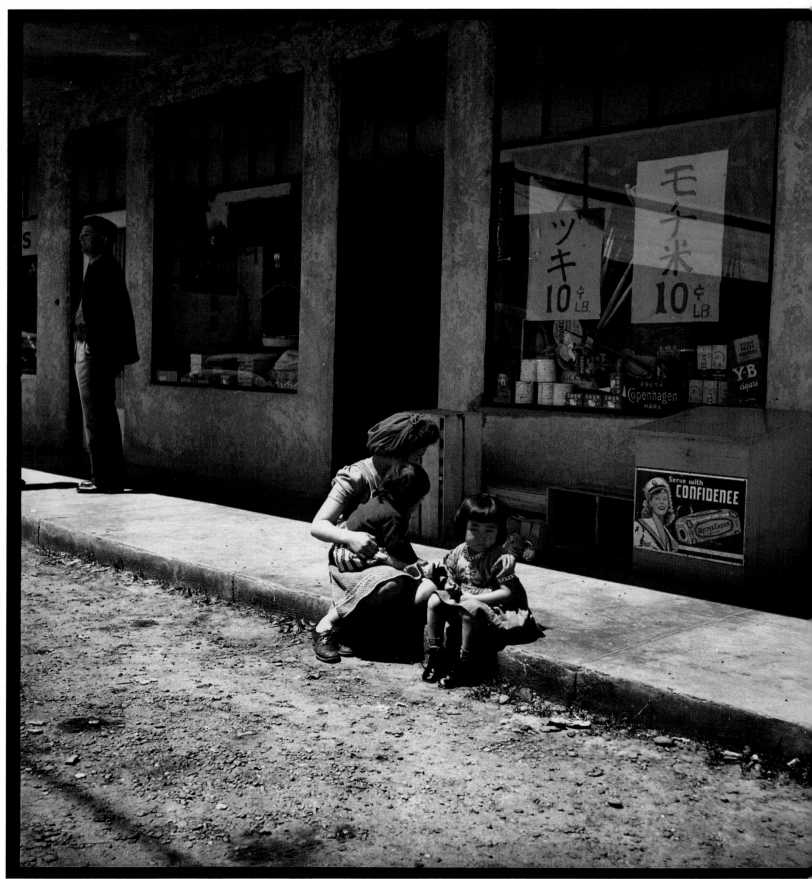

DOROTHEA LANGE FLORIN, CALIFORNIA **MAY 11, 1942**

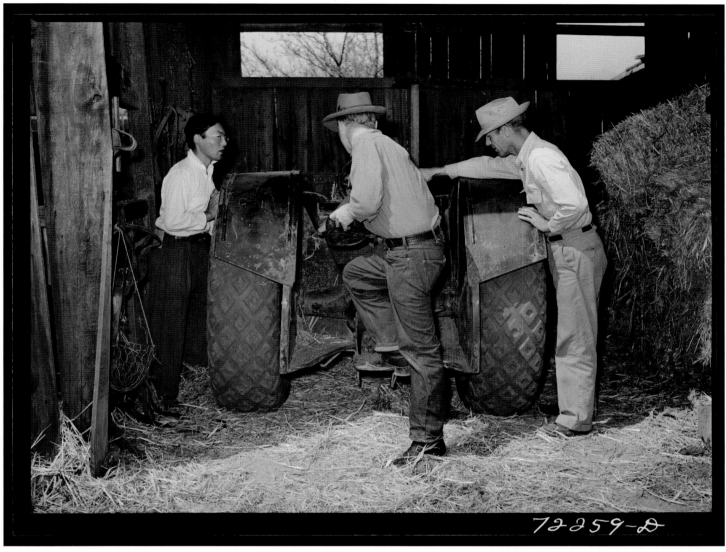

RUSSELL LEE LOS ANGELES, CALIFORNIA APRIL 1942

A Japanese American farmer tries to sell his tractor to neighbors in Los Angeles County. Years later, another man, Yasuko Ito, would remark: "It is difficult to describe the feeling of despair and humiliation experienced by all of us as we watched the Caucasians coming to look over our possessions and offering such nominal amounts knowing we had no recourse but to accept whatever they were offering because we did not know what the future held for us."

Left: Margaret Ogata holds her one-year-old daughter Shirley next to her three-year-old Margaret in front of the family grocery store two days before they were forced to leave their home in Florin. Japanese American farmers thrived in Florin before the war because they figured out an innovative way of planting strawberries between rows of grapevines—providing a crop that supplemented their income. The Ogatas, with seven children, spent the war at three camps. Then they moved to rural Michigan, where father Charles ran a fruit ranch and later started a grocery store. They did not return home. Said daughter Margaret, "We had nothing to go back to."

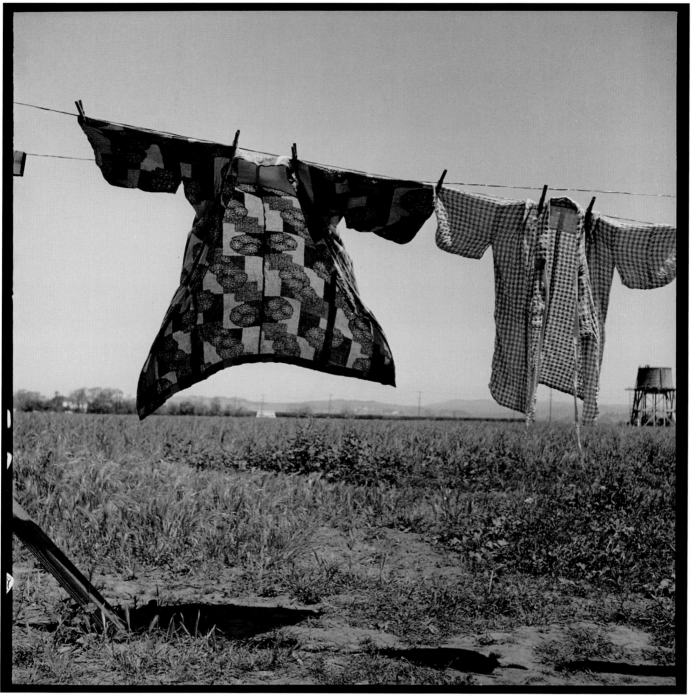

DOROTHEA LANGE SAN LORENZO, CALIFORNIA MAY 5, 1942

Forty-eight hours after these clothes were hung to dry, their owners were forced off their family farm near San Lorenzo, south of Oakland.

Right: With everything packed for the next day's expulsion, a California tenant farmer contemplates his future. A total of 858 Japanese American residents from Yolo County near Sacramento registered at the National Guard armory on Bush Street in Woodland after the posting of Civilian Exclusion Order 78.

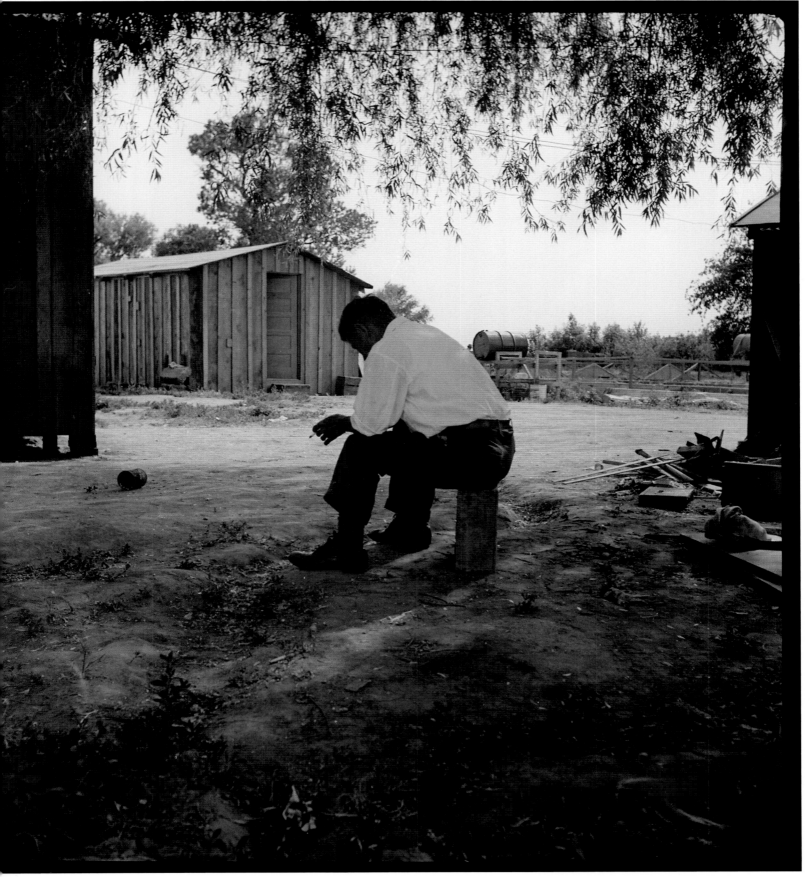

DOROTHEA LANGE WOODLAND, CALIFORNIA **MAY 20, 1942**

Picked Up

Has the Gestapo come to America? Have we not risen in righteous anger at Hitler's mistreatment of Jews? Then, is it not incongruous that citizen Americans of Japanese descent should be similarly mistreated and persecuted?

—James M. Omura to the House Select
 Committee Investigating National Defense
 Migration

Between March and August 1942, nearly 110,000 Japanese American men, women, and children were picked up at 108 locations up and down the West Coast to be taken—some by bus or train, others driving their own cars, but with military escorts—to detention camps. They were all considered security threats, suspected of being spies for imperial Japan or potential collaborators in a future invasion of the American mainland. Those final days leading up to what officials called Evacuation Day were tense, yet few Japanese Americans protested. It was believed that cooperating with the government was the correct and proper thing to do.

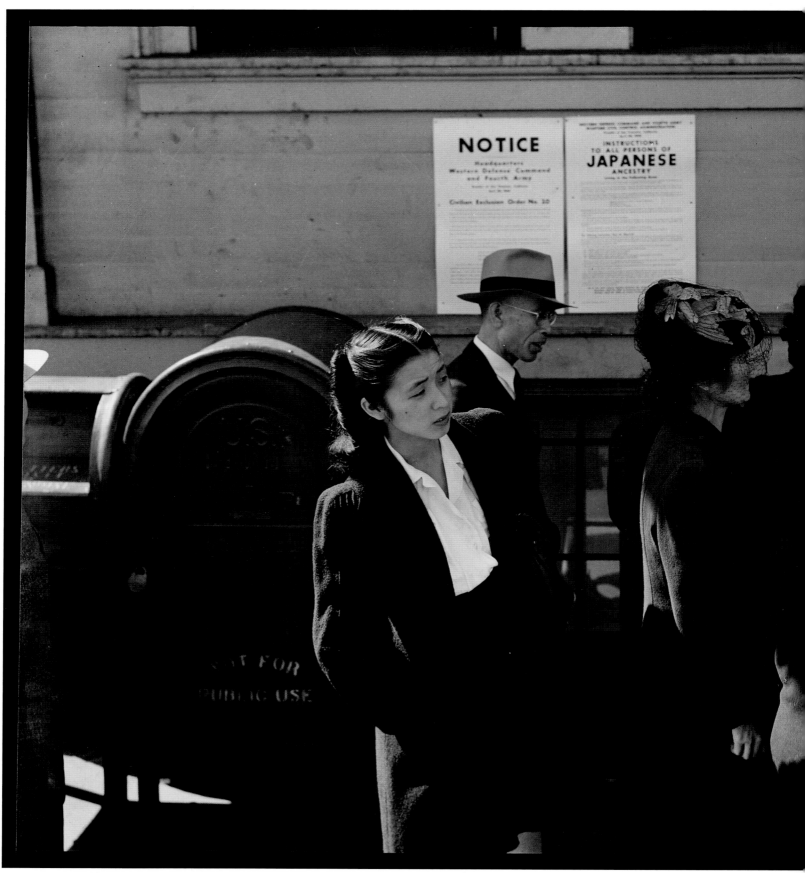

DOROTHEA LANGE SAN FRANCISCO, CALIFORNIA **APRIL 25, 1942**

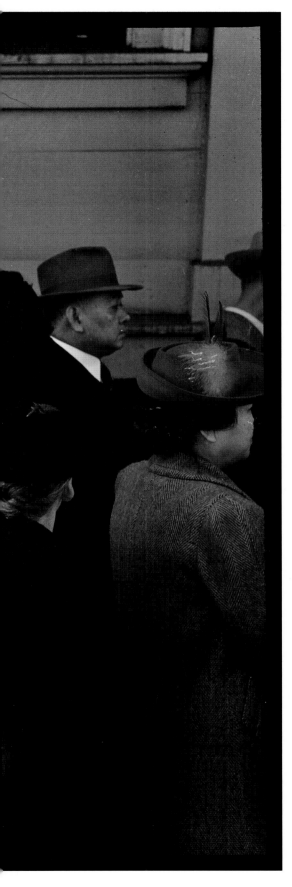

Twenty-five-year-old Shizuko Ina kept a diary during the weeks prior to her removal, writing about new travel regulations, curfews, and contraband laws and noting the businesses that closed or were shut down.

On April 24—the day before she was photographed waiting to register at the Japanese language school called Kinmon Gakuen, in San Francisco— Shizuko wrote: "12 noon today our evacuation order is effective. Every corner of block has a 'notice.' Mr. Masuko [a family friend] and I went to Kinmon Hall for registration. There was so many people that we'd been waiting almost 3 hours to get a slip for appointment for tomorrow."

On April 26, she wrote: "At 12:30 noon Mr. Masuko and I went Kinmon Hall again. We registered together as one family. Our family number is 14911. We shall leave San Francisco either Thursday or Friday. For dinner we were invited to Mrs. Aizawa's." She reported that the sushi dinner was "delicious" and lamented that it might be "our last time" to have such a meal.

This was the start of a four-year ordeal for Shizuko and her husband, Itaru. She was four months pregnant when they were sent to the Tanforan Assembly Center in San Bruno, California, where they were forced to live in a former horse stall. She suffered severe morning sickness before giving birth to a son, Kiyoshi.

Shizuko and Itaru protested policies they felt violated their constitutional rights. Their story is recounted in the award-winning 2005 documentary *From a Silk Cocoon*, produced by their daughter Satsuki Ina, who was born at the Tule Lake incarceration camp in California.

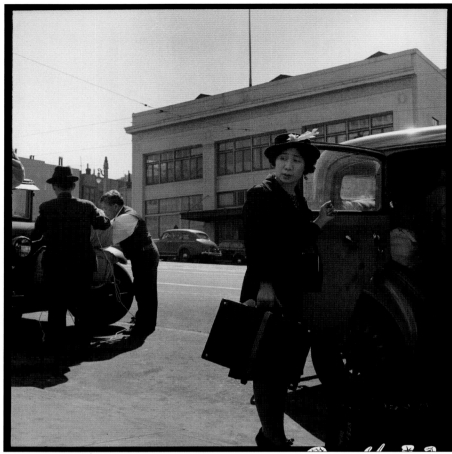

DOROTHEA LANGE SAN FRANCISCO, CALIFORNIA APRIL 6, 1942

Shima Yoshino arrives at 2020 Van Ness Avenue in downtown San Francisco to board the bus that will transport her and her family to Santa Anita. Born in Japan, Shima was a picture bride. She and her future husband—a man named Yoshiichi Ben Yoshino, who had moved to California in 1915—chose each other based on photographs and personal information provided by intermediaries. Four years later, Ben brought his bride, sight unseen, to California, where he ran a dry-cleaning business and she worked as a dressmaker and seamstress. They had three children, who accompanied them to the Topaz Relocation Center. After the war, Ben worked as a janitor, and Shima as a domestic. Their grandchildren say they never talked about their incarceration.

Right: Soldiers guard the Wartime Civil Control Administration station at 2031 Bush Street in San Francisco, where each family was assigned a number that was to be written on tags attached to personal belongings. The entrance remains.

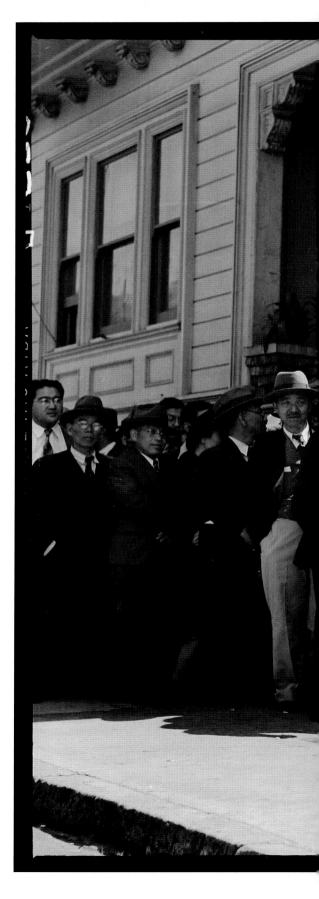

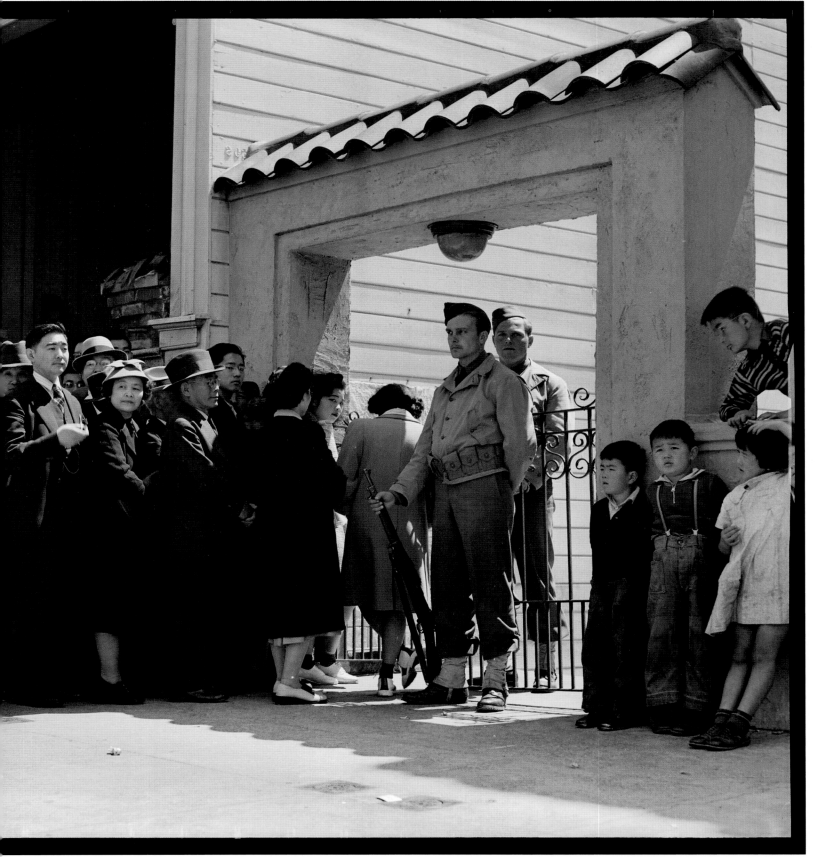

DOROTHEA LANGE SAN FRANCISCO, CALIFORNIA **APRIL 25, 1942**

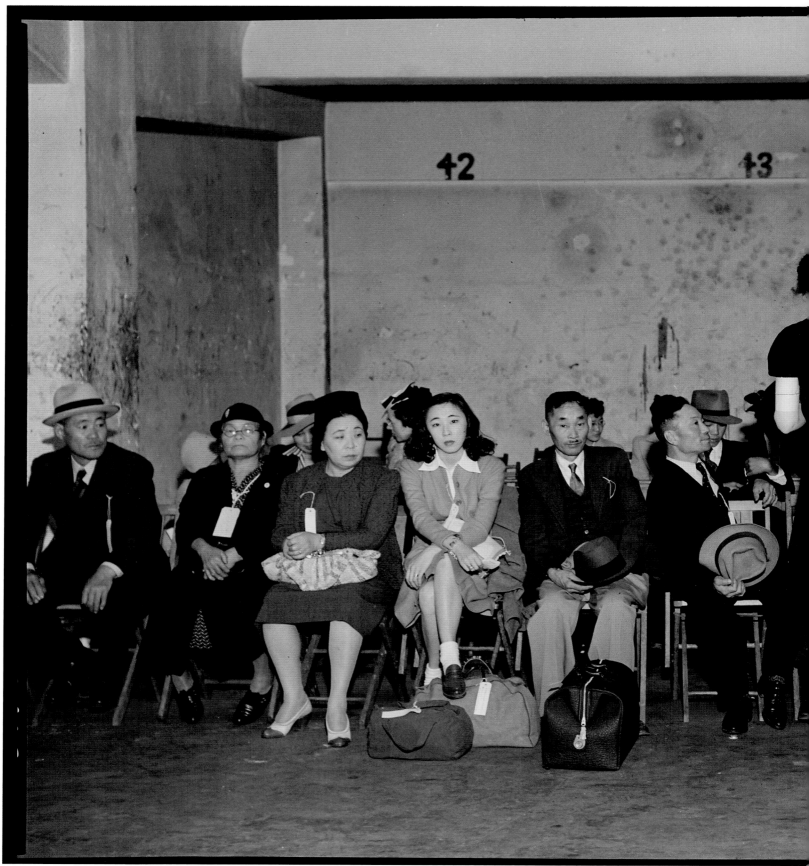

DOROTHEA LANGE OAKLAND, CALIFORNIA **MAY 6, 1942**

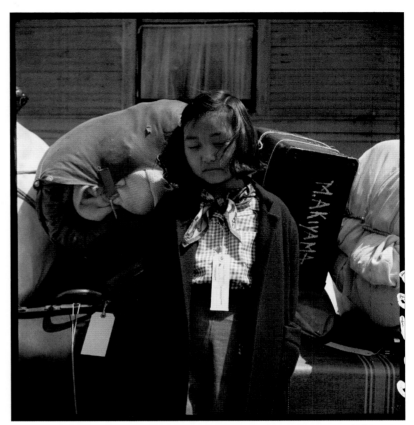

DOROTHEA LANGE OAKLAND, CALIFORNIA MAY 6, 1942

Eleven-year-old Kimiko Kitagaki waits alongside family luggage outside the control station at Oak and Eleventh Streets, near the present-day Oakland Museum of California. She would spend almost three years at Topaz.

Left: People wait at the Oakland control station for a train to take them to Tanforan. A total of 4,097 residents of California's Alameda County were removed. One Oakland resident who didn't show was 23-year-old Fred Korematsu, who refused to leave his Italian American girlfriend. After his arrest, Korematsu and the American Civil Liberties Union challenged the constitutionality of Executive Order 9066 before the Supreme Court. They lost, but his conviction was formally vacated in 1983 in federal court. Standing in court, Korematsu said: "I would like to see the government admit that they were wrong and do something about it so this will never happen again to any American citizen of any race, creed, or color."

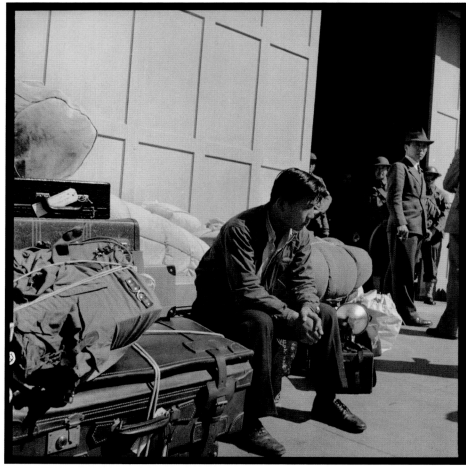

DOROTHEA LANGE SAN FRANCISCO, CALIFORNIA **APRIL 6, 1942**

As she documented the early days of the exclusion, Dorothea Lange paid special attention to young people. "They were the ones that really hurt me the most," she said, "the teenage boys who didn't know what they were." She photographed 18-year-old Mitsunobo "Mits" Kojimoto on the morning he and his family were taken to Santa Anita. (They would later be moved to Topaz.) Mits, who had been a varsity basketball player at San Francisco's Commerce High School, joined the 442nd Regimental Combat Team in 1944 and fought in Europe for fifteen months. After the war, he was asked what he missed most when he was in the military. His reply: "Our family and friends, but not the internment camps."

Right: Soldiers guard the bedrolls and luggage of those removed from the Japanese quarter in San Francisco. The view is from the control station at 2031 Bush Street.

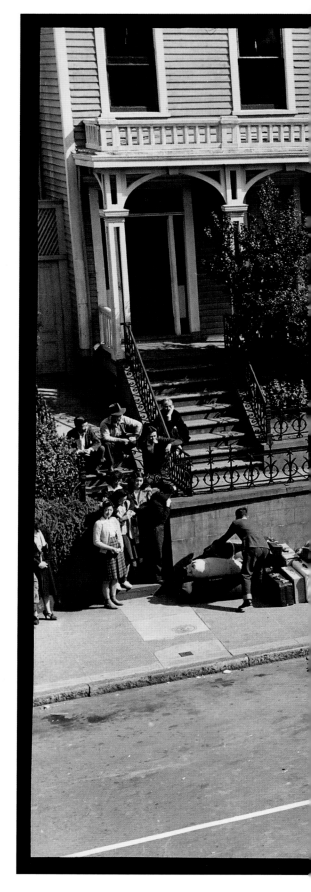

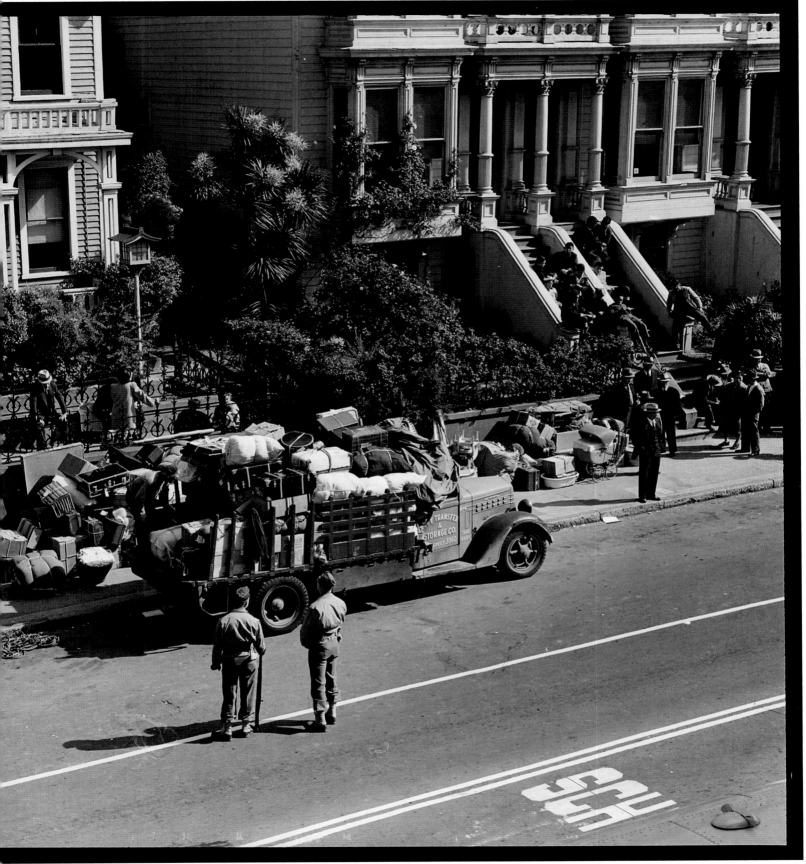

DOROTHEA LANGE SAN FRANCISCO, CALIFORNIA **APRIL 29, 1942**

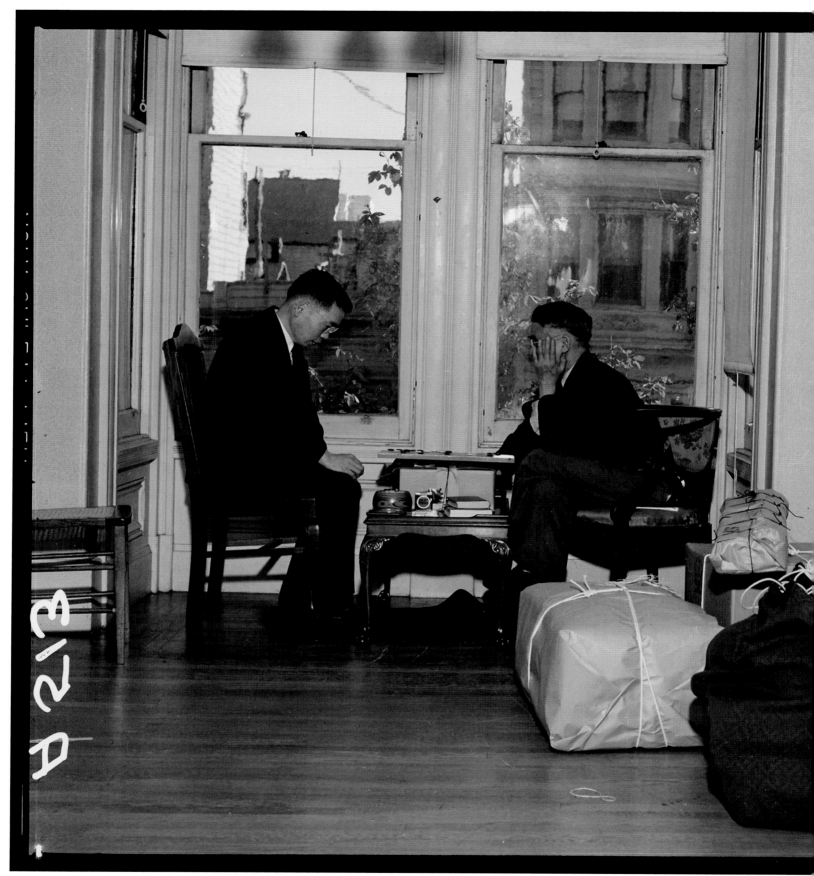

DOROTHEA LANGE SAN FRANCISCO, CALIFORNIA **APRIL 25, 1942**

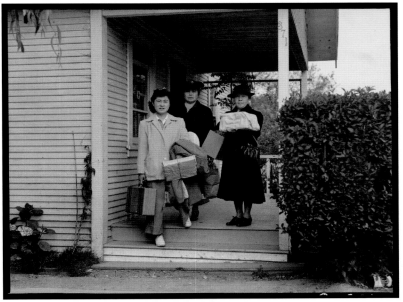

DOROTHEA LANGE CENTERVILLE, CALIFORNIA MAY 9, 1942

Tomoe Otsu, 24, leaves Centerville with her mother, Yoshino (middle), and family friend Sugino Ushijima on the morning they were taken to Tanforan. There, four months later at the Tanforan Buddhist Church, Tomoe married Susumu Tomine, who she had met in San Francisco. "He was so much in love, it didn't bother him to be in camp," said daughter Amy Tomine. Five days later they were shipped to Topaz and in 1943 to Tule Lake.

Left: Friends—all packed—play a final game before they are picked up. By late May 1942, the expulsion was nearly complete in San Francisco. "S.F. Clear of All but 6 Sick Japs," declared a headline in the *Chronicle* on May 21. The story under it noted: "Last night Japanese town was empty. Its stores were vacant, its windows plastered with 'To Lease' signs. There were no guests in its hotels, no diners nibbling on sukiyaki or tempura. And last night, too, there were no Japanese with their ever present cameras and sketch books, no Japanese with their newly acquired furtive, frightened looks.

"A colorful chapter in San Francisco history was closed forever. Some day maybe, the Japanese will come back. But if they do it will be to start a new chapter—with characters that are irretrievably changed."

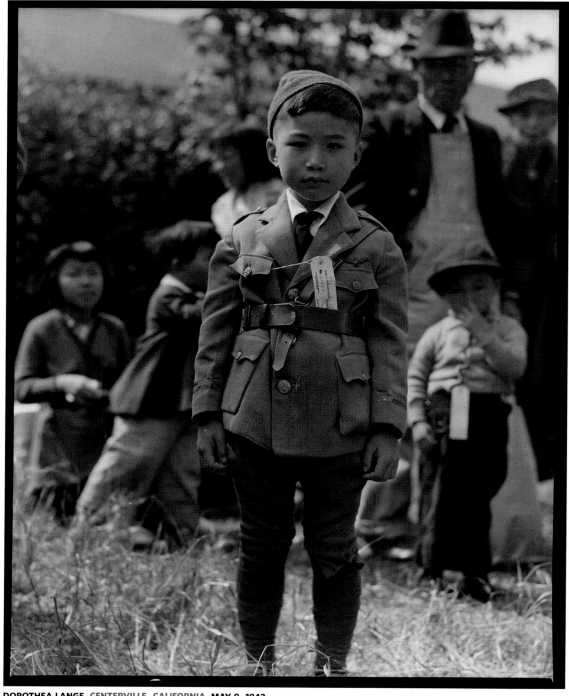

DOROTHEA LANGE CENTERVILLE, CALIFORNIA **MAY 9, 1942**

Six-year-old Mamoru "Mamo" Takeuchi reported, in uniform, with his mother, Kiwa, and three brothers. Months earlier, his father, Jingo, had been taken away as a "dangerous" alien because he taught at a Japanese-language school and ran a school that offered instruction in jukendo, Japanese sword fighting. In 1945, his mother died at the Crystal City Internment Camp in Texas. "My father was devastated," he said. After the war, Mamo worked as a mechanic and owned three service stations. He later became the CEO of a Japanese-based investment company.

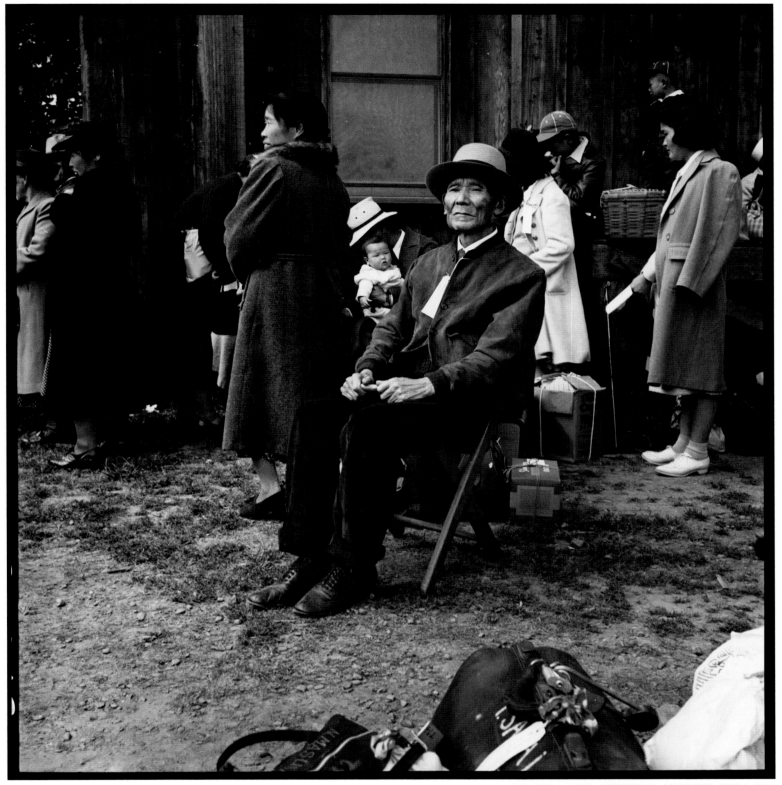

A grandfather awaits the bus in Centerville. Wrote Dorothea Lange: "The older people have more of a way of being very dignified in such a situation and not asking questions."

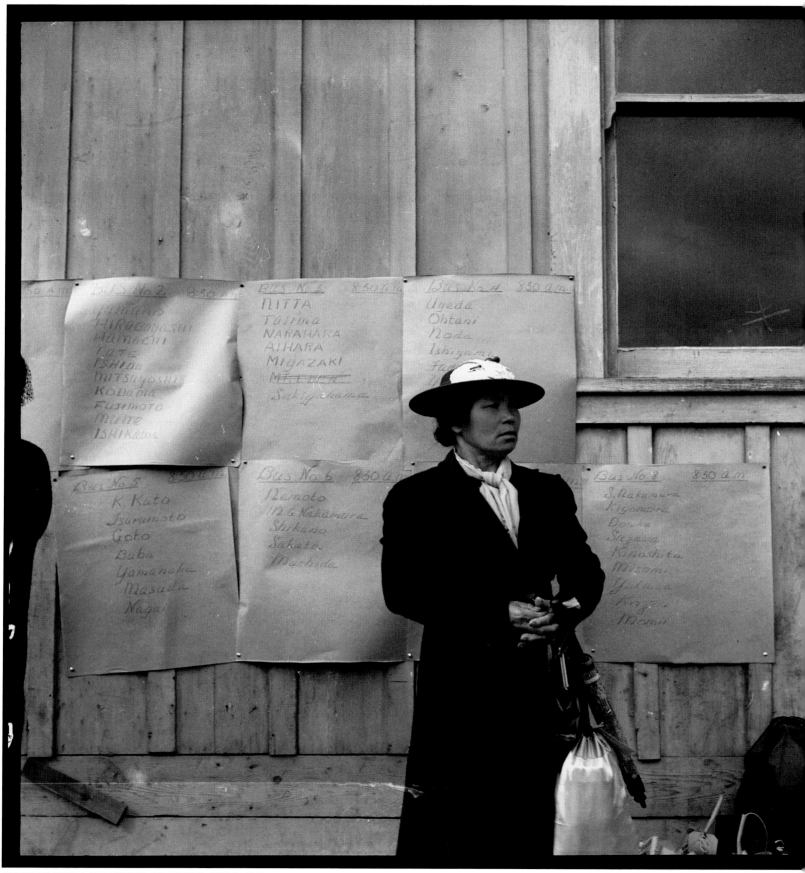

DOROTHEA LANGE CENTERVILLE, CALIFORNIA **MAY 9, 1942**

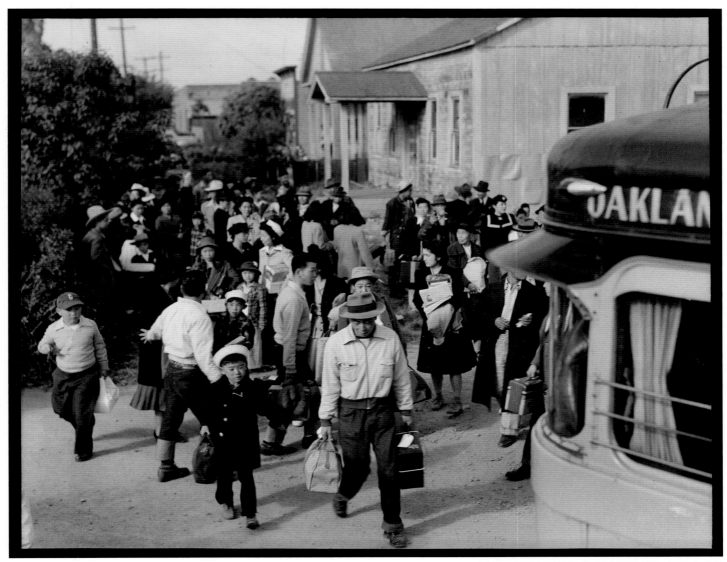

Farm families walk to buses to start their years of incarceration. "These people came with all their luggage and their best clothes, and their children dressed as though they were going to an important event," Dorothea Lange wrote. "New clothes. That was characteristic."

Walter Waynflete, editor of the *Township Register,* which covered Centerville in 1942, predicted that the exodus would eradicate Japanese Americans living in the area: "It is not to be expected that after the war the America people, who pay the bills, will tolerate resettlement of Japanese on coastal farms. Thus does the war provide a means of clearing up a problem which has been a thorn in the side of California for 30 years."

Left: A woman—likely Shige Fujishima, born in Japan in 1901, according to her identification tag—awaits the arrival of her bus bound for Tanforan. Despite the *Township Register's* prediction, she and many others did return to the area. She died in San Leandro at the age of 101 in 2003.

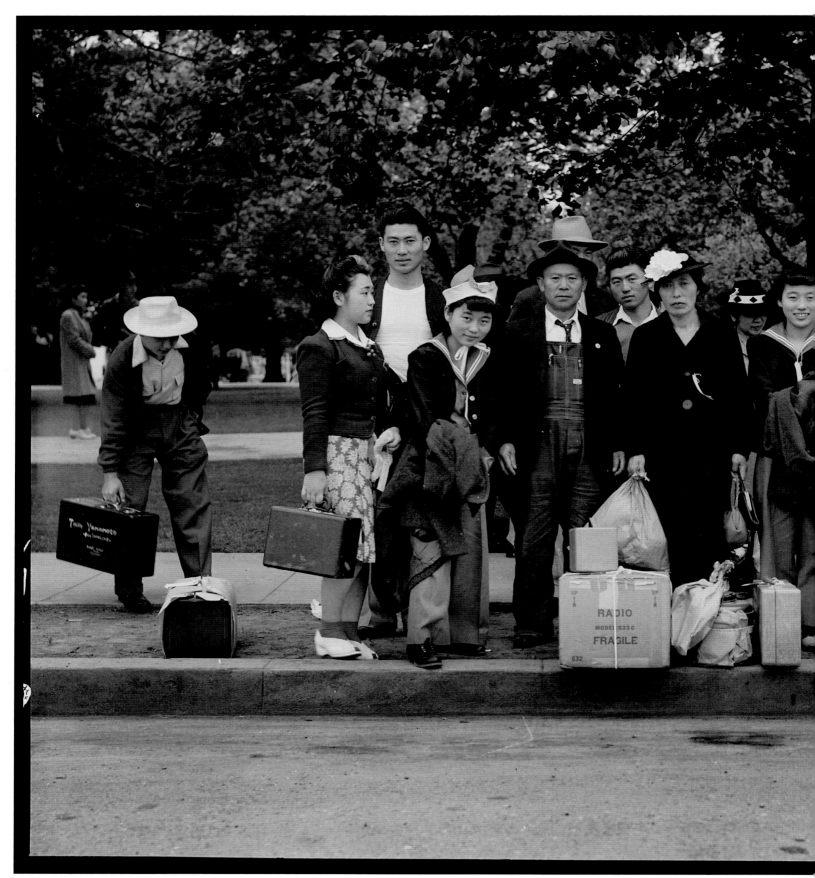

DOROTHEA LANGE HAYWARD, CALIFORNIA **MAY 9, 1942**

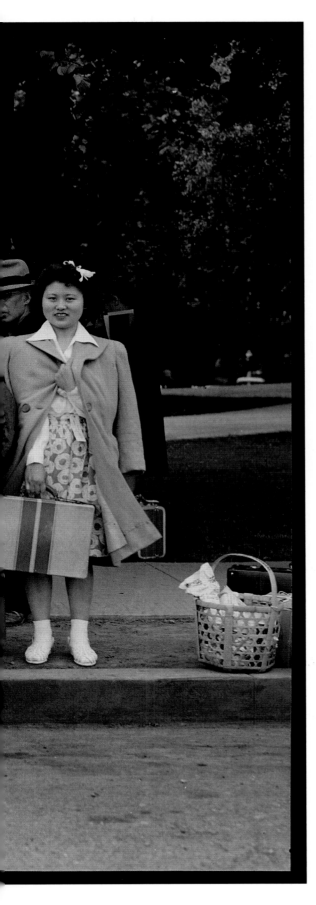

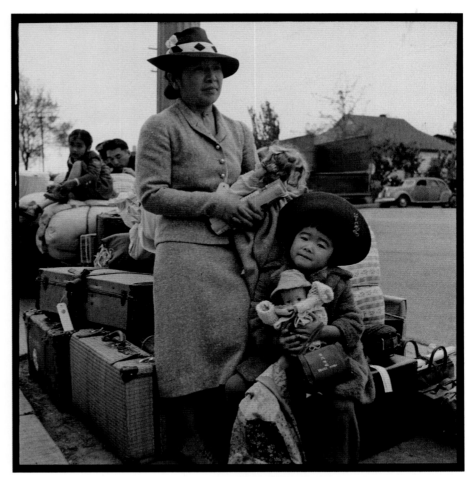

DOROTHEA LANGE HAYWARD, CALIFORNIA MAY 9, 1942

Ibuki Hibi (now Ibuki Hibi Lee) still owns the doll she carried as she and her mother waited for the Tanforan-bound bus at the edge of Hayward Park. Her parents, Hisako and George Matsusaburo (pictured in left photo in back row, right), were artists. In a farewell gesture, George donated fifty paintings and prints to the community. "I want to leave to the people of Hayward some token of my feelings of friendship and appreciation before I leave," he said. He died of cancer two years after the war. Most of his paintings have been lost, but about seventy of Hisako's incarceration camp paintings are at the Japanese American National Museum in Los Angeles.

Left: The family of Tamehisa Takeuchi and his wife, Chika, fill a curb in the plaza. After the war, the couple returned to their home in San Lorenzo, while their children went to live elsewhere in the West, according to camp records.

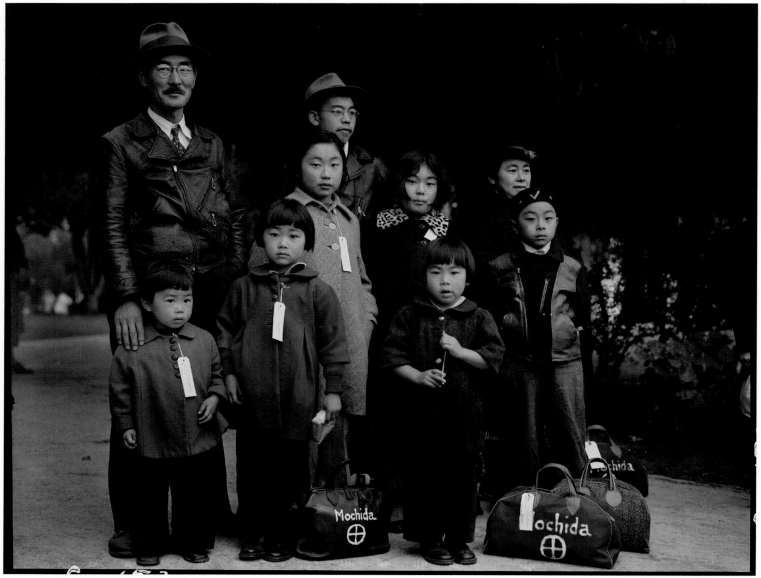

DOROTHEA LANGE HAYWARD, CALIFORNIA MAY 9, 1942

Moriki Mochida (back row, left) and his wife, Masayo (middle row, right), had just started a nursery with five greenhouses in San Leandro when they were ordered to report. "Dad was never the same," said daughter Kayoko (now Kayoko Ikuma). "His confidence was really shaken. He could not provide for his family." Tooru (now Mo) remembered that on the morning the family left home, a neighbor boy watched them gather on the street but was yanked away by his parents. The incarceration "destroyed our family," he said. "We used to eat every meal together. Once we were [at the center], I would eat in a different mess hall every single day with the other kids."

The family name and identifying symbol were painted on each bag so that the Mochida children—Hiroko, 3, Miyuki, 6, Kayoko, 4, and Tooru, 7 (front row, from left) and Satsuki, 11, and Kikue, 10 (middle row, from left)— could keep track of their possessions. Hideki Fukui, their cousin (back row, right), was visiting. A statue depicting Hiroko and Miyuki is being planned for San Bruno, California, near Tanforan, where the family was taken.

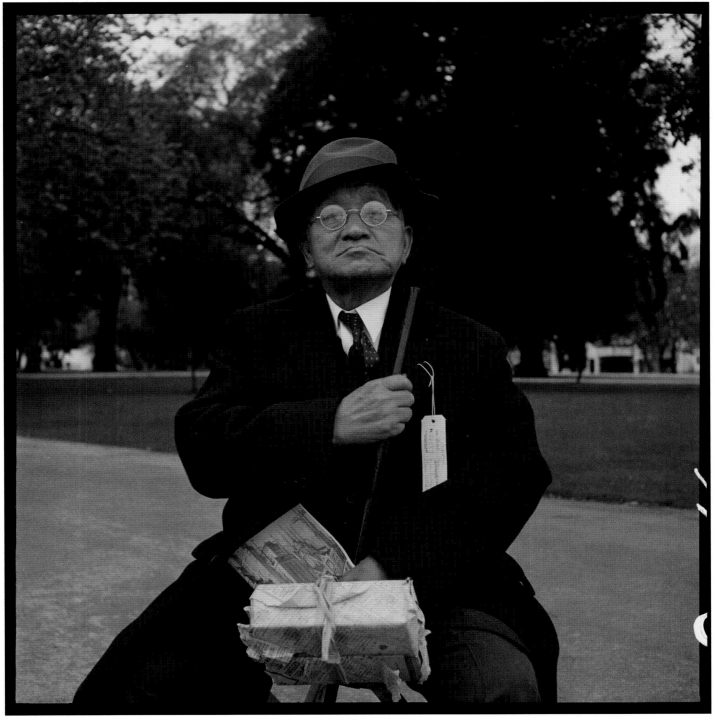

DOROTHEA LANGE HAYWARD, CALIFORNIA **MAY 9, 1942**

Seventy-year-old Sakutaro Aso sold his laundry business before reporting and never worked again after his release. "When people look at Grandfather's face, they see a lot of dignity," said Jerry Aso. "I see a lot of other things, like pain." Sakutaro spent three years in the camps with his family. Said Jerry: "He taught us all the importance of integrity."

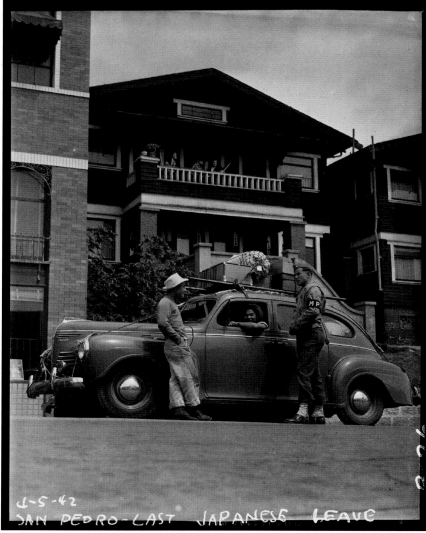

CLEM ALBERS SAN PEDRO, CALIFORNIA APRIL 5, 1942

A military policeman talks with the last Japanese Americans to leave Redondo Beach, California.

Right: Under military supervision, a convoy of cars makes its way out of San Pedro, California, to Santa Anita, about forty miles north. At first, Japanese Americans were allowed to drive their cars to the temporary detention centers, but that option was soon rescinded. Instead, they were given the choice of privately selling or storing their cars, selling them to the government, or delivering them to a Federal Reserve facility for storage. The government wouldn't guarantee the safety of the cars it stored, so few took the offer.

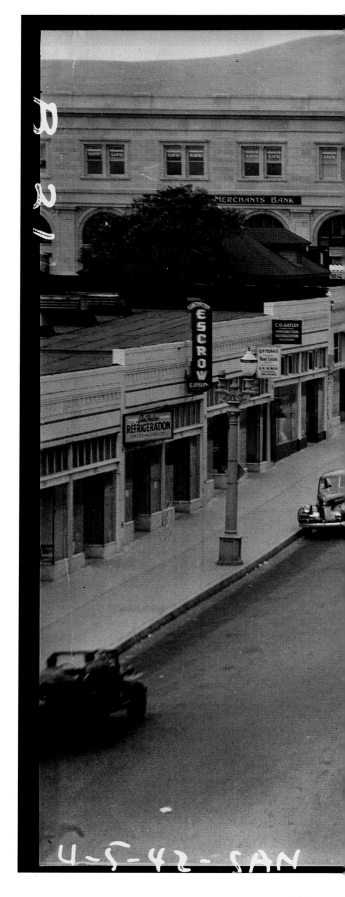

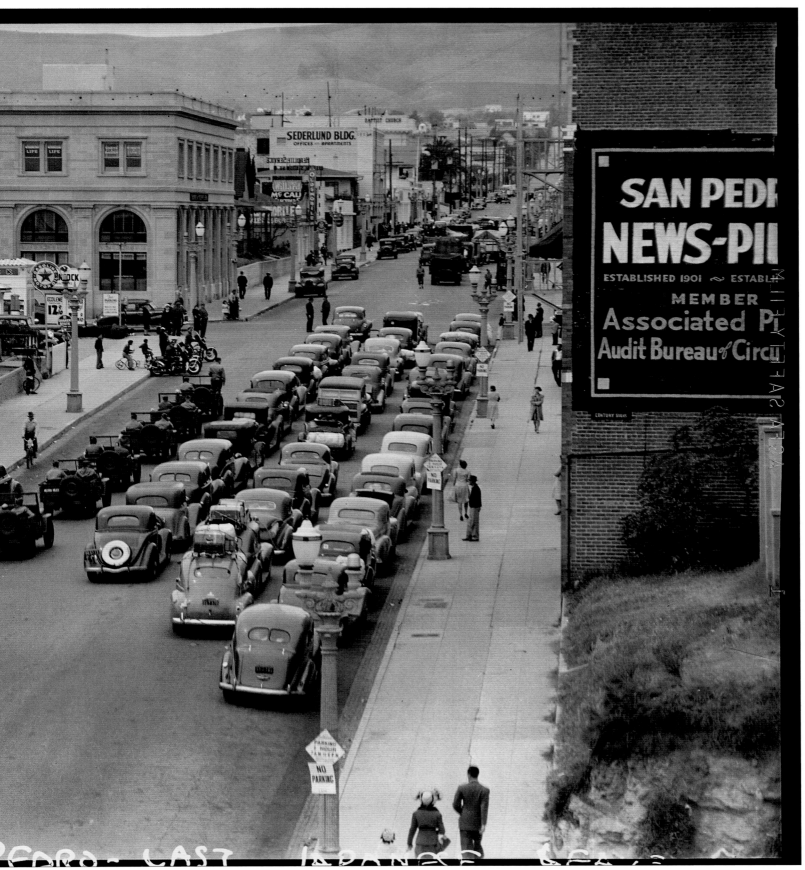

CLEM ALBERS SAN PEDRO, CALIFORNIA APRIL 5, 1942

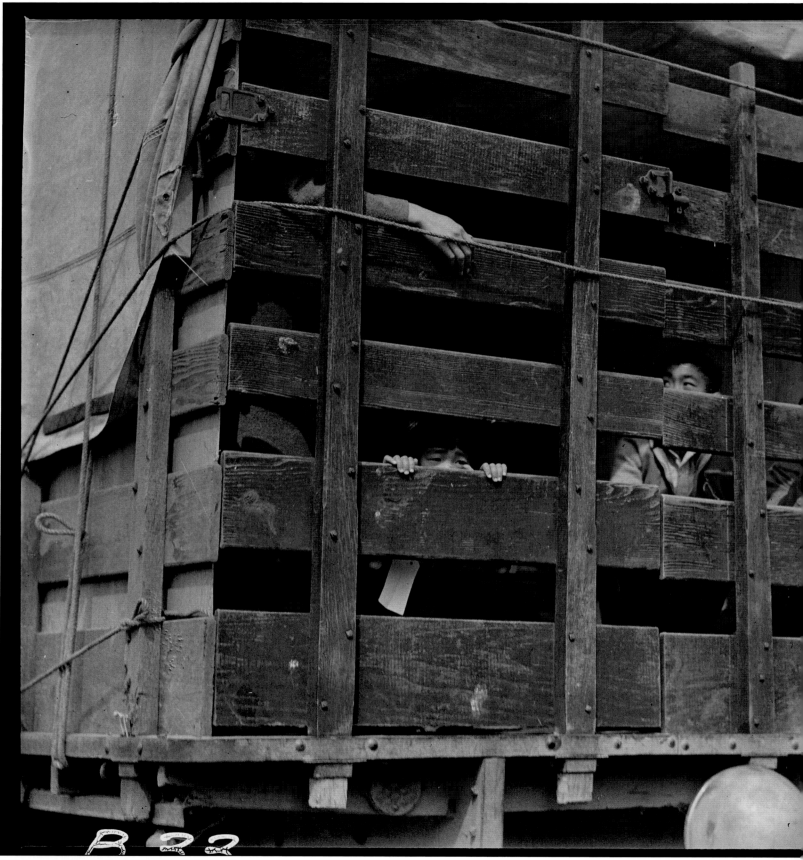

CLEM ALBERS SAN PEDRO, CALIFORNIA APRIL 5, 1942

Trucks jammed with suitcases, blankets, household items, garden tools, and people were also part of the convoy leaving San Pedro, which was closed to those of Japanese descent because of its strategic location near Terminal Island. "There were more Japanese in Los Angeles than in any other area," said Milton Eisenhower, first director of the War Relocation Authority, in the 1942 government film *Japanese Relocation.* "In nearby San Pedro, houses and hotels, occupied almost exclusively by Japanese, were within a stone's throw of a naval air base, shipyards, oil wells. Japanese fishermen had every opportunity to watch the movement of our ships."

The film was created by the new agency to convince Americans of the "military necessity" of incarcerating all Japanese Americans living near the West Coast. Dwight Eisenhower's younger brother wasn't buying it, though, and had trouble sleeping, became ill, and resigned the directorship after three months. He later wrote that "relocation" was an "inhumane mistake."

Nineteen-year-old San Pedro resident Mary Yuriko Nakahara vividly recalled the day the convoy left. "All people of Japanese ancestry were supposed to meet at a certain corner: Seventh near Pacific, which was the main drag," she said. "We all went down there, and I think all the Japanese were surprised that there were so many of us."

Even after the convoy departed, she said, nobody was told the final destination. Her most pressing concern that day was for her cherished pet: "I loved that dog; it was a collie dog, a real nice dog. And I didn't get to say goodbye to him. And I wondered what was going happen to him. We can't, we couldn't tell him, 'We have to go away.'" After the war, she married Bill Kochiyama and, as Yuri Kochiyama, went on to become an acclaimed human rights activist.

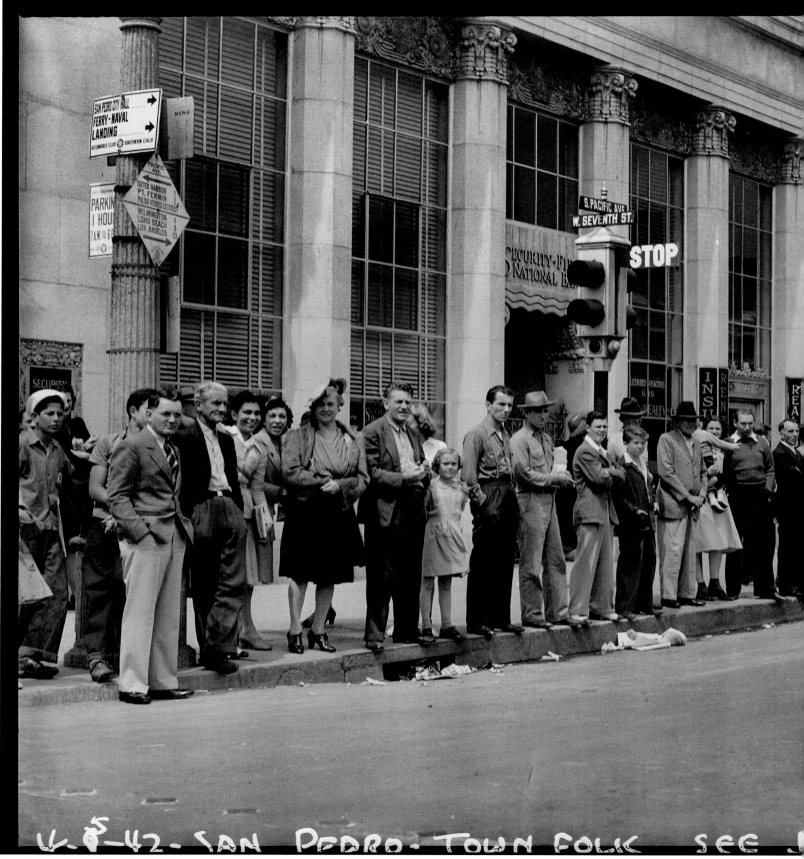

CLEM ALBERS SAN PEDRO, CALIFORNIA **APRIL 5, 1942**

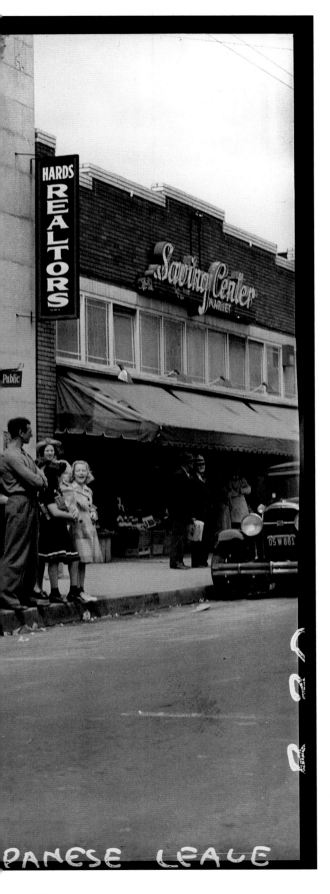

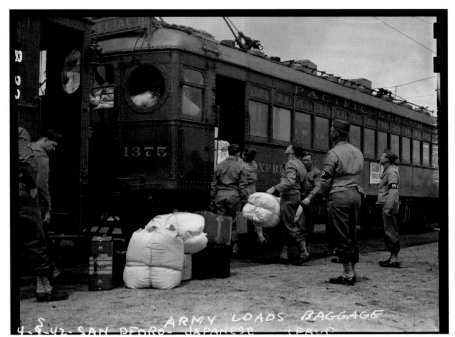

Military police load the last baggage on a train in San Pedro for the trip to Santa Anita. Once again, newspaper reporters made the trip sound like a vacation. "The alien trek from the harbor to the luxurious Arcadia racing plant was conducted in the same manner in which the initial contingent of 1,000 Japanese was moved on Friday," the *Los Angeles Times* reported on April 5. "Special Pacific Electric trains and long automobile caravans, all under military supervision, provided transportation for the evacuees, including 590 from San Pedro and 300 from Long Beach."

Left: San Pedro residents watch at the corner of West Seventh Street and South Pacific Avenue as the convoy of Japanese Americans passes by.

Yuri Kochiyama recalled that people carried signs that read "We're Sorry to See You Go" at some intersections and "Get Out Japs" at others. "Of course, most people probably were glad to get rid of Japanese because they didn't trust Japanese," she said. "And the hysteria of war was really high."

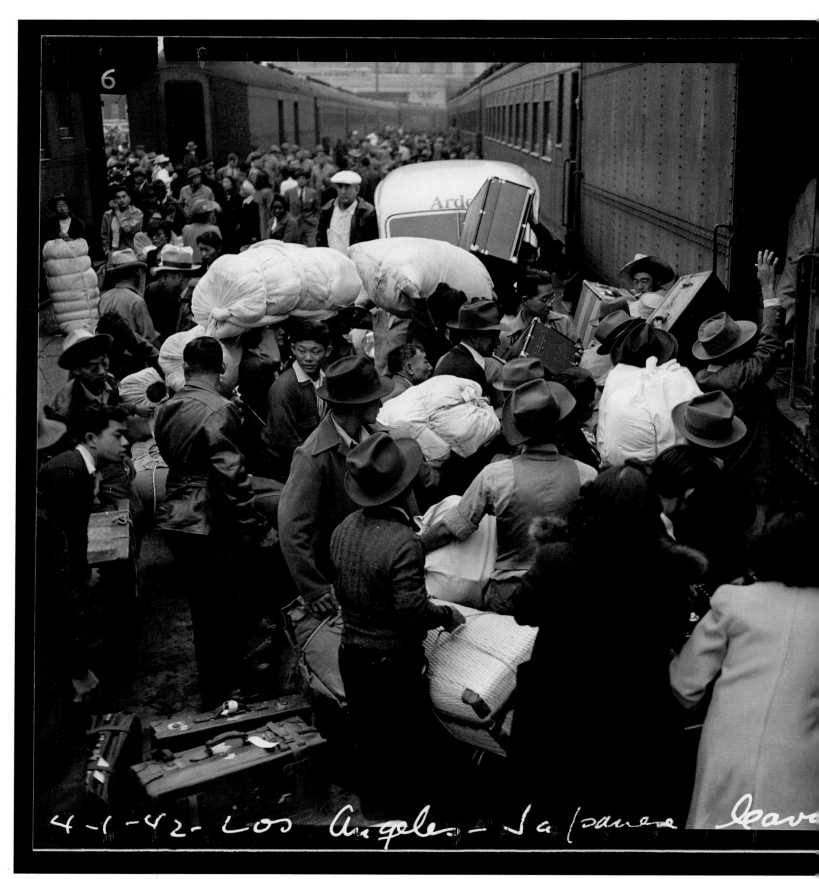

4-1-42 Los Angeles - Japanese leave

CLEM ALBERS LOS ANGELES, CALIFORNIA APRIL 1, 1942

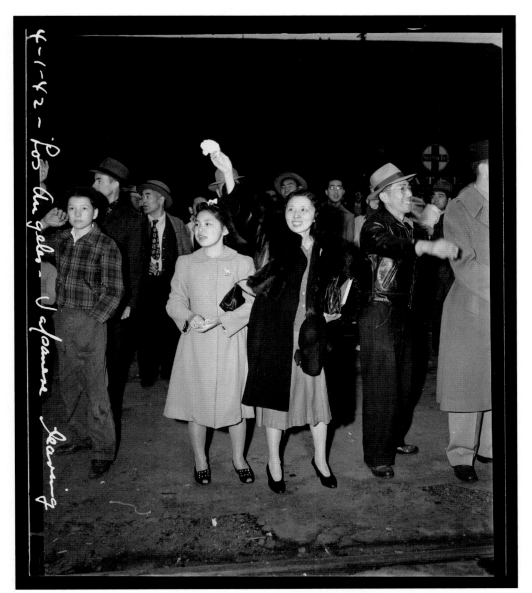

CLEM ALBERS LOS ANGELES, CALIFORNIA APRIL 1, 1942

Los Angeles residents of Japanese ancestry wave goodbye and shove their belongings onto trains at the Southern Pacific Railroad station. Four separate trains took more than a thousand people, mostly women and children, to Owens Valley during the first days of April 1942 so they could join male relatives who were getting the Manzanar incarceration camp ready for occupancy. The packed trains were hot and stuffy. Each car was guarded by military police with rifles and bayonets. The ride seemed particularly long because people were not allowed to lift the blinds on the windows. The army said it was for the protection of the passengers; most thought it was to prevent "spies" from gathering useful information on the California landscape.

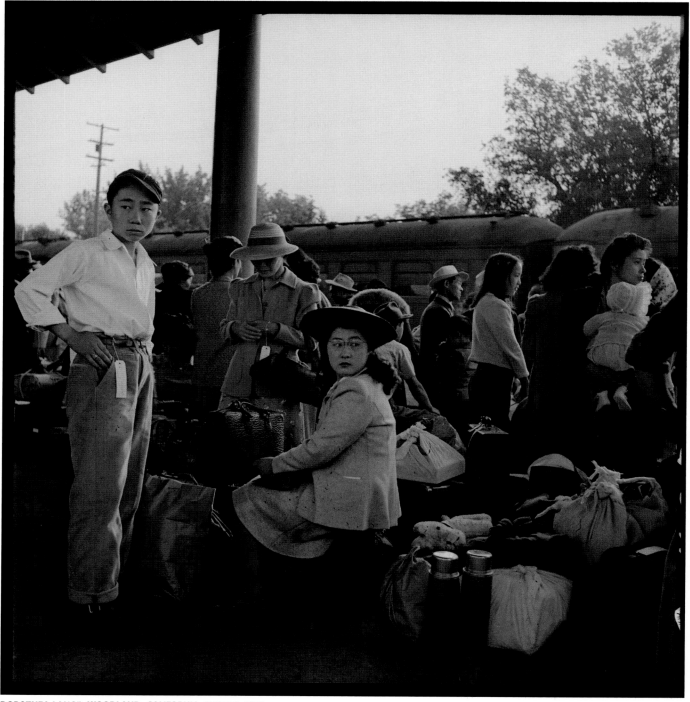

DOROTHEA LANGE WOODLAND, CALIFORNIA **MAY 20, 1942**

It took two days to move out nearly nine hundred Japanese American residents of California's Yolo County. Each day, nine coaches—and one car with Pullman berths for the sick and elderly—were used to transport them to the Merced Assembly Center. The first day at the Southern Pacific station in Woodland was "orderly, even cheerful," according to the *Woodland Democrat.* Some listened to jazz stations on their portable radios, turning up the volume when the hit "Remember Pearl Harbor" blared as the train left the station.

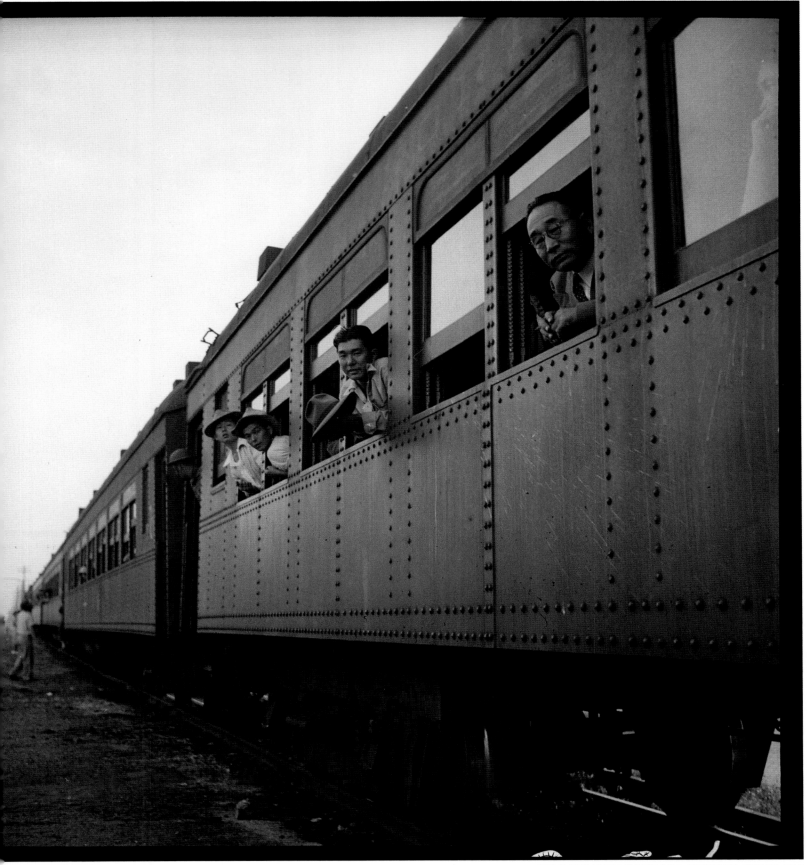

DOROTHEA LANGE WOODLAND, CALIFORNIA **MAY 20, 1942**

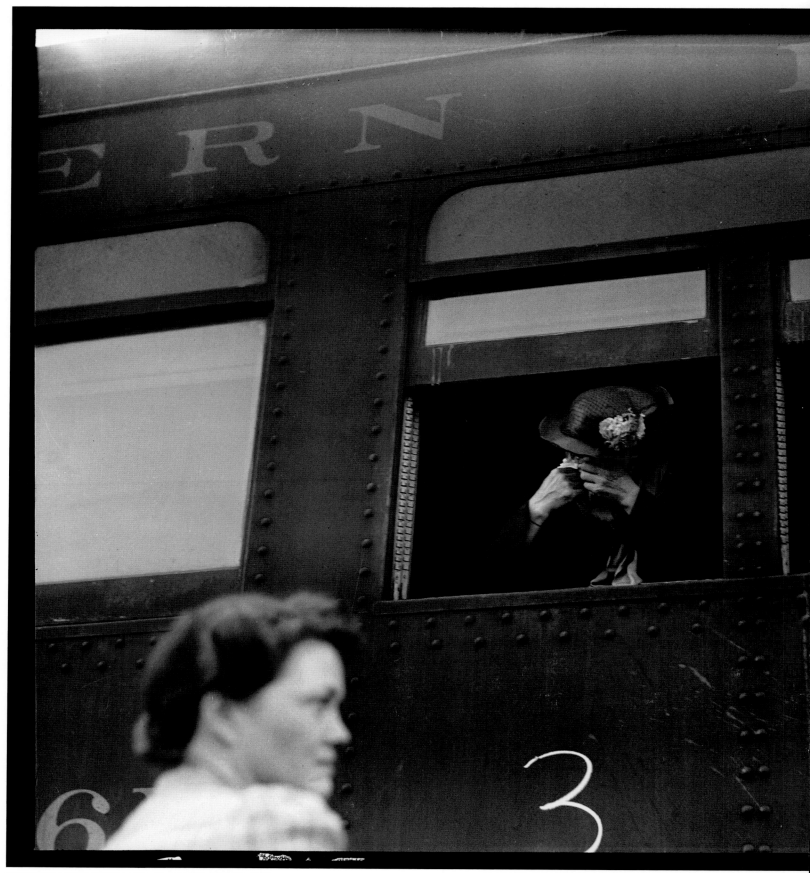

DOROTHEA LANGE WOODLAND, CALIFORNIA MAY 20, 1942

The mood turned somber on the second day. "This morning's exodus stood in direct contrast with that of yesterday, when the majority of evacuees took the trip as a lark," the *Democrat* reported. "There was little of the laughter and chatter of Wednesday morning's crowd apparent today, and there were more tears as the train rolled away from the station. The departure of the first contingent may have rubbed the gloss from the evacuation, but whatever the cause, the real seriousness of the situation was far more apparent today than it had been yesterday."

The train was delayed by half an hour because one family, from the county's river district, arrived late. "The train was held for them, however, and the breathless mother and father, two sons and two daughters climbed aboard amidst the laughter of their fellow passengers," the *Democrat* reporter noted. "They offered no explanation of their tardiness."

Several county residents and War Relocation Authority workers came to the station to bid farewell. Friends and employees of the Japanese Americans were the most disgruntled. A few told the *Democrat* reporter that the exodus was "entirely unnecessary."

But those feelings changed. One year later, the Yolo County Board of Supervisors passed a resolution that strongly opposed the release of Japanese Americans because of their "inborn native untrustworthiness." The resolution stated: "It is the general feeling of the people of this community that the presence of Japanese in this area will lead to unnecessary crime and bloodshed because of the existing revengeful feelings of the inhabitants of the West Coast toward the Japanese as a race."

The New Inmates

Mama, I want to go back to America.

—A girl at the Tanforan Assembly Center

Japanese Americans were first taken to temporary detention facilities (euphemistically called assembly centers) while permanent incarceration camps were being built. These facilities were hasty takeovers of existing horse tracks, fairgrounds, and exposition centers. Twelve were spread across California: Fresno, Marysville, Merced, Pinedale, Pomona, Sacramento, Salinas, Santa Anita, Stockton, Tanforan, Tulare, and Turlock. The other three camps for the new inmates were the Puyallup Assembly Center in Washington, the Portland Assembly Center in Oregon, and the Mayer Assembly Center in Arizona. Though far-flung, they had features in common: guard towers, barbed wire fences, and armed soldiers.

Military police stand guard with rifles and a machine gun at Santa Anita, the first temporary detention center to open. About fifteen miles northeast of downtown Los Angeles, at the base of the San Gabriel Mountains, Santa Anita was by far the largest—with a peak population of 18,719—of the fifteen detention facilities.

The center was built within and around the Santa Anita Racetrack, one of many tracks that were closed to temporarily house Japanese Americans. The most lavish track in America, Santa Anita included about sixty horse barns, which until early 1942 quartered more than a thousand thoroughbreds. The horses were removed just days before the stables were converted into tiny residences. Tarpaper-covered army-type barracks were built in the massive parking lot, and a barbed-wire fence was installed. The clubhouse was used for offices, and the grandstand became a huge mess hall, where more than three thousand people an hour could be served.

The army painted the floors and walls of the stables, but the smell of horse urine and manure remained. "A stable which houses a horse now houses from 5 to 6 humans, its ventilation is poor due to the absence of windows," the Stanford professor Yamato Ichihashi wrote in his diary after being taken to the camp. "A stable is generally portioned into 2 parts, the back-part is dark. These are not only unsanitary, but mentally and morally depressive; they are bound to produce evil results and therefore should be condemned. These present occupants should be removed."

This photo was impounded by army officials, who made it clear to War Relocation Authority photographers that they should not take pictures of guard towers or barbed-wire enclosures.

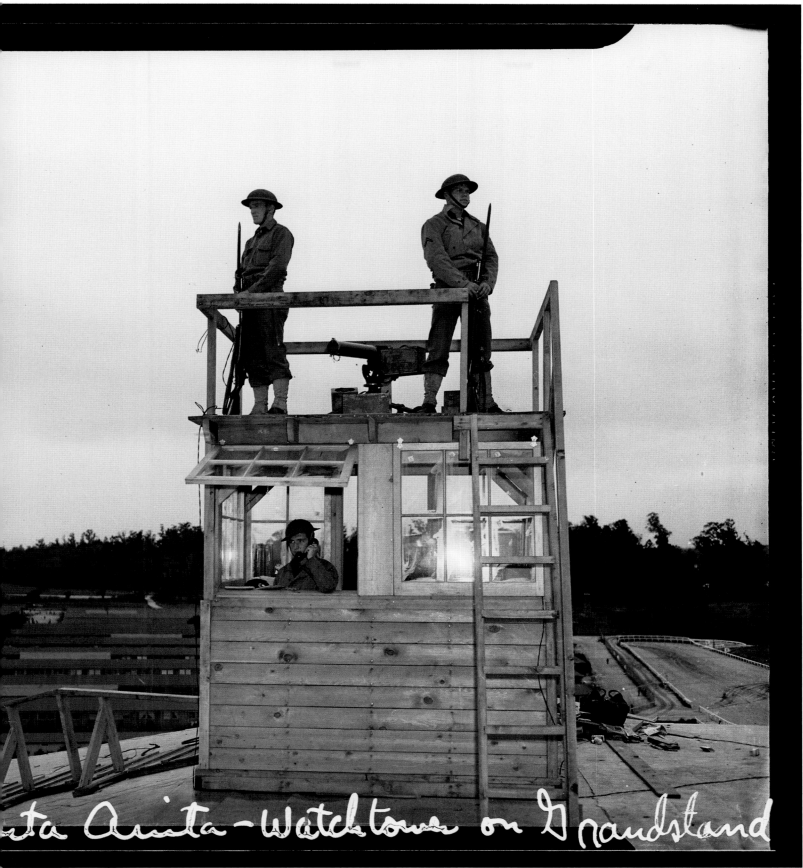

ta Anita - Watchtower on Grandstand

CLEM ALBERS ARCADIA, CALIFORNIA APRIL 6, 1942

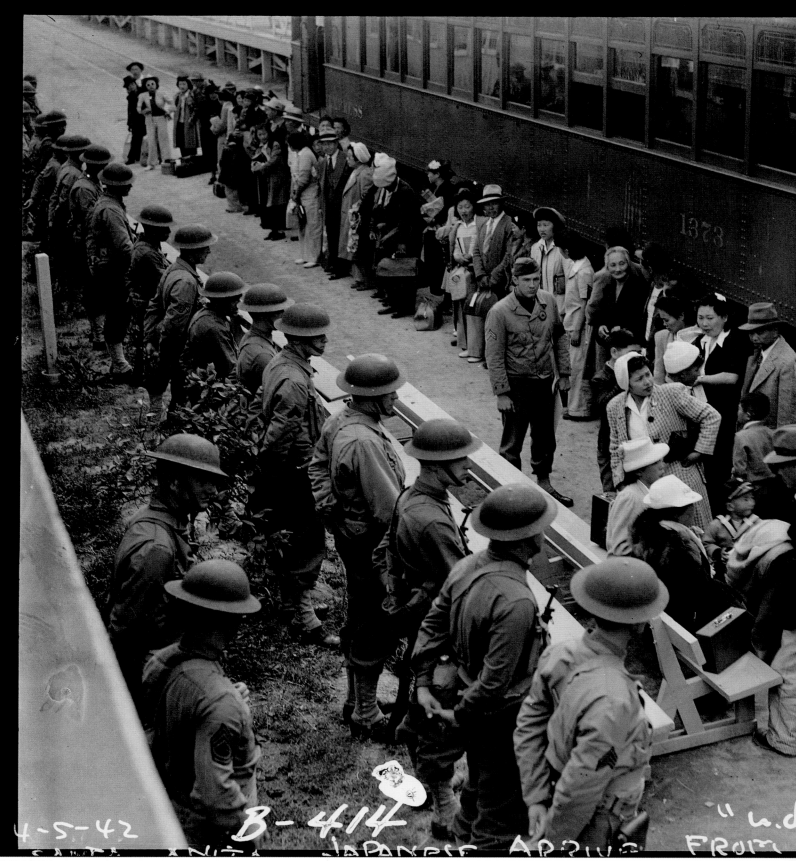

CLEM ALBERS ARCADIA, CALIFORNIA **APRIL 5, 1942**

Arriving at Santa Anita was a bewildering experience. The sight of barbed wire and armed guards shocked many Japanese Americans, who had no idea what to expect or how long they would be incarcerated. "For many evacuees, arrival at the assembly center brought the first vivid realization of their condition," stated the Commission on Wartime Relocation and Internment of Civilians, which Congress established in 1980. "They were under guard and considered dangerous."

Leonard Abrams, a former Santa Anita guard, told the commission that his field artillery battalion had been put on full alert, issued ammunition belts, and told to report to Santa Anita. "There we formed part of a cordon of troops leading into the grounds; buses kept on arriving and many people walked along," he said, and described seeing "many weeping or simply dazed, or bewildered by our formidable ranks."

Tohsio Kimura, who came to Santa Anita with his large family, simply wrote: "I never dreamed I would see my children behind barbed wire."

Dorothea Lange recalled the first days at the temporary incarceration center in San Bruno, California, about four hundred miles north of Santa Anita. "At Tanforan many funny things happen, which only accentuate the pathos," she wrote. "As an old man lines up his baggage for the inspection, an alarm clock begins to ring. A young girl jumps off the bus in her brave new clothes all smiles, sees a friend up above, yells 'Hi, how is it?' The other replies 'awful' and the smile fades into bewilderment, mistrust, questioning. A sick child also descends, and an old cripple gets helped out. The worst thing about lunch is that when you go into the cafeteria the smell of mass-cooked food reverberates through the recesses under the grandstand. Everything smells of disinfectant, too."

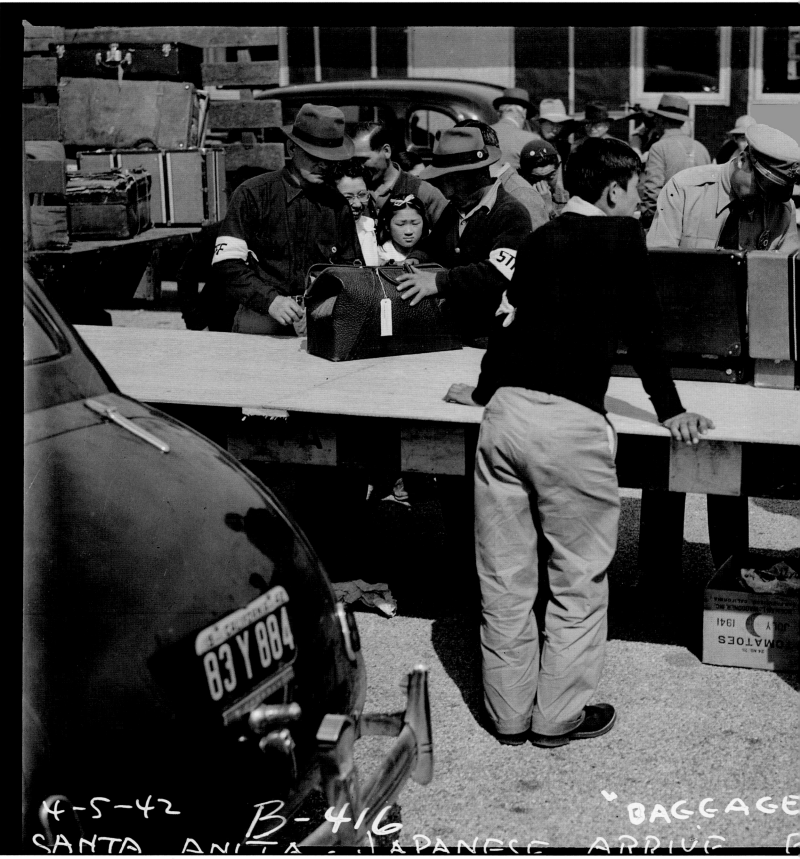

4-5-42 B-416 ʼBAGGAGE
SANTA ANITA...JAPANESE ARRIVE

CLEM ALBERS ARCADIA, CALIFORNIA **APRIL 5, 1942**

EXAMINATION ROOM SAN PEDRO

The baggage of newcomers is inspected at Santa Anita. The government began searching the homes of Japanese immigrants right after Pearl Harbor, looking for shortwave radios, cameras, firearms, explosives, and signaling devices. The FBI interpreted contraband broadly. In March 1942, for instance, agents raided the home of a Santa Cruz man who had a large fireworks collection. The headline in the *San Francisco Examiner* read: "Jap with Signal Lights Arrested."

The FBI looked for any "evidence" that might tie Japanese immigrants to imperial Japan. Jeanne Wakatsuki Houston, coauthor of *Farewell to Manzanar,* watched her father burn a flag that he had brought with him from Hiroshima thirty-five years earlier. "It was such a beautiful piece of material. I couldn't believe he was doing that," she wrote. "He burned a lot of papers, too, documents, anything that might suggest he still had some connection with Japan."

The term "concentration camp" was common at the time, but the army discouraged its use. "Assembly Centers were not internment or concentration camps," the army noted in its *Final Report: Japanese Evacuation from the West Coast, 1942.* "They were temporary shelters where evacuees could be assembled and protected." The army's position is restated later in the report: "The camps are not 'concentration camps' and the use of this term is considered objectionable."

In 1945, Supreme Court justice Owen J. Roberts wrote: "An Assembly Center was a euphemism for a prison. No person within such a center was permitted to leave except by Military Order." Decades later, another justice, Tom C. Clark, who had been one of the architects of the incarceration, said, "We picked them up and put them in concentration camps. That's the truth of the matter."

CLEM ALBERS ARCADIA, CALIFORNIA APRIL 5, 1942

Lily Okura, who was twice named to the Tournament of Roses Royal Court, poses with a statue of the famed thoroughbred Seabiscuit, a former resident of Santa Anita. Later that day, she and her husband, Patrick, learned that they would be living in a tack room of a stable. Lily used tea towels to make curtains. "Coming to the assembly center at Santa Anita after being married only five months left us disgusted, disoriented, apprehensive and confused," she said.

The Okuras were allowed to leave camp—on the last day of Santa Anita—for Nebraska, where Patrick got a job as a psychologist at Boys Town. Years later, they used reparation money from the federal government to establish the Okura Mental Health Leadership Foundation.

Right: One of the first days at Santa Anita—some arrived in surprisingly high spirits. The opening of the detention centers finally put an end to weeks of waiting and worrying.

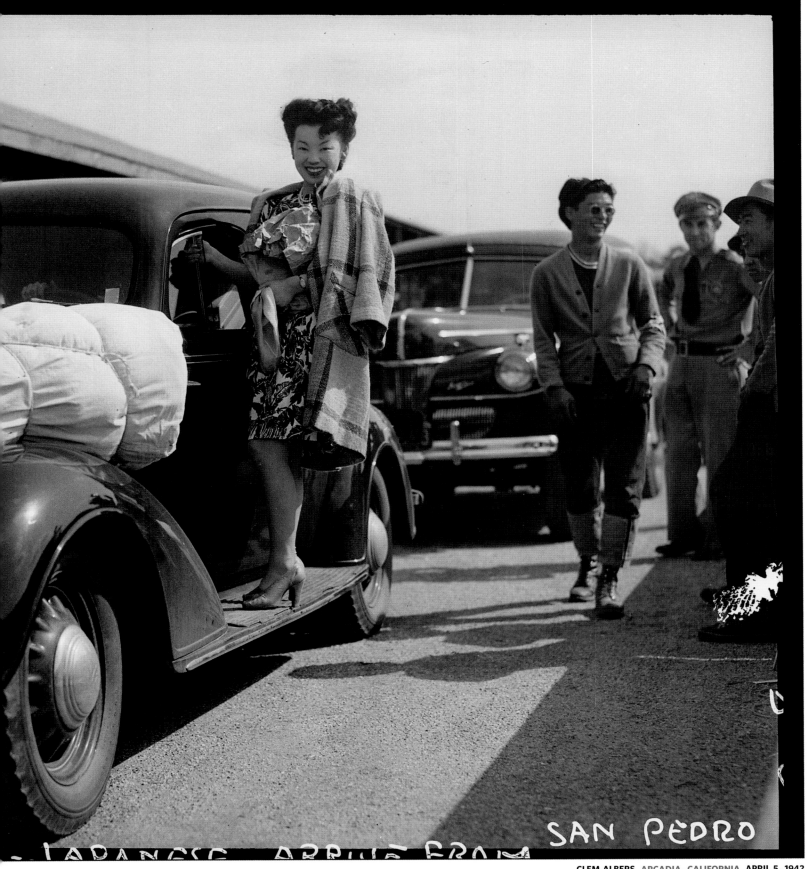

SAN PEDRO

JAPANESE ARRIVE FROM

CLEM ALBERS ARCADIA, CALIFORNIA **APRIL 5, 1942**

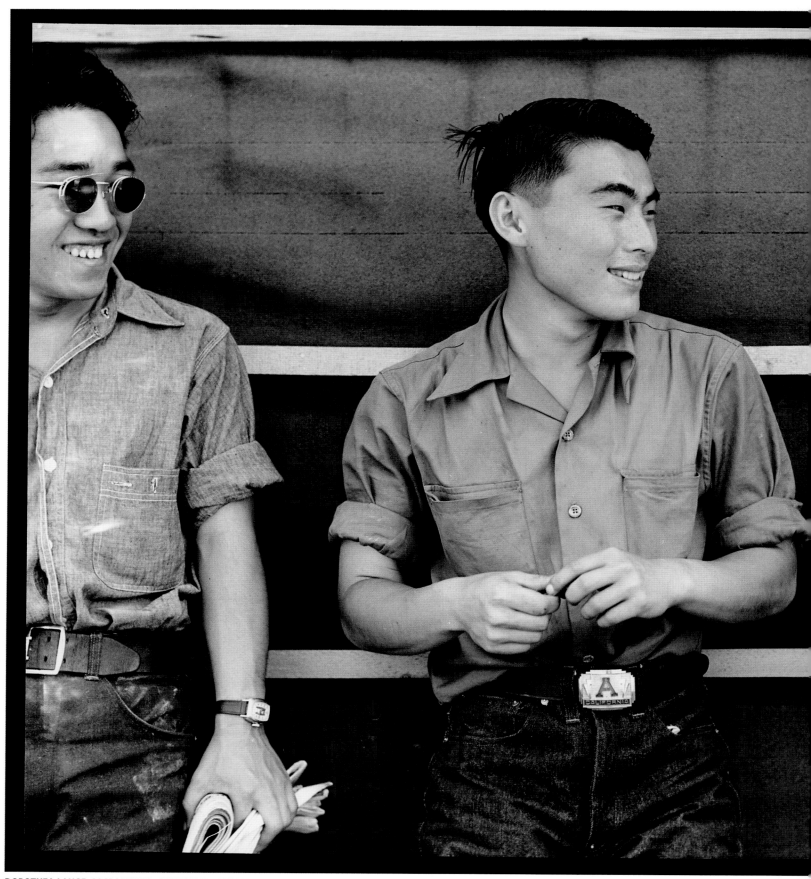

DOROTHEA LANGE SACRAMENTO, CALIFORNIA **MAY 20, 1942**

Former students at the University of California mingle at the Sacramento Assembly Center during its first weeks.

The ten permanent camps provided education from nursery school through high school but did not offer college classes. In late spring 1942, the National Japanese American Student Relocation Council was created to give thousands of incarcerated college students a chance to continue their education. It sought out colleges and universities that would accept these students and tried to come up with scholarship money. Few parents in the camps were in a position to pay for higher education.

Considered "ambassadors of good will," students were among the first to be released from camps. "Upon their scholarship, their conduct, their thoughts, their sense of humor, their adaptability, will rest the verdict of the rest of the country as to whether Japanese Americans are true Americans," observed the *Santa Anita Pacemaker,* the center's newspaper.

About 150 students were enrolled at the start of the 1942–43 academic year. Most went to small colleges in the Midwest and East. Large schools generally had connections to the War Department and were not allowed to accept Japanese Americans. Some prestigious schools, including Princeton and the Massachusetts Institute of Technology, refused them admittance. By the start of the 1943–44 academic year, about a thousand students were on campuses. The following year, a total of thirty-six hundred students attended more than 550 colleges.

Dorothea Lange's husband, University of California economics professor Paul Schuster Taylor, was a consultant to the relocation council. Lange cared, too. Her professional papers contain many notes about the council's work—including letters about college trips that Taylor and Lange arranged for students she had met in the camps.

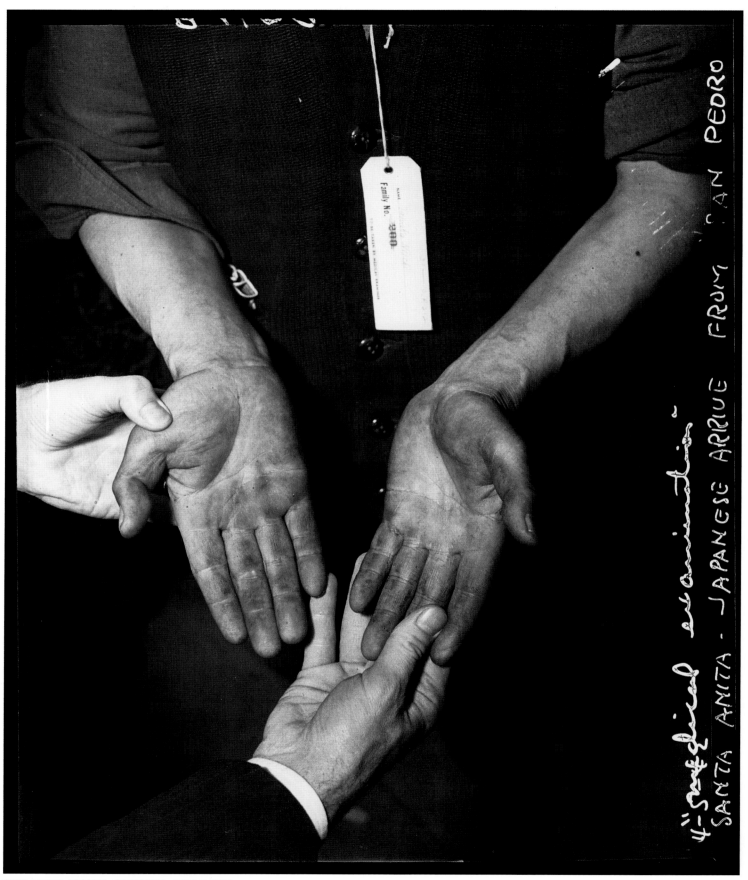

CLEM ALBERS ARCADIA, CALIFORNIA **APRIL 5, 1942**

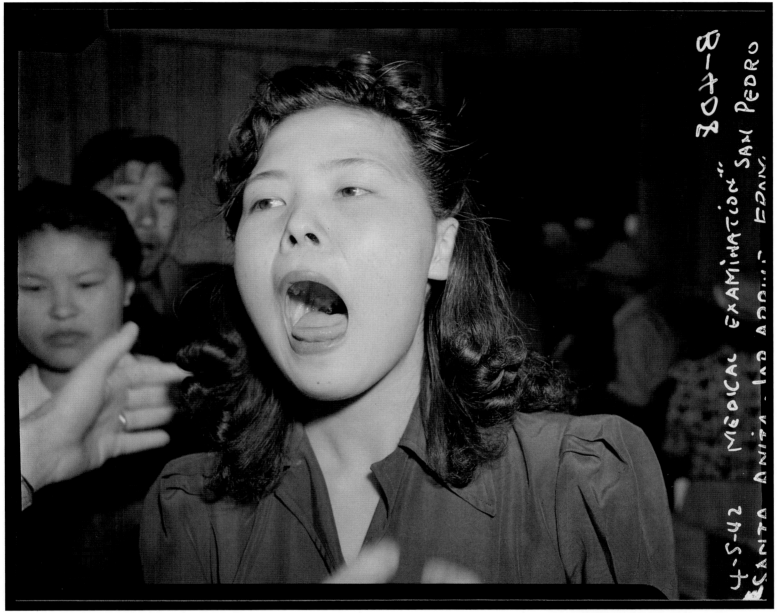

Medical workers under the supervision of the U.S. Public Health Services screened each person entering Santa Anita for infectious diseases. Almost everybody was vaccinated against smallpox and typhoid, and children were immunized against diphtheria and whooping cough. Most of the medical care was given by the incarcerated. "They refused Army doctors," Dorothea Lange wrote. "Their own doctors did it. Everything that was possible that they could do themselves, they did. Asked the minimum, took huge sacrifices, made practically no demands. This was very unusual, almost unbelievable."

Left: The hands of 54-year-old Niichi Tanaka are examined. He was born in Japan and immigrated to California in 1906. From Santa Anita, he and his family were sent to the Jerome Relocation Center in Arkansas and then to the Gila River Relocation Center in Arizona. They were released in late 1945.

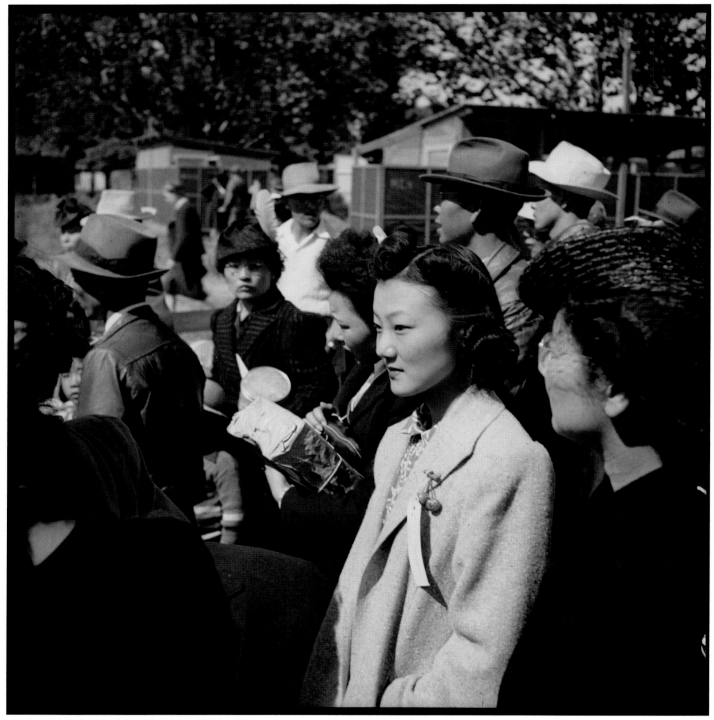

DOROTHEA LANGE TURLOCK, CALIFORNIA MAY 2, 1942

Families arrive at Turlock Assembly Center, formerly a fairground, and wait for baggage inspection. A woman named Elsie Inouye, who came by train from Los Angeles, wrote, "We were dusty, tired, worn and sleepy. This was Turlock." Walking the mile to camp, she felt like a prisoner. "Remember Lincoln's Gettysburg address," she wrote. "The greatest emancipator ever born in our world. We need another Lincoln—we the Japanese people."

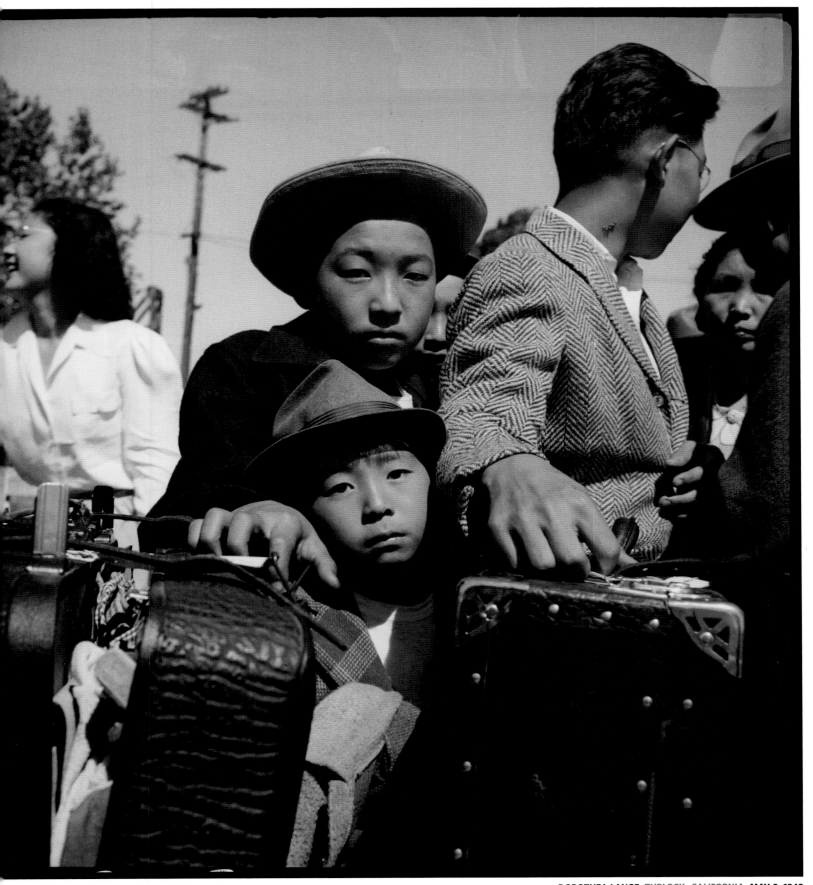

DOROTHEA LANGE TURLOCK, CALIFORNIA **MAY 2, 1942**

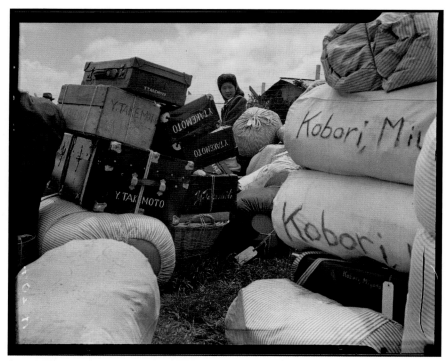

CLEM ALBERS SALINAS, CALIFORNIA **APRIL 1942**

Mounds of baggage are dropped off at the Salinas Assembly Center, a converted rodeo grounds in the northern part of the city. Baggage followed Japanese Americans to their temporary detention camps and later to their permanent camps. In addition to what they brought with them, people purchased clothes and household items at camp co-ops and from mail-order companies, usually Sears, Roebuck.

Baggage was a frequent subject of those who photographed the camps, including Russell Lee, who, like Dorothea Lange, was a key figure in American documentary photography. He worked for the Office of War Information in 1942 and, at Salinas, couldn't resist the piles of trunks and duffel bags.

Salinas was open for only sixty-nine days. From there, most inmates were sent to the Poston incarceration center in Arizona. One, Henry Tanda, wrote in the *Watsonville Register-Pajaronian* just before Salinas closed: "We, of course, hate to leave this vicinity and we don't know if we will be welcomed back, but we sincerely hope we will."

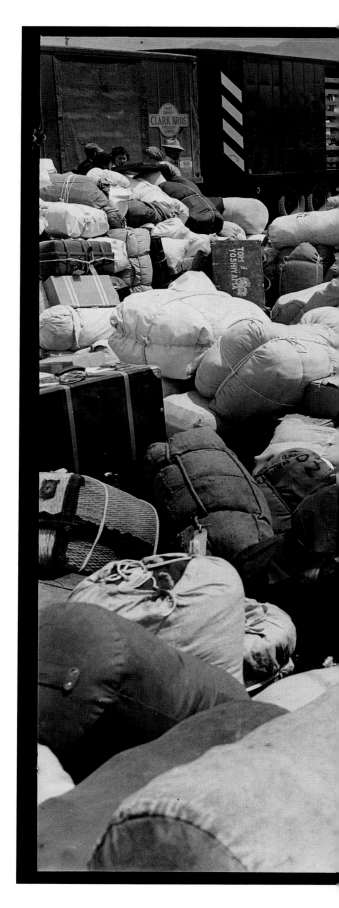

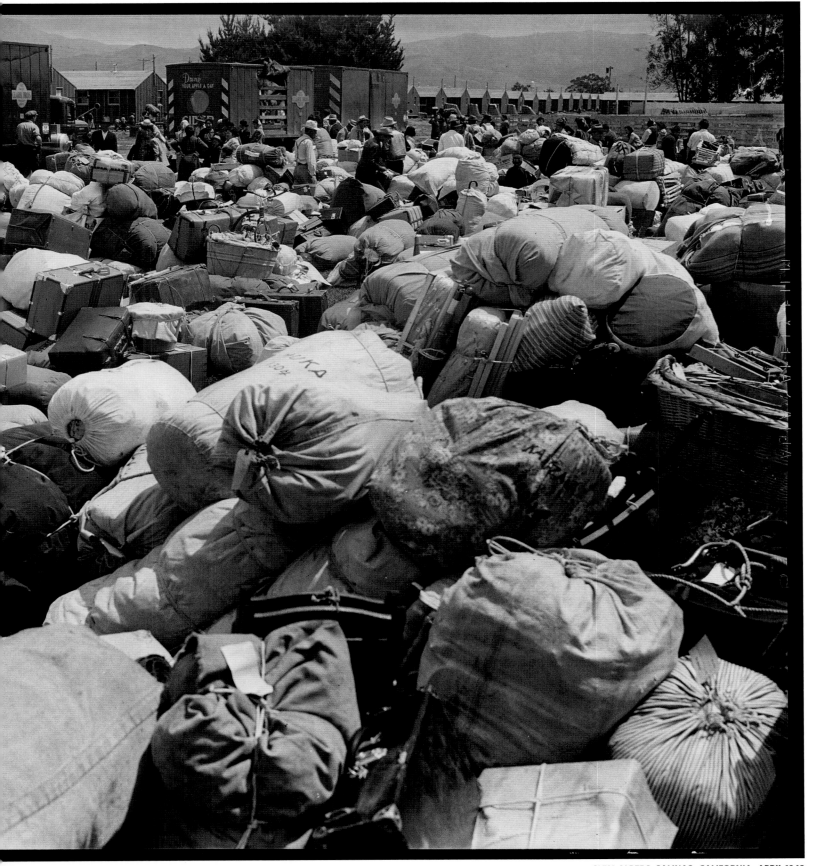

CLEM ALBERS SALINAS, CALIFORNIA APRIL 1942

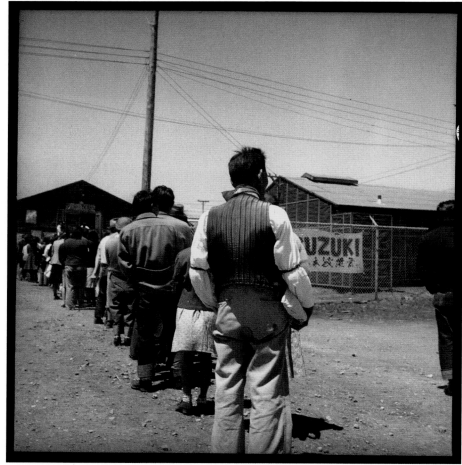

DOROTHEA LANGE SAN BRUNO, CALIFORNIA **JUNE 16, 1942**

Tanforan and the other temporary camps were not set up to provide much more than housing and food. Inmates lined up at mealtime, which was a major event. Wrote Dorothea Lange: "They carry with them their own dishes and cutlery in bags to protect them from the dust. They, themselves, individually wash their own dishes after each meal because dish washing facilities in the mess halls proved inadequate." Most preferred the second shift because they would sometimes receive second helpings.

Right: "The attitude of the man shown in this photograph [from Tanforan] is typical of the residents in assembly centers," Lange wrote, "and because there is not much to do and not enough work available, they mill around, they visit, they stroll and they linger to while away the hours." The barracks behind him was originally built to house horses. This photo was impounded by the Army.

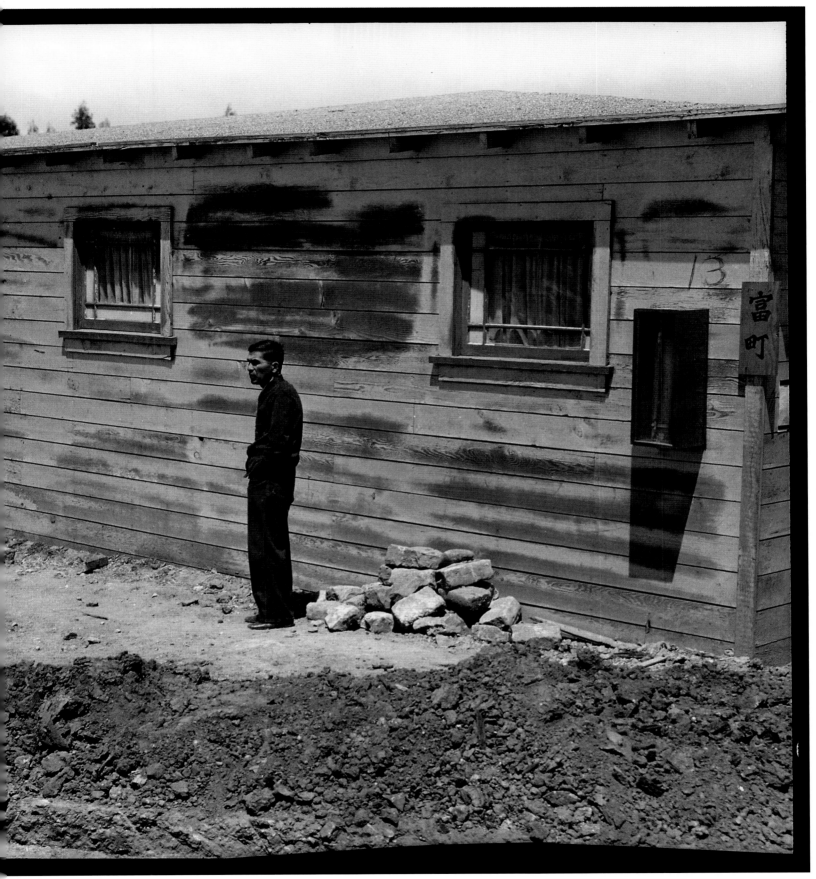

DOROTHEA LANGE SAN BRUNO, CALIFORNIA **JUNE 16, 1942**

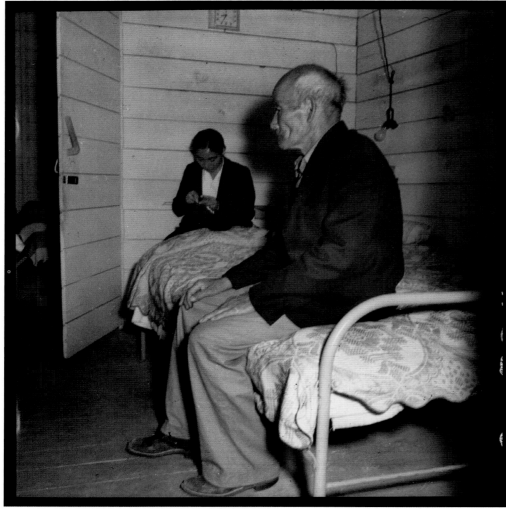

DOROTHEA LANGE SAN BRUNO, CALIFORNIA JUNE 16, 1942

Kumataro Konda, 72, sits with his daughter, Asako Takeda, in one of Tanforan's bleak old horse stalls. He immigrated in 1891 and worked as a farmer. His son, Harry, organized the evacuation of Centerville in early 1942, which Dorothea Lange documented. Kumataro died ten years after the war.

Right: Akira Toya, 23, relaxes in his quarters at Salinas with his mother, Aki. Soon after being assigned a place to stay, inmates started making their spaces livable by building furniture and installing such things as hooks and shelves. Everybody slept on standard steel army cots. Akira's parents and four siblings were sent to Poston. After the war, Akira was known as the most skillful fishmonger in Sawtelle Japantown, West Los Angeles. Said Jack Fujimoto, his brother-in-law, "He could take a tuna and slit it so you could see the bone."

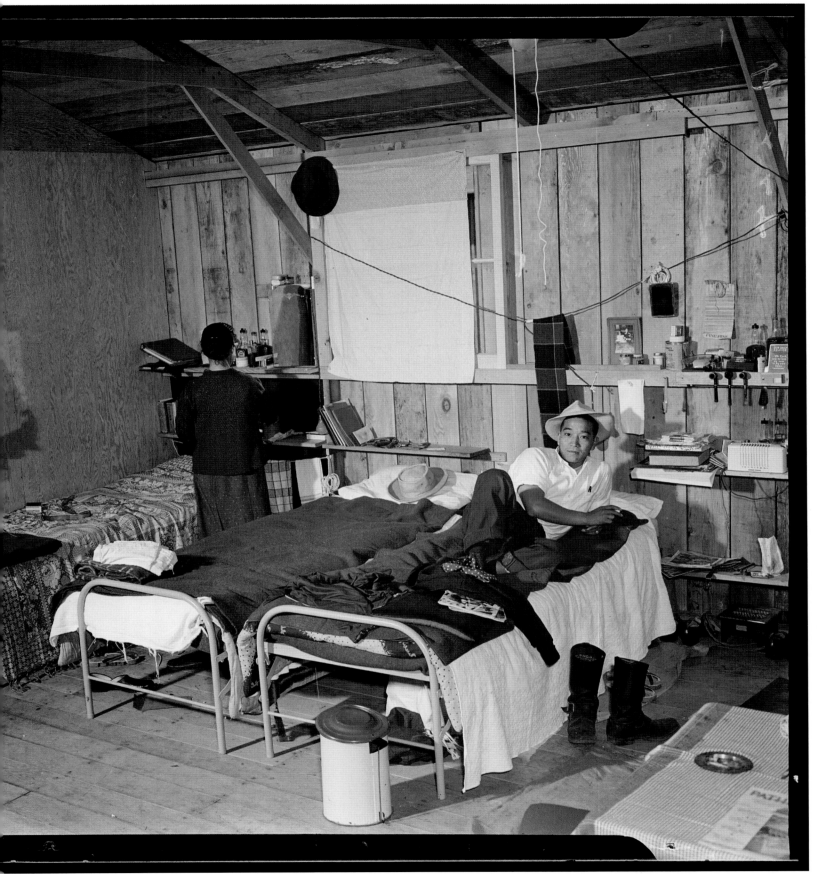

CLEM ALBERS SALINAS, CALIFORNIA APRIL 1942

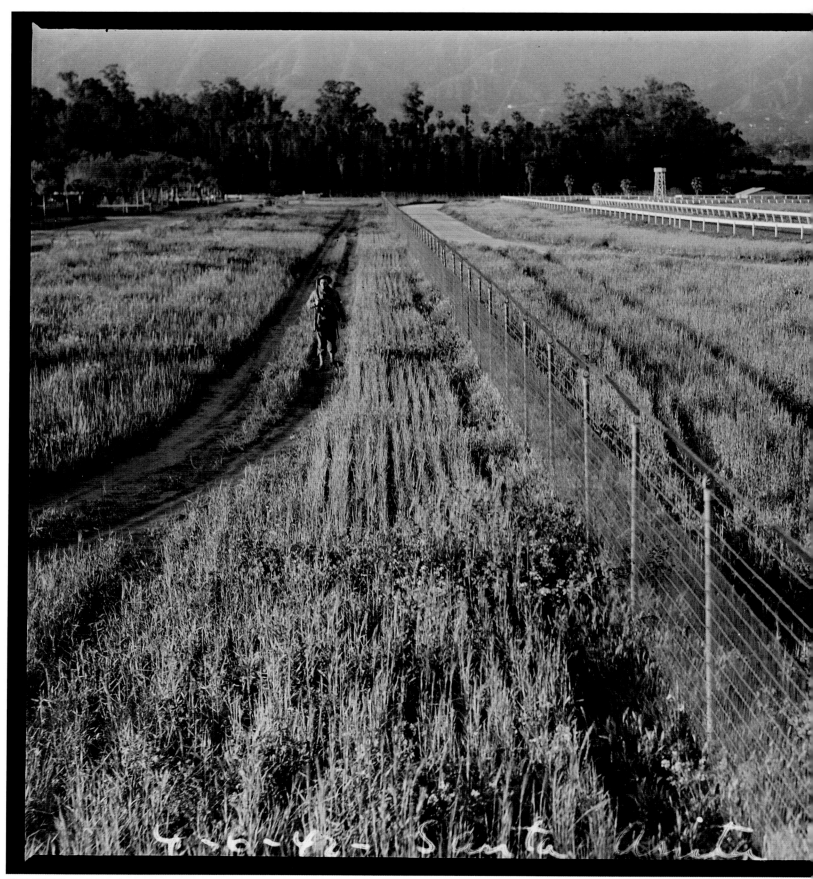

CLEM ALBERS ARCADIA, CALIFORNIA **APRIL 6, 1942**

R-200

Military police patrol the fence around Santa Anita. Detention center inmates were not free to come and go, but they were allowed visitors. Military police guarded the perimeters of the camps. Interior security was provided by a small staff of Japanese Americans under the supervision of a police officer.

The lack of privacy was shocking. Communal showers had no curtains; latrines had no doors or partitions. The artist Miné Okubo, whose book *Citizen 13660* detailed her experiences at Tanforan, described how difficult it was to sleep in the flimsy horse stalls of the barracks. "You could hear all the people crying, the people grinding their teeth; you could hear everything. Even lovemaking," she wrote.

Santa Anita closed in late October 1942, the last of the fifteen temporary centers to do so. The military then used it and eight others—Fresno, Pinedale, Pomona, Puyallup, Sacramento, Salinas, Tanforan, and Tulare—as training centers or prisoner-of-war camps. Santa Anita reopened for horse racing in 1945. Rodeos and county fairs returned to Merced, Pomona, Puyallup, Salinas, Stockton, and Tulare.

Today, the site of the Marysville Assembly Center is a farm, Portland an exposition center, Sacramento a residential subdivision, and Tanforan a shopping mall. Where the tiny Mayer Assembly Center sat in Arizona is now part of State Route 69. Most, but not all, sites have plaques marking their brief time as wartime homes for incarcerated Japanese Americans.

Vandalism and Thievery

The things we stored, we never got back, because the place we stored it, in Seattle, it was all stolen [before] we came back from camp. And I didn't realize the impact of what it does to the parents, because when they find there's not even that left, not even a bedspring or the personal stuff that they thought they left behind, is all gone. So you kind of wonder to this day where is all that stuff, you know? Whether they threw it away, or junkyard, or whatever.

—Frank S. Fujii

The fear and hatred of Japanese Americans persisted on the West Coast even after they were sent away to incarceration camps. In late 1942, the War Relocation Authority dispatched photographer Francis Stewart to make an inventory of the property left behind. The result was disturbing. Across rural California, Stewart found abandoned strawberry fields, grape farms in disarray, and looted homes. Vandalism and thievery continued through the war years—documented but not stopped. Padlocks and bolts gave little protection to isolated homes and churches, and neither the police nor the courts were of any help. No arrests were made until the Japanese Americans returned home in 1945.

DOROTHEA LANGE CENTERVILLE, CALIFORNIA **MAY 8, 1942**

Tomato beds sit ready in front of a Centerville farmhouse on the day of evacuation. The farm was leased by Arajiro and Yone Hamachi, who were taken with their children to the temporary incarceration center at Tanforan and the permanent camp at Topaz. Their 12-year-old daughter explained that her family left the farm in such good condition because it was the proper thing to do: "We were not going to take it out on the owner because of our condition." Their incarceration was a "shocking part of our lives," she said. "We were poor, but our folks were calm and kept us together." After the war, the daughter worked as a clerk and her six siblings became successful professionals. "No more farming," she said.

Right: The government allowed refugees from the Dust Bowl to work farms "abandoned" by Japanese Americans. But when the war was over, the migrants were loath to give back the farms. Some Japanese Americans fought for the property, while others, figuring the odds were against them, walked away.

FRANCIS STEWART PENRYN, CALIFORNIA NOVEMBER 10, 1942

DOROTHEA LANGE SAN LORENZO, CALIFORNIA **MAY 9, 1942**

FRANCIS STEWART FLORIN, CALIFORNIA NOVEMBER 11, 1942

Bob Fletcher (walking in field on the left) quit his job as an agriculture inspector to manage the fruit farms of three Japanese American families during the war. Despite being taunted by neighbors, he harvested their crops, paid their taxes and mortgages, and cleaned up the farms when the families returned in 1945. "He saved us," Doris Taketa said. Fletcher was honored in 2011 when he turned 100. "I don't know about courage," he said. "It took a devil of a lot of work."

Left: After Pearl Harbor, many Asians—like this owner of a roadside stand—took pains to make it clear that they were not Japanese.

FRANCIS STEWART PENRYN, CALIFORNIA **NOVEMBER 10, 1942**

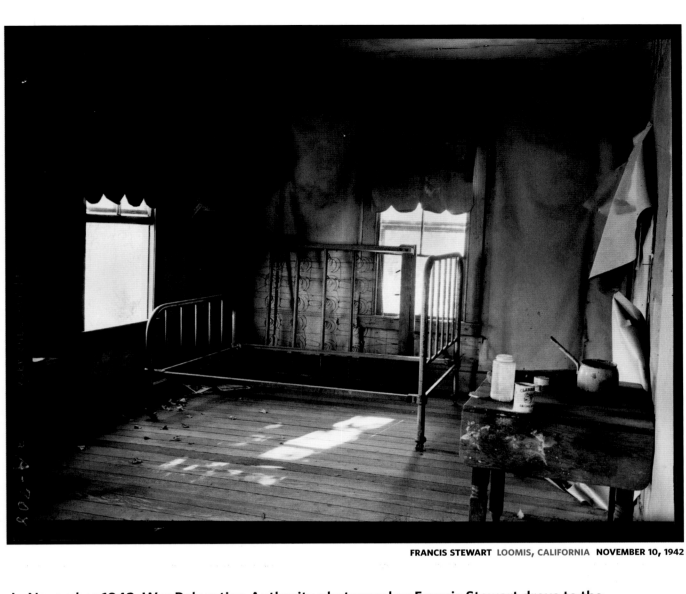

In November 1942, War Relocation Authority photographer Francis Stewart drove to the Sacramento area to document the vandalism of Japanese American farms following the evacuation. Wrecked homes were not difficult to find. Wrote a WRA property supervisor of the rampant destruction: "It might be well to note here that in several areas, and the Florin area in particular, the train in which the evacuees were leaving had not left before people from various parts of the county began to pilfer their homes and ranches, breaking windows, filling wells with debris, and committing other acts of vandalism."

The next year—after it was clear that the Japanese Americans would not be returning anytime soon—thieves took lumber, fixtures, doors, window frames, and plumbing. "Night raiders, who had descended upon abandoned farm houses to smash boxes of stored dishes and to break up stored furniture, now went with a view of appropriating anything which their own establishments might lack," the supervisor noted.

The desert hamlet of Parker, Arizona, won notoriety during the war for the hatred it spewed against Japanese Americans. Inmates at the Poston incarceration center were allowed to leave camp for brief periods if they received daily passes, but they were discouraged from stopping in nearby Parker.

"The place worked itself into a frenzy of suspicion and hate," wrote Georgia Day Robertson, a Caucasian woman who taught high school math at the camp. Several business owners painted large signs on their doors warning "Japs Keep Out," she wrote.

Parker residents later said that only one proprietor, a man named Andy Hale, painted such a sign. In November 1944, Hale tossed a Japanese American soldier out of his barbershop. "Can't you read that sign?" he asked Raymond Matsuda, a 29-year-old private who was on crutches because he had been shot in the knee while serving in the 442nd Regimental Combat Team. A sympathetic story about the incident was carried widely by the Associated Press, but it had no apparent effect on the town. The next month, Parker's deputy sheriff ejected three Japanese American soldiers in uniform from a restaurant in town.

The War Relocation Authority's caption for this photo, taken by Poston administrator Pauline Bates Brown, states, "A Parker café-owner was caught by the camera as he watched the photographer." In a letter to Arizona governor Sidney Osborn, Bates said that Japanese American servicemen continued to be hassled and that some were not allowed to visit the camp.

The following year, more than forty Parker business owners—"desirous of obtaining whatever business" they could—pledged that they would serve Japanese Americans.

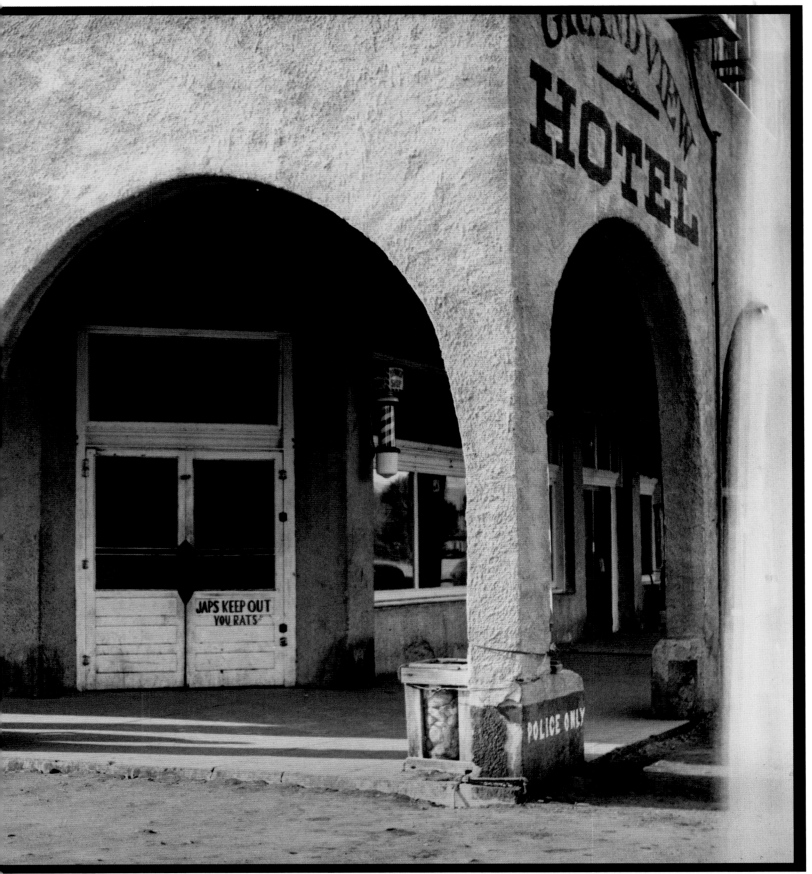

PAULINE BATES BROWN PARKER, ARIZONA **NOVEMBER 11, 1944**

RICHARDS STUDIO TACOMA, WASHINGTON OCTOBER 27, 1944

Possessions stored by Japanese Americans in the basement of the Tacoma Buddhist Church in Washington were stolen or damaged in 1944. The church closed in May 1942 after its members were sent to the nearby Puyallup Assembly Center.

"The people who went into the church left the door of the basement open, so water ran down from the hillside into the basement," said Ronald E. Magden, a historian who spent nearly two decades writing about the lives of Japanese Americans in Tacoma. "Not all the material was destroyed, but quite a lot." Neither of Tacoma's two daily newspapers reported the incident.

Buddhist churches were frequent targets. Government photographers also documented what happened to property stored at the Nichiren Buddhist Church in Los Angeles, which was broken into in 1943. The destruction was so extreme that church member Mrs. Cecil Itano was taken from the Granada Relocation Center in Colorado to Los Angeles so that she could report back to other inmates. "The catastrophe before my eyes was a hopeless mass of deliberate destruction," she wrote. "Everything was a conglomeration of unrecoverable damaged things. Nothing was untouched. Sewing machines were ruined, furniture broken, mirrors smashed to smithereens, broken glass from breakable articles, household goods scattered helter-skelter, trunks broken beyond repair."

The War Relocation Authority later admitted that the federal government mishandled the protection of goods. Local and state police showed "considerable indifference to vandalism and even to arson committed upon evacuee property," the agency stated in its 1946 report *The Wartime Handling of Evacuee Property.* The army took little responsibility. "These factors have contributed heavily to the failure of the Government's attempts to protect the property of the evacuated Japanese Americans and have made the wartime handling of evacuee property a sorry part of the war record," the report concluded.

A Serious Documentary Manner

Down in our hearts we cried and cursed this government every time when we were showered with sand. We slept in the dust; we breathed the dust; and we ate the dust. Such abominable existence one could not forget, no matter how much we tried to be patient, understand the situation, and take it bravely.

—Joseph Yoshisuke Kurihara

The War Relocation Authority wanted a photographic record of its camps for promotional purposes and to assure the public, official international observers, and history that Japanese Americans were well treated. But Dorothea Lange and others sought to photograph the camps in a serious documentary manner, and they were able at times to circumvent the assignment. Ansel Adams, who gained permission to photograph Manzanar in his own style, supplemented their work. The majority of WRA photographs were taken at the ten permanent incarceration centers, but the documentation went beyond the camps as photographers showed former camp residents after they were released and relocated around the nation.

CLEM ALBERS NEWELL, CALIFORNIA **APRIL 23, 1942**

FRED CLARK POSTON, ARIZONA MAY 19, 1942

Workers at the Poston incarceration center construct barracks that will house Japanese Americans for the duration of World War II. Located just east of the California border, Poston was the largest camp, built for twenty thousand people. Crews hired by the Del Webb Company could raise standard 120-by-20-foot barracks in less than an hour if all the materials were on site. But construction, as per government instruction, was shoddy. Workmen used green lumber, which would shrink and leave gaps in the walls. Thin tarpaper did little to keep out wind and dust, and insulation wasn't added until later.

The barracks were the exact same type used by soldiers in combat zones. The army acknowledged in 1943 that the structures, while adequate for troops, were "too cruel for the housing of women, children and elderly people."

Left: Construction begins at the Tule Lake camp, just south of the Oregon border in a desert wilderness. The camp, built for sixteen thousand, opened five weeks later.

CLEM ALBERS POSTON, ARIZONA **APRIL 10, 1942**

The two camps in Arizona, Poston and Gila River, were built on Indian reservations. The Bureau of Indian Affairs pushed the idea, saying that Native Americans would be able to use the improvements, such as the barracks and irrigation canals, after the war. The tribal councils opposed the idea. They were overruled by the government.

On the Colorado River Indian Reservation, Clem Albers photographed Ben Butler (right), a Mohave, and Ruby Snyder (above), a Chemehuevi, who told him, "I hear that the Japanese are wonderful farmers. I would like to go down to see how they grow things." The Japanese and Native Americans were deliberately kept apart for most of the war.

CLEM ALBERS POSTON, ARIZONA **APRIL 10, 1942**

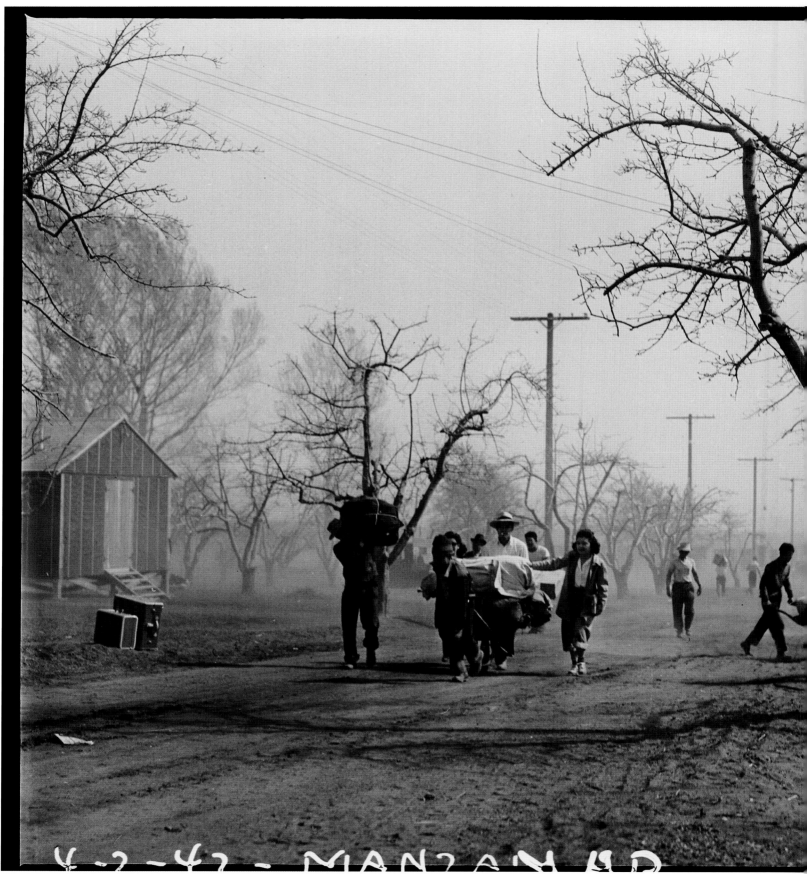

CLEM ALBERS OWENS VALLEY, CALIFORNIA APRIL 2, 1942

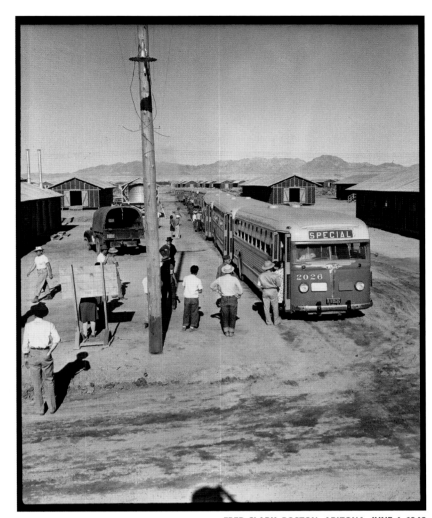

Japanese Americans arrive at Poston (above) and Manzanar (left). "It seems comical, looking back; we were a band of Charlie Chaplins marooned in the California desert," wrote Jeanne Wakatsuki Houston and James D. Houston in *Farewell to Manzanar.*

The unfinished camp, near the aqueduct in the Owens Valley that supplied Los Angeles with water, was pure chaos at the start. The food, not in keeping with the traditional Japanese diet, gave people "the Manzanar runs," and the latrines were unsanitary. Wrote the Houstons: "Some old men left Los Angeles wearing Hawaiian shirts and Panama hats and stepped off the bus at an altitude of 4000 feet, with nothing available but sagebrush and tarpaper to stop the April winds pouring down off the back side of the Sierras."

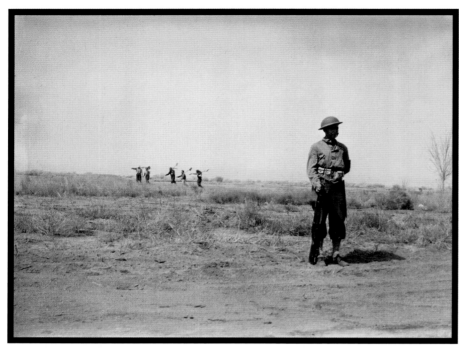

CLEM ALBERS OWENS VALLEY, CALIFORNIA APRIL 2, 1942

Inmates clear brush at Manzanar. In a brochure called *Questions and Answers for Evacuees,* the War Relocation Authority cast camp life as an adventure, with stores, a post office, and banking facilities. "Be prepared for the Relocation Center, which is a pioneer community. So bring clothes suited to pioneer life and in keeping with the climate or climates likely to be involved," it advised, warning that temperatures could range from freezing to 115 degrees in "your new war-duration home."

In early 1942, Henry McLemore, a Hearst syndicated columnist, called for sending the Japanese "to a deep point in the interior." He wrote: "I don't mean a nice part of the interior either. Herd 'em up, pack 'em off and give 'em the inside room in the badlands." That is exactly what happened. The ten permanent centers were built in deserts and forests far from where the Japanese Americans had come.

Right: New arrivals fill sacks with straw to make mattresses at Poston. Sharon Tanagi Aburano, 15, recalled the humiliation she felt when her family was told to make their mattresses. "That's the first time I saw my mother's tears," she said. "To be reduced to that, I think, was just too much for her to bear."

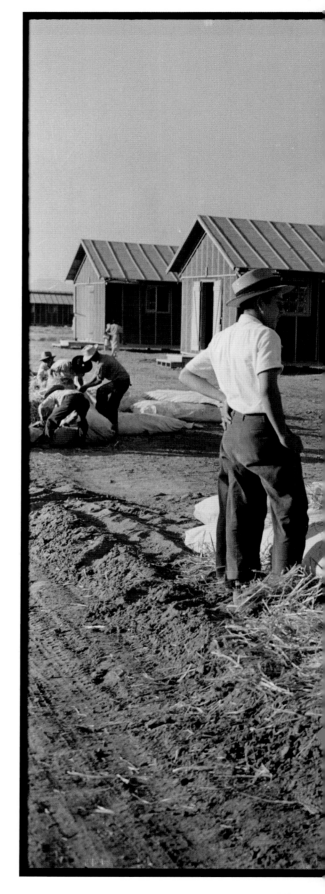

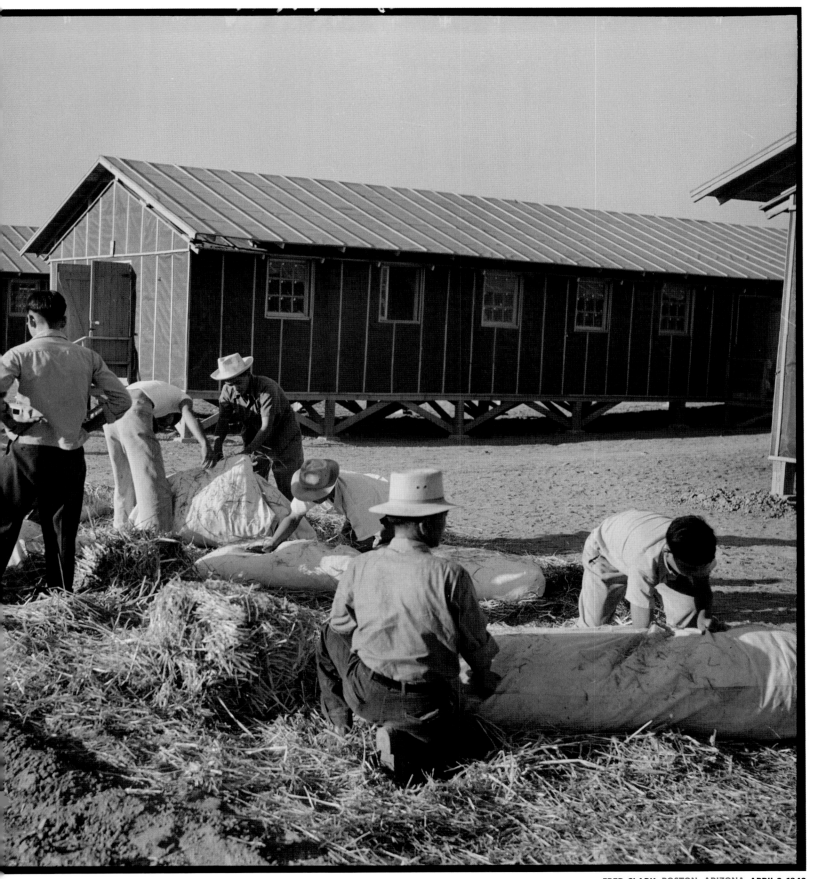

FRED CLARK POSTON, ARIZONA **APRIL 2, 1942**

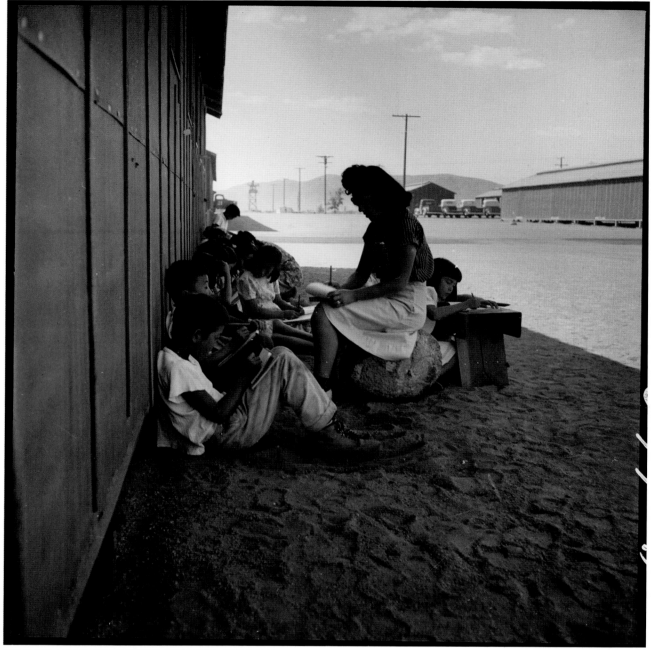

DOROTHEA LANGE OWENS VALLEY, CALIFORNIA **JULY 1, 1942**

A volunteer instructs schoolchildren at Manzanar. Informal classes began at the temporary centers and continued through the first months at permanent centers, taught mostly by college-educated inmates. Formal classes started in the fall of 1942. "No school equipment is as yet obtainable and available tables and benches are used," Dorothea Lange wrote. "However, classes are often held in the shade of the barrack building."

Right: Children watch Memorial Day services. Patriotism ran high during the first months of incarceration, with war bond rallies, scrap metal drives, and blood drives being held. It was another way to prove loyalty.

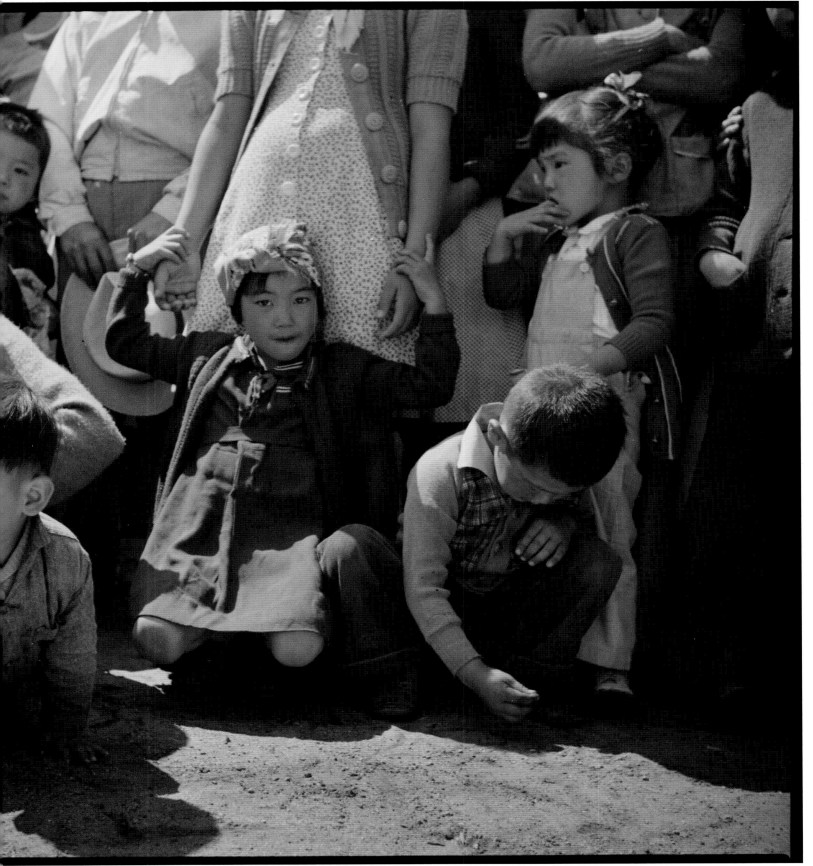

FRANCIS STEWART OWENS VALLEY, CALIFORNIA MAY 30, 1942

Aya and Henry Tsurutani and their son, Bruce, are shown in a typical apartment at Manzanar. Ansel Adams contacted the family because Henry was a friend of the camp's director. Adams photographed the family on Bruce's third birthday. Less than a year later, the Tsurutanis were able to leave Manzanar after Henry, an attorney, got a job with the Office of Strategic Services, a wartime intelligence agency.

Decades later, Bruce, who became a principal and senior scientist at NASA's Jet Propulsion Laboratory at the California Institute of Technology, took Aya back to Manzanar. "My mother never expressed her feelings until we returned to camp," he said. "She didn't express sorrow or anger—that's just part of the Japanese culture." But when she returned to the camp, she talked about the cracked wood sealed with tarpaper, the dust that swept into the rooms, and how people tried so hard to make their homes livable.

She also remembered Adams. "He sure knew his business," she said, "because it didn't take him very long to seat us and take the picture." Aya died in 2013 at the age of 100. Henry had died ten years earlier.

Bruce met with Adams in the early 1980s because he admired the photographer's book about Manzanar, *Born Free and Equal,* and wanted to use the $20,000 he had received in reparations to reprint it. He secured permission and made arrangements with a publisher, but another book with Adams's Manzanar pictures was released, so the project was never completed.

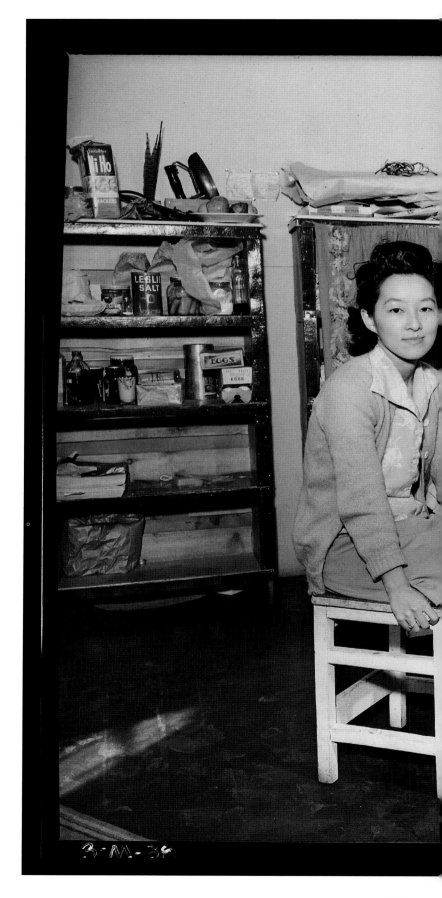

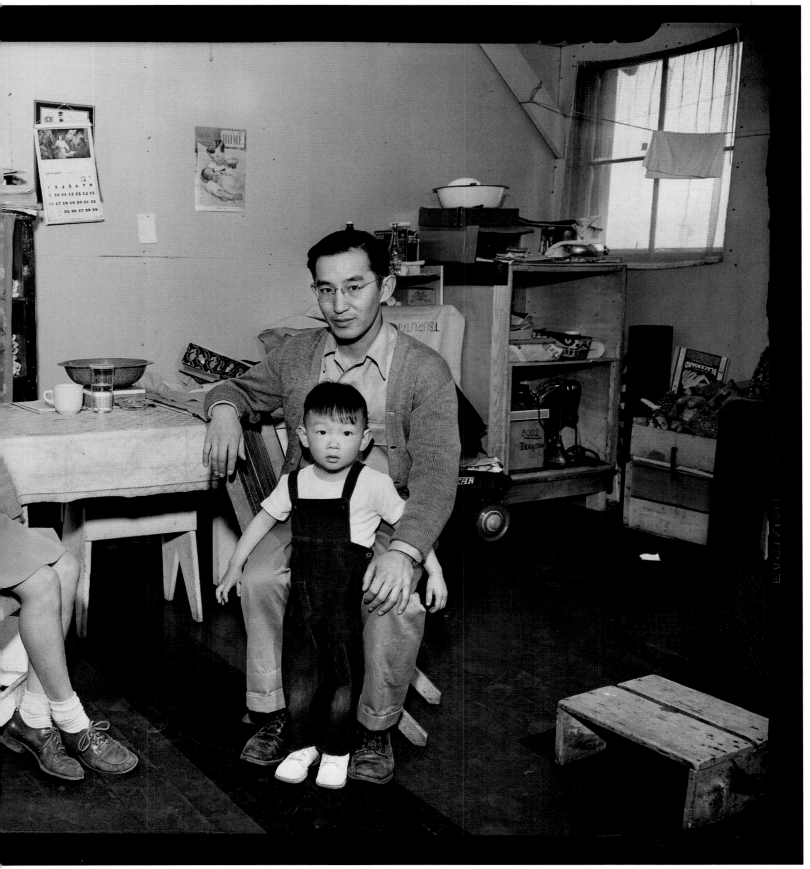

ANSEL ADAMS OWENS VALLEY, CALIFORNIA **JANUARY 29, 1944**

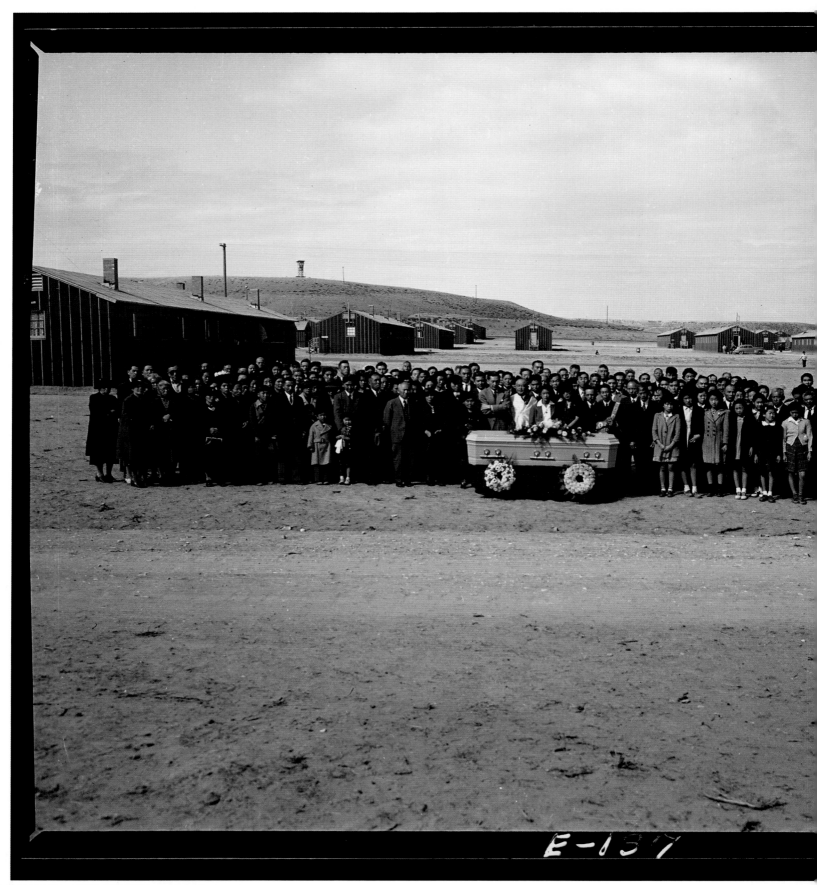

TOM PARKER CODY, WYOMING **SEPTEMBER 18, 1942**

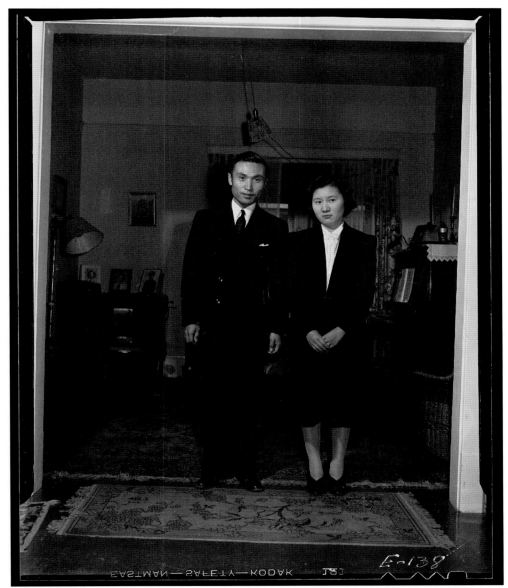

Heart Mountain's first bride and groom, Shizuko and Kenichi Tanaka, pose after their wedding at a minister's home in Cody, Wyoming. They were driven to town under military guard. Shizuko, 21, met Kenichi, 27, at Santa Anita and married a few days after arriving at Heart Mountain. "This was unusual because until that time most Japanese marriages were arranged," said their son Fred Noboru Tanka. After the war, the Tanakas moved to Japan where Kenichi worked as a civilian for the army. They returned to America around 1957 and lived long lives together.

Right: Heart Mountain inmates gather for the funeral of Yoichi George Ochiai, 60, who died of a heart attack. From San Francisco, he left a 12-year-old daughter, Lillian. She stood directly behind the casket.

Manzanar inmates were hired to manufacture camouflage nets for the War Department. The pay was paltry, the labor was monotonous and tiresome, and rumors floated through camp that the constant weaving of fibers could cause serious lung irritation and perhaps even tuberculosis.

The nets were first made at Santa Anita, where a work force that numbered close to a thousand produced hundreds of nets a week that were used in gun embankments and on Allied tanks. The work was essential to the army, which paid miniscule wages (about one-tenth the going rates) for this and all other work. Recruiting workers was not easy. Because it was a defense project, Issei were not allowed to make the camouflage nets. Security concerns aside, the Geneva Conventions stipulated that Japanese nationals could not be forced to do war work. So young Nisei were pressured to fill the ranks. They were told that working in the net factories was their patriotic duty.

In June 1942, a Santa Anita worker walked off the job, telling bosses he was hungry. When he was ordered back to work, his coworkers joined him in a spontaneous strike. They complained about the food, the dust, the fumes, and the long hours. It was the first mass act of resistance against the incarceration.

As the work moved to Manzanar and the two incarceration centers in Arizona, Japanese Americans who were opposed to the government tried to convince fellow inmates that they should not take jobs that contributed to the war effort. After months of disputes and more strikes, the camouflage factory at Manzanar was closed in December 1942.

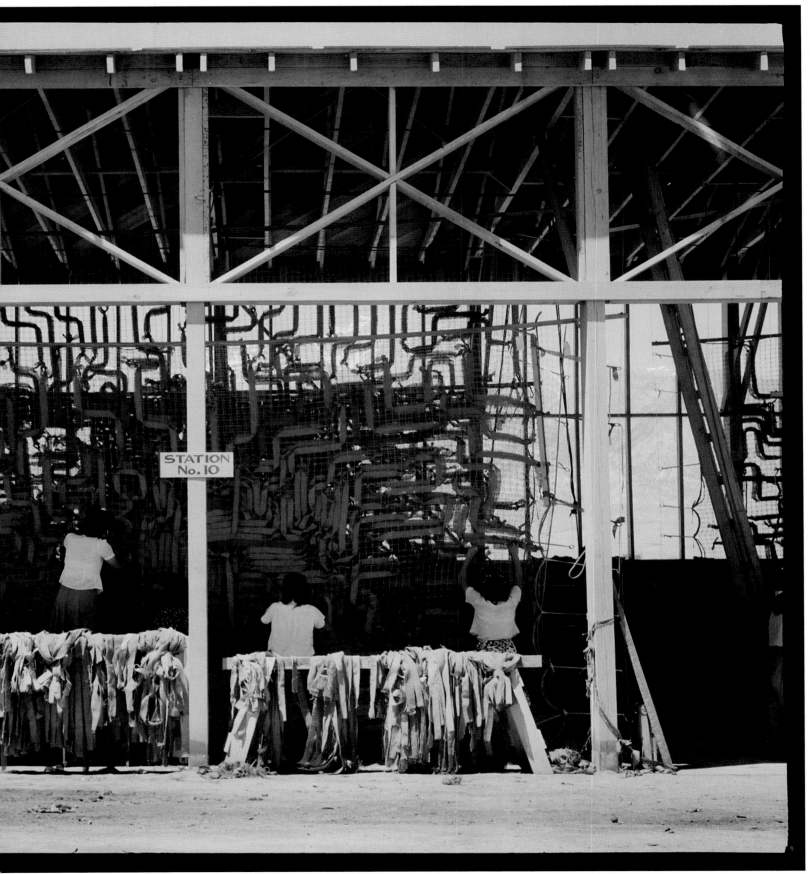

STATION
No. 10

DOROTHEA LANGE OWENS VALLEY, CALIFORNIA **JULY 1, 1942**

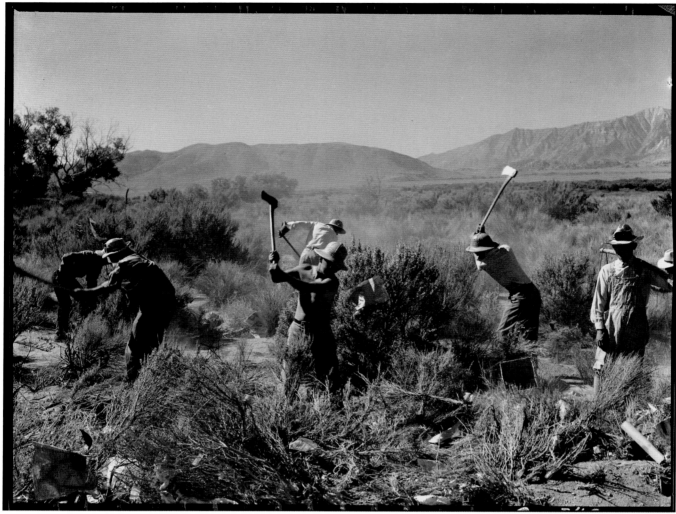

DOROTHEA LANGE OWENS VALLEY, CALIFORNIA **JUNE 30, 1942**

To battle boredom and make spending money, about 30 percent of the inmates at the incarceration centers held jobs. They cleared brush at Manzanar (above) and harvested potatoes at Tule Lake (right). They raised chickens, hogs, and cattle, delivered mail, stoked the coal furnaces, served as doctors and nurses, and worked as midlevel camp administrators. They also labored in camp factories, making mattresses, furniture, and clothes for the centers. They were paid between twelve and nineteen dollars a month. The public demanded that salaries be kept below the twenty-one dollars paid monthly to army privates.

Built by the army, the camps were basic at first: barracks, mess halls, hospitals, and laundries. Wanting to create small towns that were nearly self-sufficient, the War Relocation Authority added co-ops and canteens, churches and movie theaters, beauty parlors and barbershops. Under its direction, inmates constructed an ice rink at Heart Mountain (skates were purchased by mail order), a swimming pool at Poston, and golf courses at Manzanar and Topaz.

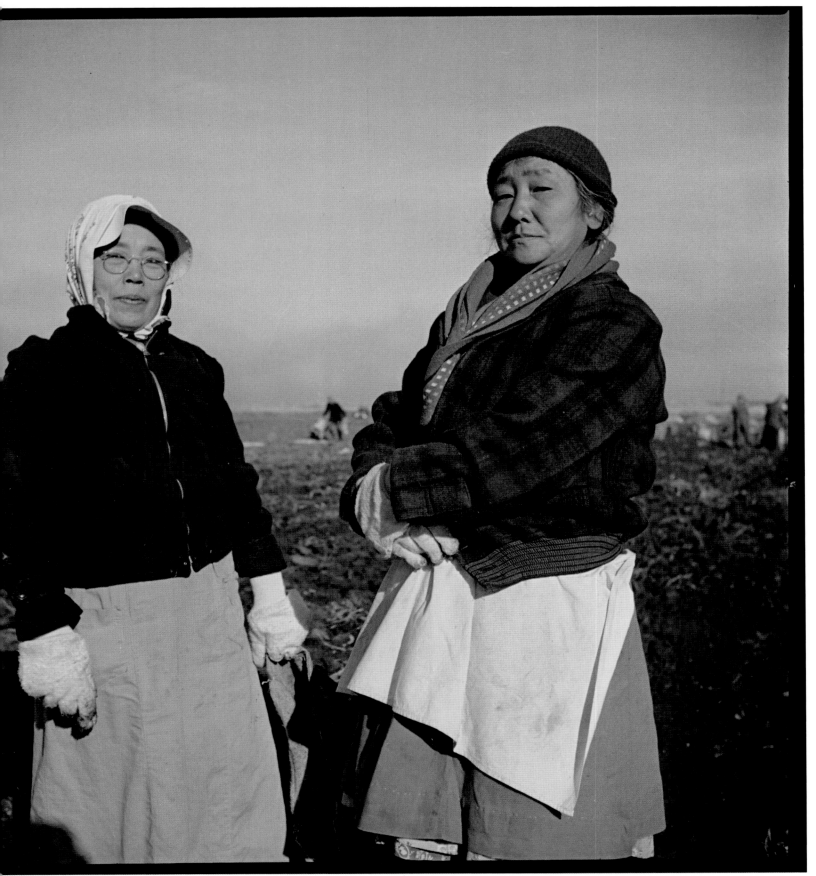

FRANCIS STEWART NEWELL, CALIFORNIA NOVEMBER 5, 1942

Kaoru Karlene Nakaishi (center) waits for her fourth-grade class to start at Manzanar. She recalled that classes were held in the barracks and students sat at tables instead of individual desks. "I don't remember having any books or a blackboard," she said. "Much of our writing was on flimsy paper, which was handed out one sheet at a time."

Kaoru (now Karlene Koketsu) was living in the West Los Angeles neighborhood of Sawtelle when she and her parents and two siblings were taken by bus to Manzanar. She attended third through fifth grades there. "I don't remember learning a lot," she said, "but I do remember singing because our fourth-grade teacher, Miss Schoaf, was very musical." Classes were crowded at the ten camps, with a student-teacher ratio of 48 to 1 in elementary school and 35 to 1 in high school, about twice the national average.

Right: Men receive training in auto mechanics at the Minidoka Relocation Center in Idaho. With a captive audience, adult education was popular. The WRA taught English to Issei and offered Americanization classes that focused on democracy, government, and history. Most popular classes were music, painting, and flower arranging.

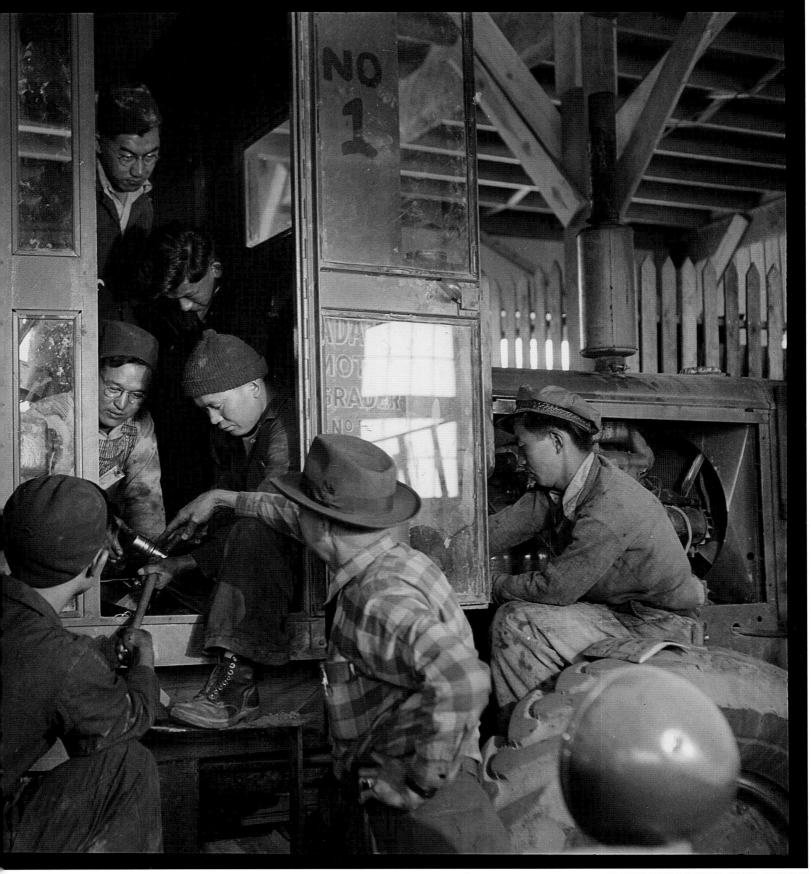

FRANCIS STEWART HUNT, IDAHO **JUNE 1943**

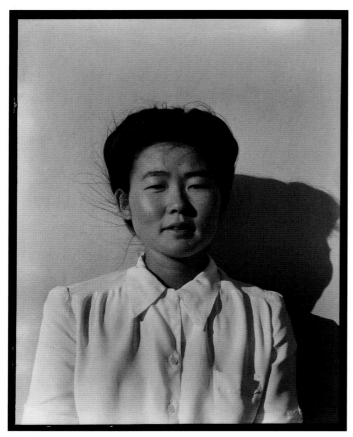
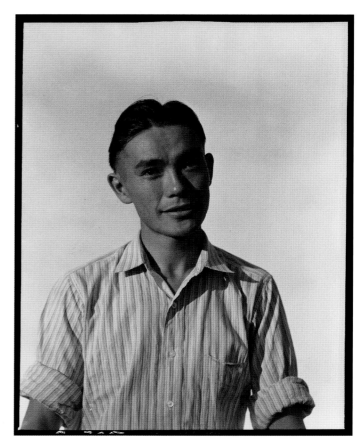
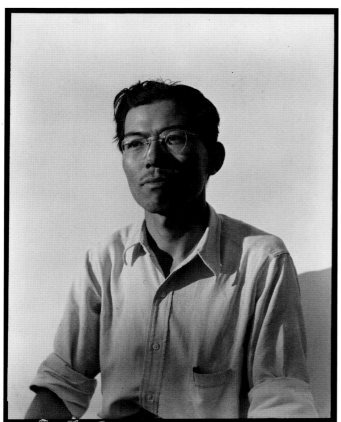
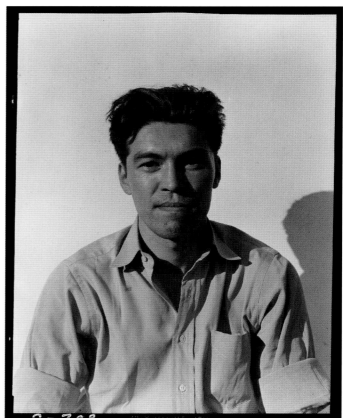

DOROTHEA LANGE OWENS VALLEY, CALIFORNIA **JULY 3, 1942**

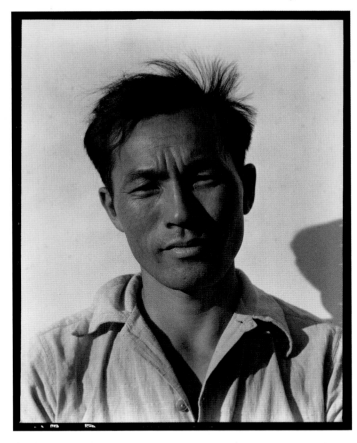

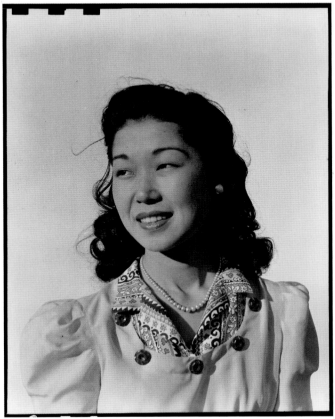

July 3, 1942, was the last day Dorothea Lange photographed for the War Relocation Authority. After two days of shooting at Manzanar, she took a rare series of portraits. Clockwise from top left:

Chiyeko "Chico" Sakaguchi was a reporter at the inmate-run *Manzanar Free Press.* She left the camp in 1944 to teach school in Philadelphia but died a year later at the age of 26. Her brother, Bo Sakaguchi, said that the asthma she'd developed in the camp because of the dust and cold led to fatal pneumonia.

Togo Tanaka, a journalist, was removed from camp in December 1942 for his own protection during what was called the Manzanar riot. Later, Lange wrote letters of recommendation for Tanaka, who responded: "We are deeply grateful above all for your having helped us discover, amidst the tragedy of war where darkness has instilled so much hate and fear, that love and kindness are the really enduring qualities of life."

Karl Yoneda, a longshoreman and union organizer, was also removed for his own protection during the Manzanar riot. He was married to a Jewish Communist labor activist, Elaine Black Yoneda, who demanded that she and their young son, Tom, be allowed to join him during his incarceration.

Shizuco Setoguchi, a secretary from Los Angeles, worked for the *Manzanar Free Press.*

Joe Blamey, the original city editor of the *Manzanar Free Press,* had a Japanese mother and an Irish father. He was incarcerated along with other mixed-race West Coast residents. Mixed-race families were allowed to seek exceptions from the camps, but exemptions were not always granted.

Frank Nobuo Hirosawa, a scientist who helped run a project to determine if guayule plants could be used for the production of rubber in the war.

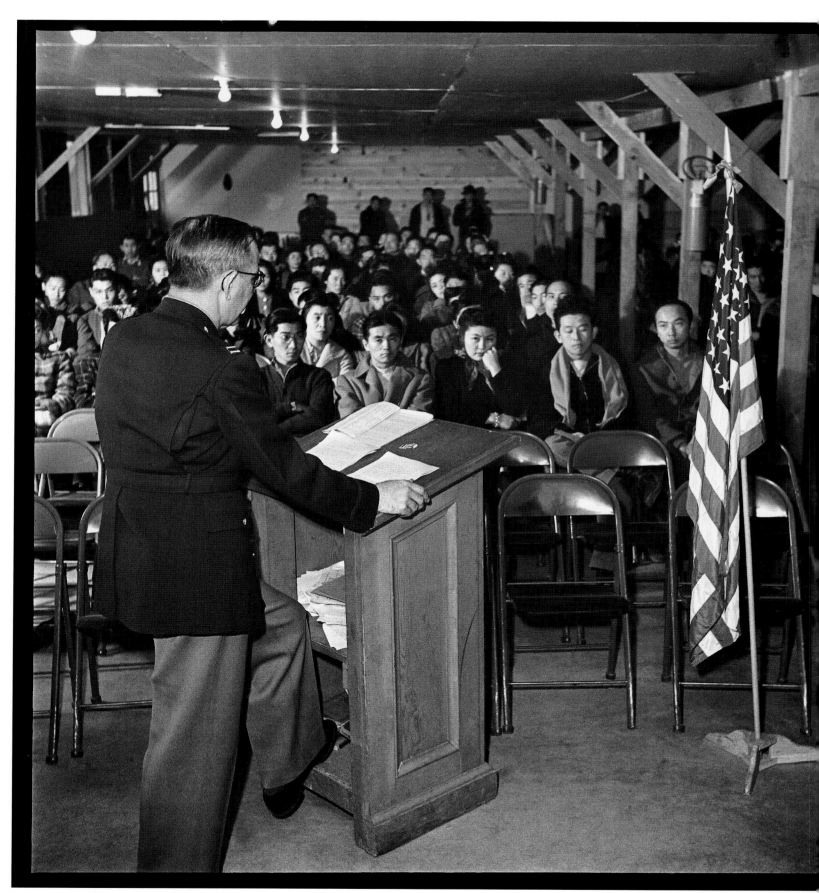

TOM PARKER AMACHE, COLORADO FEBRUARY 9, 1943

UNCREDITED PHOTOGRAPHER **POSTON, ARIZONA 1944**

Left: Trying to recruit volunteers for the army, Captain William S. Fairchild addresses Granada inmates. He later handed out a questionnaire designed to determine their loyalty. The questions, asked at all the camps, angered many. Question 27: "Are you willing to serve in the armed forces on combat duty?" Question 28: "Will you swear unqualified allegiance to the United States and forswear allegiance to the Japanese emperor?" About twelve thousand refused to respond or answered no to both questions. Some Nisei felt the questions were inappropriate for U.S. citizens; others could no longer affirm their allegiance to the United States. They came to be known as "no-nos." The questionnaire divided inmates at all the camps—and was a recruitment flop. The military expected 3,500 volunteers but got only 805.

Above: For those young men who volunteered, the army took photographs of their family members to send to them overseas. Top left: Alice Fukuhara stands by her father, Ukichi Fukuhara. Her brother Minoro Fukuhara served in the 442nd Regimental Combat Team. Top right: Charlie S. Fujiki poses for his brother Tom, also assigned to the 442nd. Charlie later enlisted, and he died while serving in Italy.

This still life is the most reprinted of Ansel Adams's Manzanar work, according to Elena Tajima Creef, author of *Imaging Japanese America.* "The photograph is striking as an altarlike memorial to family, religion, and patriotism," she wrote.

The picture, a portrait Robert Yonemitsu in uniform next to letters he sent to his sister, "tells much about the Yonemitsu family, and about many other families as well," Adams said. Though he claimed the objects atop the console were shot "just as they were," another photo taken in the room reveals that he slightly rearranged them, removing a family snapshot, straightening the doily, and moving the gourds.

Robert was born in 1921 in Los Angeles, the son of Japanese immigrants. His father, Francis, was a produce buyer; his mother, Alice, died of cancer only four months after the family arrived at the incarceration center. A medic with the 442nd Regimental Combat Team, Robert returned from Italy suffering from war trauma. While undergoing rehabilitation in Chicago, he met and married Sueko "Sue" Nishimori, a nurse's aide. They moved to the Seattle area, where they raised seven children and he worked as a machinist at Boeing for 35 years.

"Almost every member of our family has a copy of the photograph framed in our homes," said their son David Yonemitsu. He said he didn't learn about the incarceration of Japanese Americans until high school or college: "It just wasn't taught."

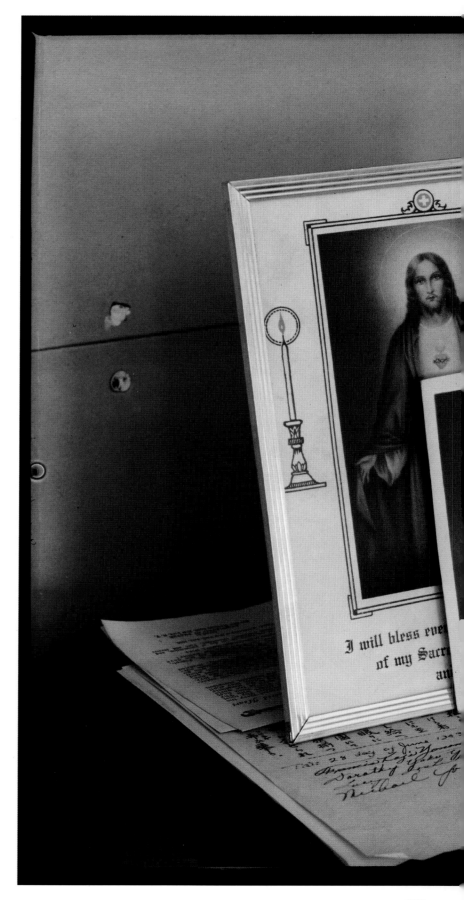

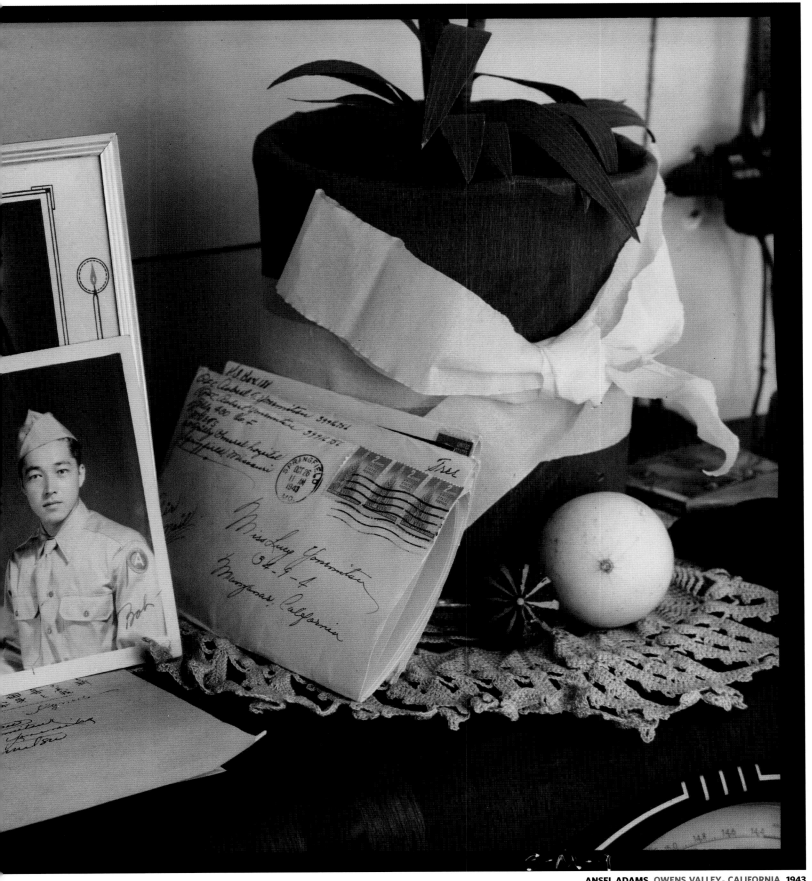

ANSEL ADAMS OWENS VALLEY, CALIFORNIA **1943**

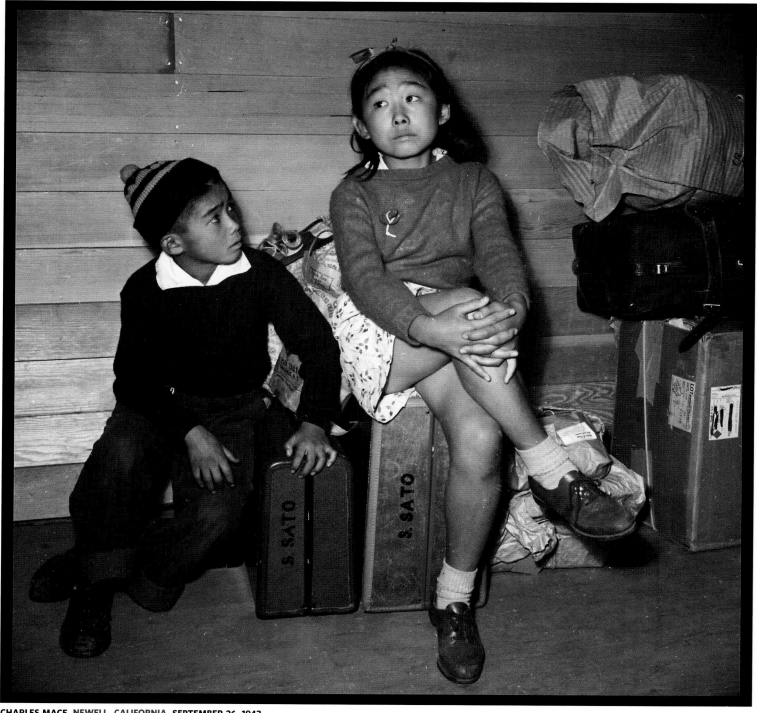

CHARLES MACE NEWELL, CALIFORNIA SEPTEMBER 26, 1943

The loyalty questionnaire changed the makeup of the camps. The Tule Lake Relocation Center became the high-security Tule Lake Segregation Center. "Disloyal" inmates, as those who answered no to questions 27 and 28 were labeled, were sent there. To make room, "loyal" Tule Lake inmates were sent by train to the other camps. Photographer Charles Mace rode the trains to and from Tule Lake. He wrote, "To the very young, the whole business of evacuation, relocation and segregation is incomprehensible, as registered in the faces of these two children from the Jerome Center."

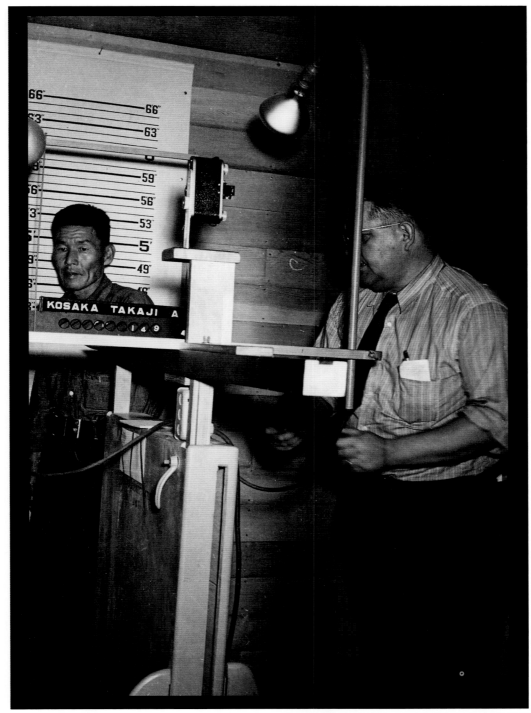

CHARLES MACE NEWELL, CALIFORNIA SEPTEMBER 1943

Sixty-three-year-old Takaji Kosaka is photographed and fingerprinted at Tule Lake after his transfer from the Rohwer incarceration center in Arkansas. Kosaka, who had worked as a farmhand in Stockton, California, emigrated from Japan in 1903 and dutifully registered with the Selective Service for both world wars. He was one of about three thousand Issei and fifty-six hundred Nisei—almost all from Tule Lake—who sought to be sent to Japan at the end of the war. Eventually, about thirteen hundred men, women, and children were deported, including Kosaka.

A softball game draws a big crowd at Rohwer. Baseball was by far the most popular sport at the detention centers. Pickup games started within days after they opened, and the formation of leagues soon followed. Dozens of baseball diamonds were built at the camps.

Introduced in Japan during the 1870s, baseball was ingrained in the culture, said Kerry Yo Nakagawa, founder of the Nisei Baseball Research Project. "The sport was looked upon as a discipline and introduced the spirit of team play—nine players with one mind." Issei could talk baseball when they arrived in the United States, he said, making them feel more American.

Manzanar boasted one hundred men's teams and fourteen women's teams. The game was even more popular at Gila River, where Kenichi Zenimura built a baseball field, complete with bleachers and a dugout, just outside the camp perimeter. He used dozens of volunteers to level the field and diverted water from an irrigation canal and the camp laundry. "The infield was perfect," said Zenimura's son Kenso Howard, who was 15 at the time. "There were no bad bounces." The camp's project director, L. R. Bennett, tossed out the first ball.

In the spring of 1945, Gila River's Butte High School team challenged the state championship team from Tucson High School, which had not lost a game in three years. The game is etched in the memory of Tetsuo Furukawa, who pitched that day. Several thousand Gila River inmates packed the stadium to watch Butte beat Tucson 11–10 in ten innings. Afterward, players from the two teams shared dinner. The Tucson players taught those from Butte the finer points of eating watermelon. "Then we taught them a thing or two about sumo wrestling," recalled Furukawa. The players met again in 2006, when both teams were recognized by the Pima County Sports Hall of Fame in Arizona as models of American sportsmanship.

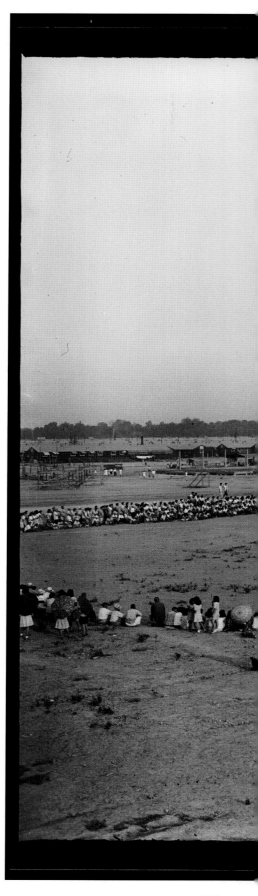

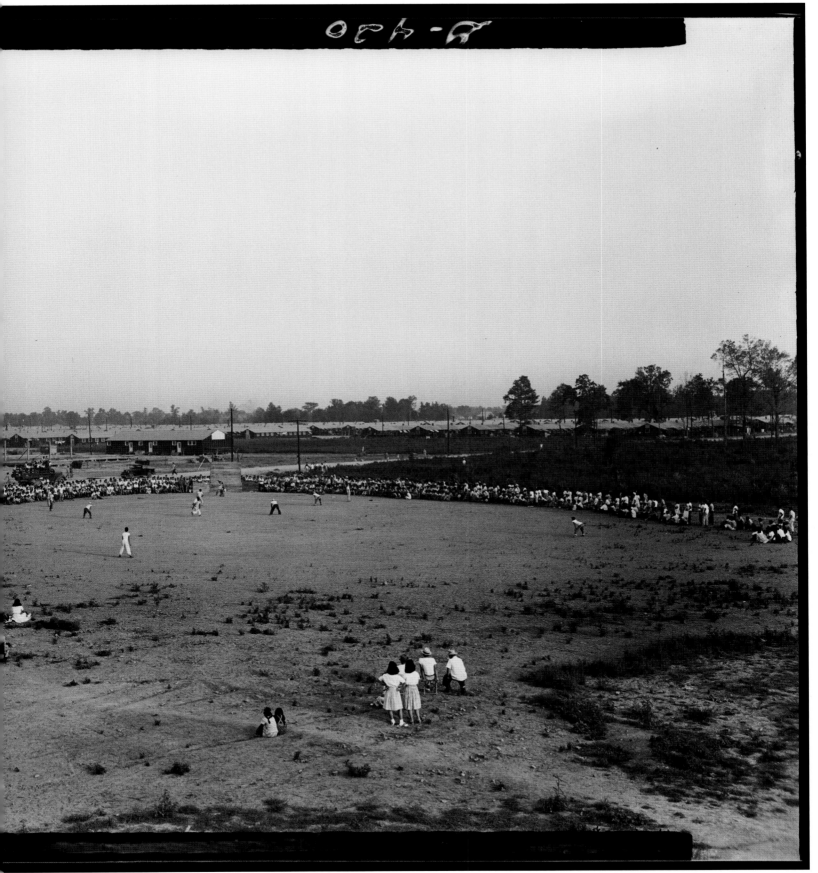

UNCREDITED PHOTOGRAPHER MCGEHEE, ARKANSAS AUGUST 25, 1943

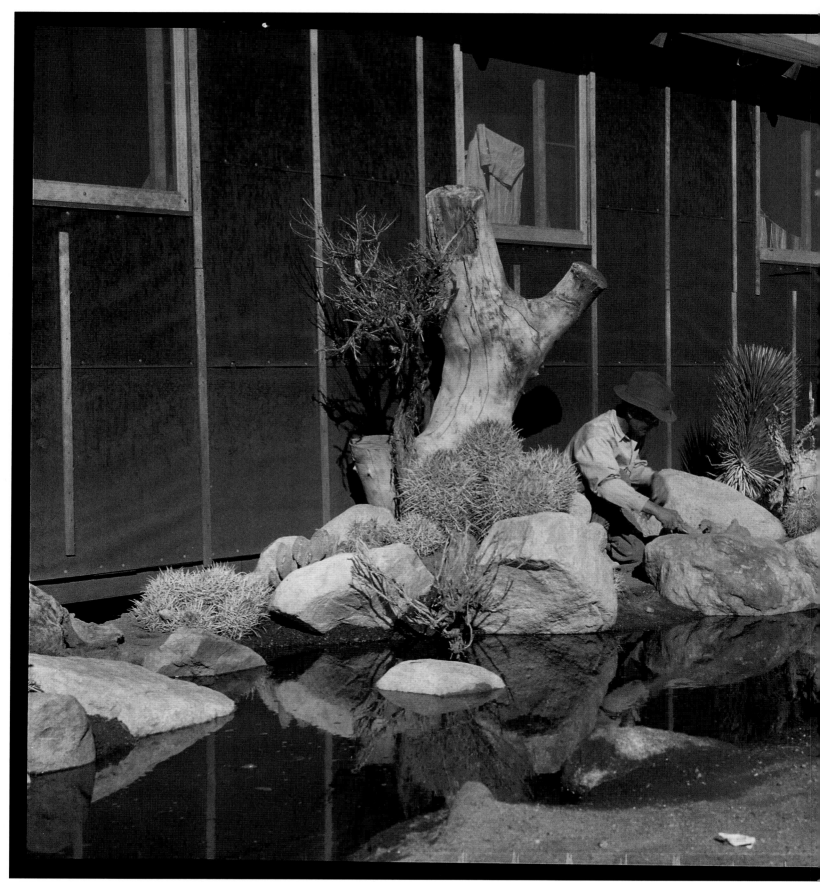

DOROTHEA LANGE OWENS VALLEY, CALIFORNIA **JUNE 30, 1942**

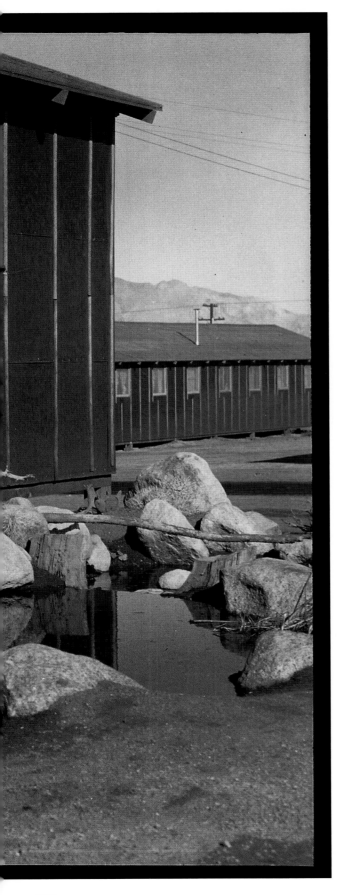

Wooden vases carved by camp residents from local trees are displayed at the Granada incarceration center.

Left: William Manjiro Katsuki was the first to build an ornamental garden at Manzanar. He came to the United States in 1903 and worked as a professional landscaper. His garden—a small stream, rocks, Joshua trees, cacti, brush, and branches—inspired more than a hundred gardens. "Six months ago Manzanar was a barren, uninhabited desert," observed the Manzanar Free Press in October 1942. "Today, beautiful green lawns, picturesque gardens with miniature mountains, stone lanterns, bridges over ponds where carp play, and other original, decorative ideas attest to the Japanese people's traditional love of nature, and ingenuity in reproducing the beauty of nature in miniature."

Many of the gardens, bulldozed when the camp closed in 1945, are being excavated and mapped by the National Park Service. Katsuki left Manzanar in March 1945 but visited later that year to help other gardeners start their businesses again.

The War Relocation Authority also photographed artwork that depicted camp life, including pieces by Frank Morihiko Taira (above) and Miné Okubo (opposite), who were at the Topaz camp. Taira's portrait of his wife, Bunny, was shown at a 1943 exhibit in Cambridge, Massachusetts, of work by incarcerated artists. "To me it depicts not only the sad feeling of the people in the camps but of people all over the world," he wrote. "It is the thing that all of us who stop to think feel when we ask ourselves—How Long?" Miné Okubo's drawing shows a dust storm at Topaz. "It was a desolate scene," she said, recalling her arrival at the camp. "When we finally battled our way into the safety of the building we looked as if we had fallen into a flour barrel." The sketchbook she kept in Topaz, published as *Citizen 13660,* is one of the clearest artistic accounts of the incarceration. "It gave me the chance to study human beings from cradle to grave, when they were all reduced to one status," she wrote.

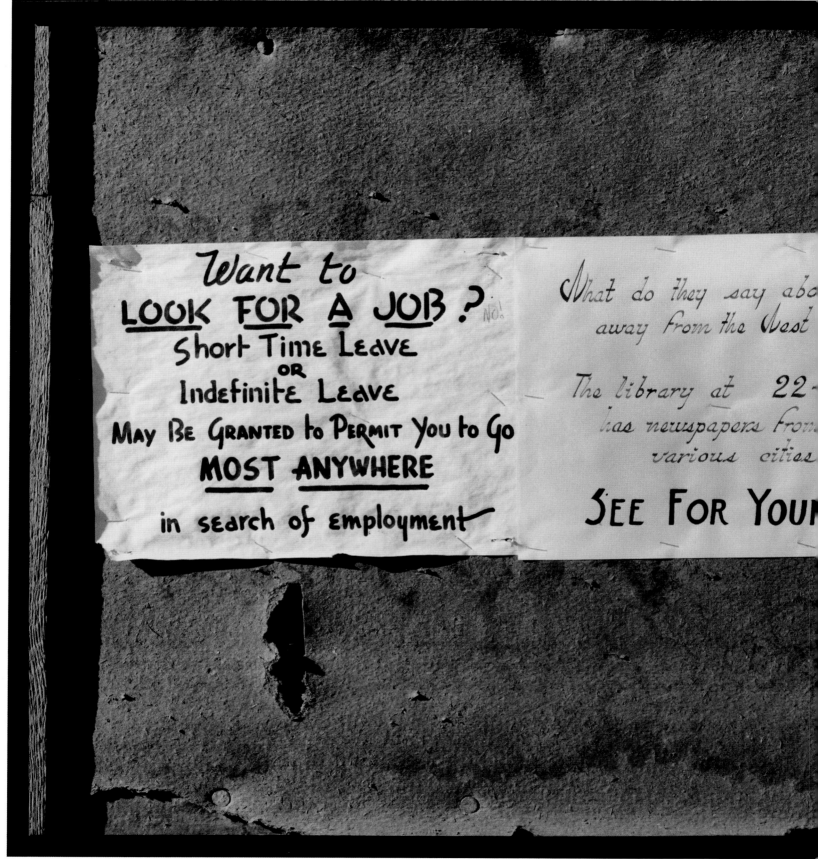

ANSEL ADAMS OWENS VALLEY, CALIFORNIA 1943

ANSEL ADAMS OWENS VALLEY, CALIFORNIA **1943**

Signs at Manzanar lists available jobs back east. Leaving camp was not easy. Starting in March 1943, only people who had answered yes to questions 27 and 28 on the loyalty questionnaire could receive indefinite leaves. The decision was left up to camp directors. Banned from leaving was anyone with an FBI file or who had applied to return to Japan. To leave the camps for good, people were required to show that they had a job or means of support in a community that was not antagonistic toward Japanese. The War Relocation Authority pushed residents deemed loyal to leave. About 16,000 left the camps in 1943, and another 18,500 left the following year.

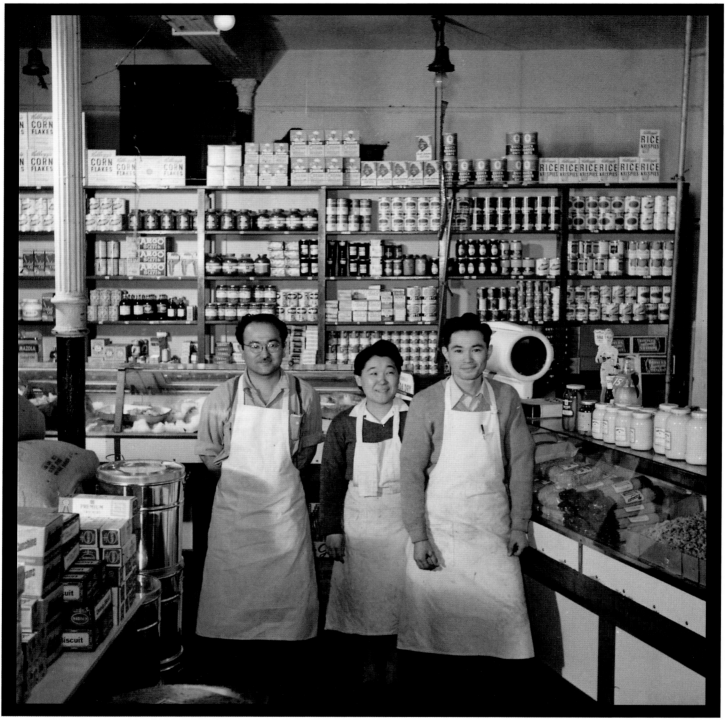

HIKARU CARL IWASAKI CHICAGO, ILLINOIS **SEPTEMBER 19, 1944**

In 1944, photographer Hikaru Carl Iwasaki, a former Heart Mountain inmate, was sent to about twenty-five cities to take pictures of Japanese Americans who had found jobs outside the camps. These success stories offered evidence to those still inside that work was attainable.

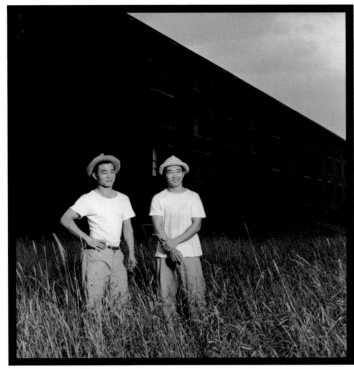

HIKARU CARL IWASAKI WRENTHAM, MASSACHUSETTS AUGUST 1944

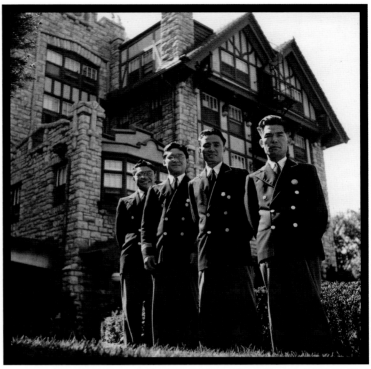

HIKARU CARL IWASAKI EXCELSIOR SPRINGS, MISSOURI SEPTEMBER 22, 1944

Left: Fred Toguri (left), owner of the Toguri Food Shop, poses with his sister June Toguri and employee Masachi Hori at 1012 North Clark Street in Chicago. Fred and June left Gila River in 1943. In 1945, their older sister Iva Toguri D'Aquino was arrested and charged with treason for broadcasting Japanese propaganda aimed at U.S. servicemen in the Pacific. Known as Tokyo Rose, she said she was coerced into working for Radio Tokyo. The first woman in the United States tried and convicted of treason, she spent six years in prison. She worked the rest of her long life at the family store (later called Toguri Mercantile Company) and was granted a pardon by President Gerald Ford in 1977.

Above left: Brothers Ted (left) and Hiroshi Kusudo stand in front of a poultry building at the Redbird Farm in Wrentham, Massachusetts. Ted left Gila River in the summer of 1943; Hiroshi left Rohwer a few months later. They were both chicken sexers, experts in instantaneously determining the sex of newborn chicks. Sexing, invented in Japan in the 1920s, was perfected among Japanese Americans in the 1930s. Separating male and female chicks became vital to the poultry industry because farmers valued females and did not want to waste money raising males. By the 1940s, Japanese Americans dominated the profession to such an extent that hatcheries demanded the release of sexers from the camps.

Above right: Bellhops (from left) Ben Matsunaga, his brother Tom, Bob Nishimura, and Frank Sugiura were all from Poston. Frank's father and brother also worked at the Elms Hotel in Excelsior Springs, Missouri. Employment opportunities there and throughout America were plentiful because so many men who had filled the jobs were off at war.

The Closing of the Camps

For one thing we had no home to return to. Worse, the very thought of going back to the West Coast filled us with dread. What will they think of us, those who sent us here? How will they look at us?

—Jeanne Wakatsuki Houston
and James D. Houston

It took months to shut down the camps. Some inmates were eager to leave and start new lives; others were apprehensive about what was beyond the barbed wire. War Relocation Authority photographers were sent to cover the closing of the camps as well as the resettlement of Japanese Americans back in their home states. Robert H. Ross, a camp administrator, photographed the last days at Tule Lake, where thousands of Japanese Americans endured an arduous last year and hundreds protested their treatment as the war wound down. His painful photos contrast with most in the WRA archive. They provide clues to the complexity of camp life and the range of emotions of those who lived through it.

CHARLES MACE DELTA, UTAH DECEMBER 31, 1944

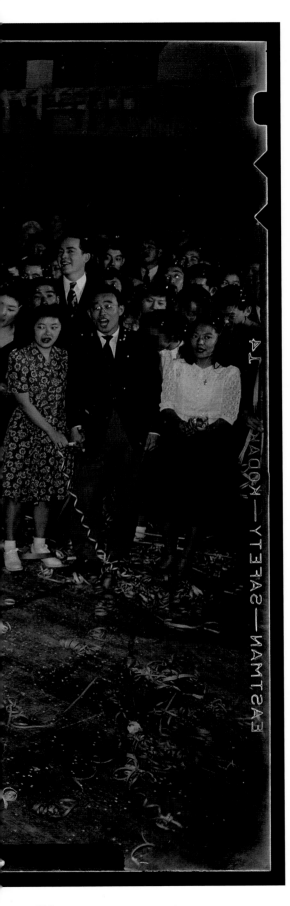

At a New Year's Eve party at Topaz, Japanese Americans celebrate the West Coast being reopened to them. Joseph Aoki played Father Time, and his son, Tommy, was Baby New Year. Project director Luther T. Hoffman wore the 1945 New Year's hat.

Two weeks earlier, Public Proclamation 21 was issued. It allowed most Japanese Americans to leave the incarceration camps and live anywhere. The proclamation came one day before the Supreme Court ruled that the government had no authority to hold "concededly loyal" citizens. Mitsuye Endo, who worked as Hoffman's secretary, had filed the lawsuit in 1942. The government offered to let her leave the camp before the court ruled, but she refused because she did not want to jeopardize the case.

President Franklin Roosevelt opened the camps because he knew that the Supreme Court decision was coming. "There are roughly a hundred—a hundred thousand Japanese-origin citizens in this country," he told reporters in November 1944, "and it is felt by a great many lawyers that under the Constitution they can't be kept locked up in concentration camps." That contradicted the government's position in 1942, when Assistant Secretary of War John McCloy stated that his attorneys could come up with a legal argument to uphold the expulsion of Japanese Americans "in spite of the Constitution." He wrote, "If it is a question of the safety of the country or the Constitution of the United States, why the Constitution is just a scrap of paper to me." Most of the camps stayed open through late 1945.

Baby New Year is now an endocrinologist in California.

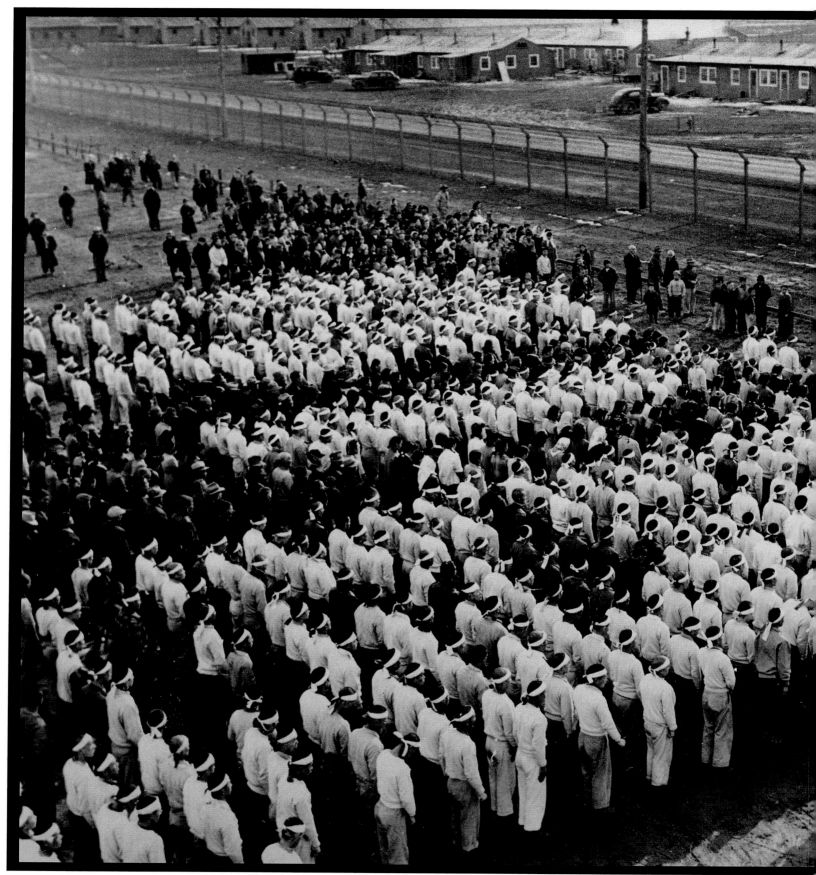

ROBERT H. ROSS NEWELL, CALIFORNIA **JANUARY 26, 1945**

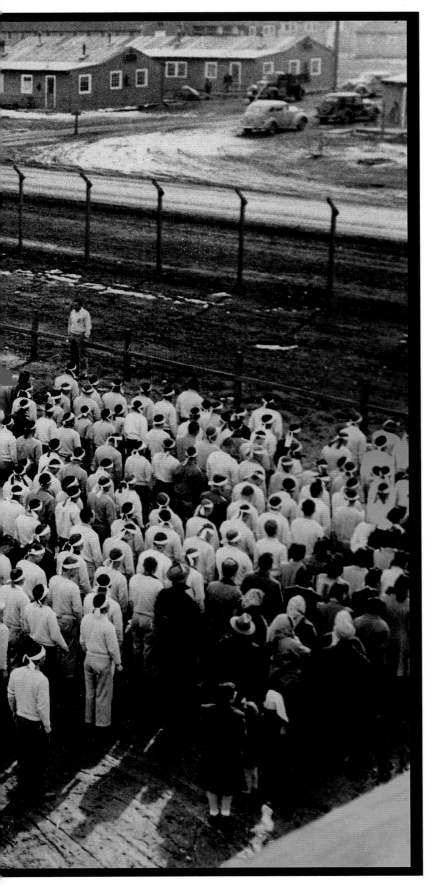

The year 1945 was a different story at Tule Lake. As inmates at other camps were forced to leave, conditions there deteriorated. The loyalty segregation program had swelled its population to almost 18,500—far above capacity. A high double fence was built along its perimeter. Military police were added. Lines of tanks surrounded it.

The militarization provoked a similar response from inmates. Fanatical pro-Japanese groups pressed Nisei to renounce or give up their U.S. citizenship. In a show of strength, hundreds of young men marched every morning. This is one of the few photographs of resistance in the War Relocation Authority archive. Taken by Tule Lake administrator Robert H. Ross, it is captioned: "Members of the Hokoku Seinen Dan gather at Gate 1 to give 'banzai' sendoff to 171 members of their pro-Japan organization being sent to Department of Justice internment camp at Santa Fe, N.M."

Ross, an American born in Japan, was sympathetic to many of the inmates but was critical of a small group of "goose-stepping, bugle-blowing, shouting hoodlums" who made camp life miserable. They frightened and bullied others into believing they would be sent out of camp at short notice into a dangerous world unless they agreed to give up their citizenship. More than fifty-five hundred inmates did so, almost all at Tule Lake. Ross wrote: "A sizable number of those who renounced their citizenship did so with no feelings of disloyalty to this, their native country, but did so merely because they were victims of the mass hysteria which swept the whole community."

Itaru Ina (foreground) was among those who gave up their citizenship. A member of the Hoshi Dan, another group formed to resist the government and promote allegiance to Japan, he was taken to the Tule Lake stockade—a jail within a jail—after protesting camp conditions. He was later sent to the Department of Justice internment camp in Bismarck, North Dakota, where he remained for almost two years.

"He was not a radical, outspoken guy. He was a studious haiku poet," said daughter Satsuki Ina, who was born at Tule Lake. "Anybody who protested was characterized as part of the radical element. Many people who said 'no no' were just in despair."

Itaru and his wife, Shizuku (first shown on page 84), formally renounced their U.S. citizenship. Like other Nisei, they strongly felt their rights had been deprived during the long years of incarceration. The couple and their children were not among the thirteen hundred Japanese Americans who were deported to Japan after the war.

Back in California, Itaru and Shizuku worked as artists, making window displays for jewelry stores. They did not talk about their fight against the government until the 1960s, when daughter Satsuki told them of her plans to take part in a free-speech demonstration in Berkeley. She said, "They worried about me and warned me about the price I might pay."

ROBERT H. ROSS NEWELL, CALIFORNIA **JUNE 24, 1945**

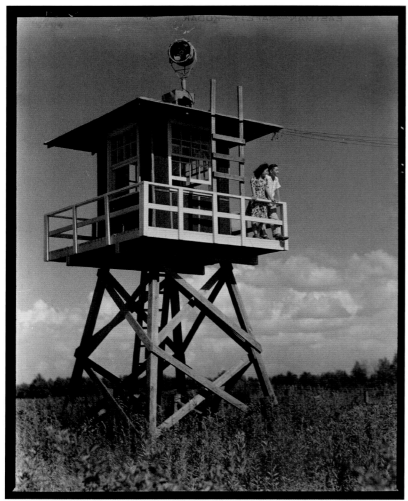

CHARLES MACE DENSON, ARKANSAS **JUNE 19, 1944**

Clara Hasegawa and a friend take a last look from a guard tower at Jerome, the first camp to close. In late June 1944, inmates were sent to other camps. "The towers have not been manned since segregation was completed during the latter part of 1943 and have been popular with the young folks as a place of rendezvous," wrote photographer Charles Mace. Hasegawa was one of fifteen hundred Hawaiians (roughly 1 percent of the ethnic Japanese population of the state) sent to an incarceration center on the mainland. Japanese workers were allowed to remain because they were considered essential to the Hawaiian economy. Hasegawa and her family returned to Hawaii after the war.

Right: Photographer Hikaru Carl Iwasaki and a WRA staff member look over a drainage ditch at Jerome. The camp closed eleven days later.

198

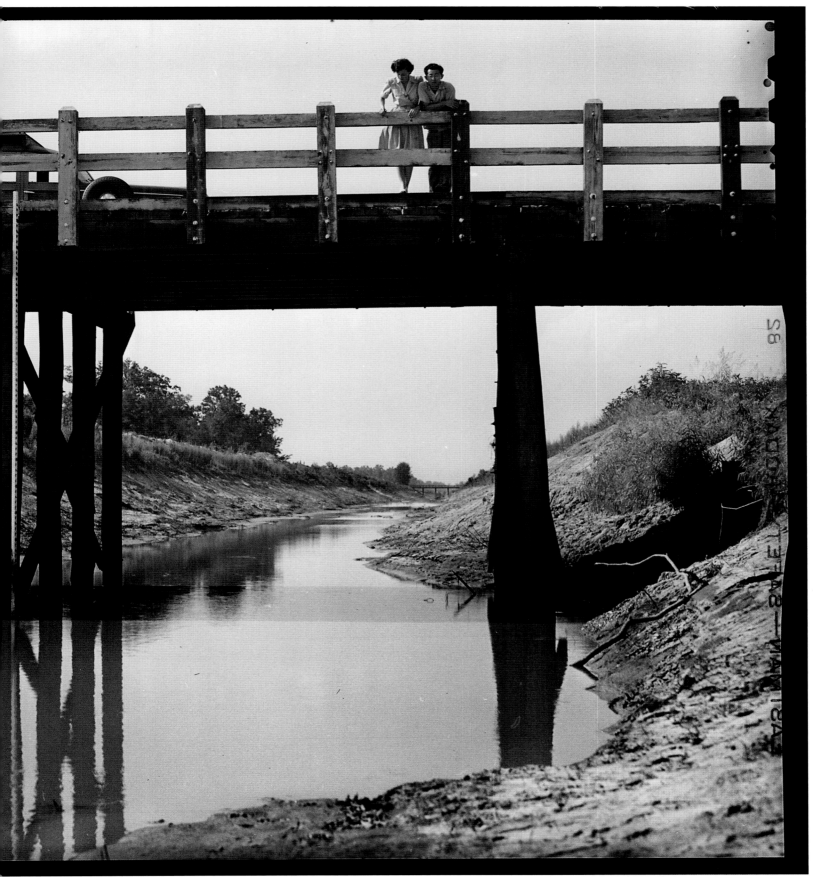

CHARLES MACE DENSON, ARKANSAS **JUNE 22, 1944**

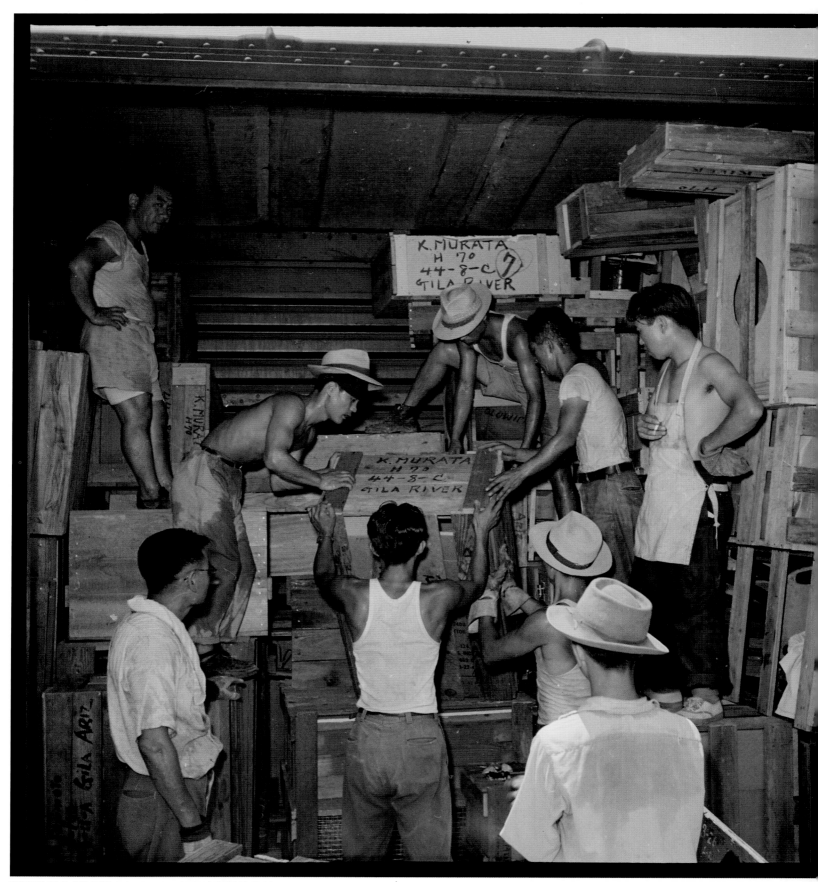

HIKARU CARL IWASAKI DENSON, ARKANSAS **JUNE 19, 1944**

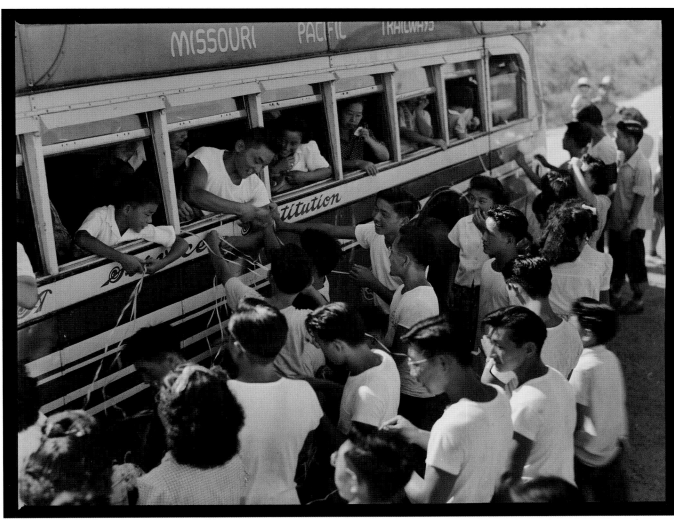

CHARLES MACE DENSON, ARKANSAS JUNE 22, 1944

Students at Jerome's Denson High School bid farewell before their move to Rohwer. "We use slang, chew gum, go on dates, wear bobby socks and dirty saddle [shoes] and jitterbug and we are almost sentimental in our honor of Old Glory," students wrote in the 1944 Denson yearbook. In her valedictory address, "Land of (Unequal) Opportunity," Betty Kagawa was more serious. "It is up to us to win not merely a tolerant attitude but full acceptance and welcome in any community in the land," she told her class. "We must convince all with whom we come in personal contact that we are true Americans by our speech, thought, and actions."

Left: A boxcar is packed with the possessions of Kanichi and Kikuye Murata at Jerome. Inmates could choose where they would be moved. Some wanted to be reunited with friends; others sought a certain climate. The Muratas went to Gila River and returned to Hawaii in late 1945. Kanichi worked as a Japanese-language announcer at a local TV station in Hawaii, and his wife was a Japanese-language teacher. She died in 2010 at the age of 99.

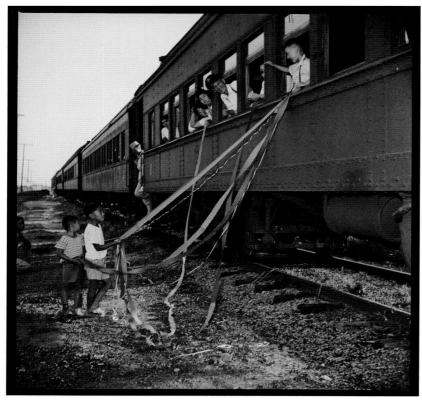

CHARLES MACE DENSON, ARKANSAS JUNE 19, 1944

The closing of the camps was an emotional experience. "A sentimental custom still practiced by many when friends part is the trailing of paper streamers from the car windows," wrote Charles Mace. "The parties hold tightly to the ends of the tape until it is broken by the movement of the train, thus in a sense prolonging the hand clasp." Most of the Jerome inmates were sent by bus to nearby Rohwer or by train to Gila River or Granada.

Right: Camp residents return to their homes at Jerome after seeing friends off. Dave Tatsuno's 1945 footage from Topaz shows similar scenes. "After they leave, all the people who are left behind feel quite forlorn and have to go back to their barracks," Tatsuno said. Jerome, which mostly held Japanese Americans from California and Hawaii, closed on the last day of June 1944. It was turned into a prisoner-of-war camp for German soldiers and SS officers. Most all that remains is a smokestack from the hospital incinerator.

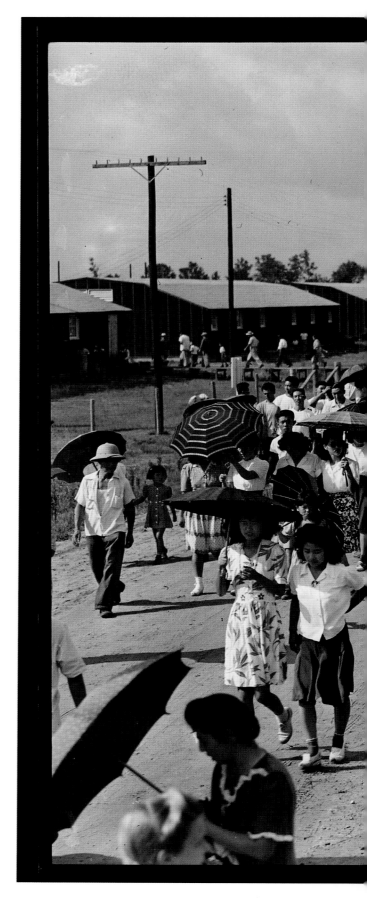

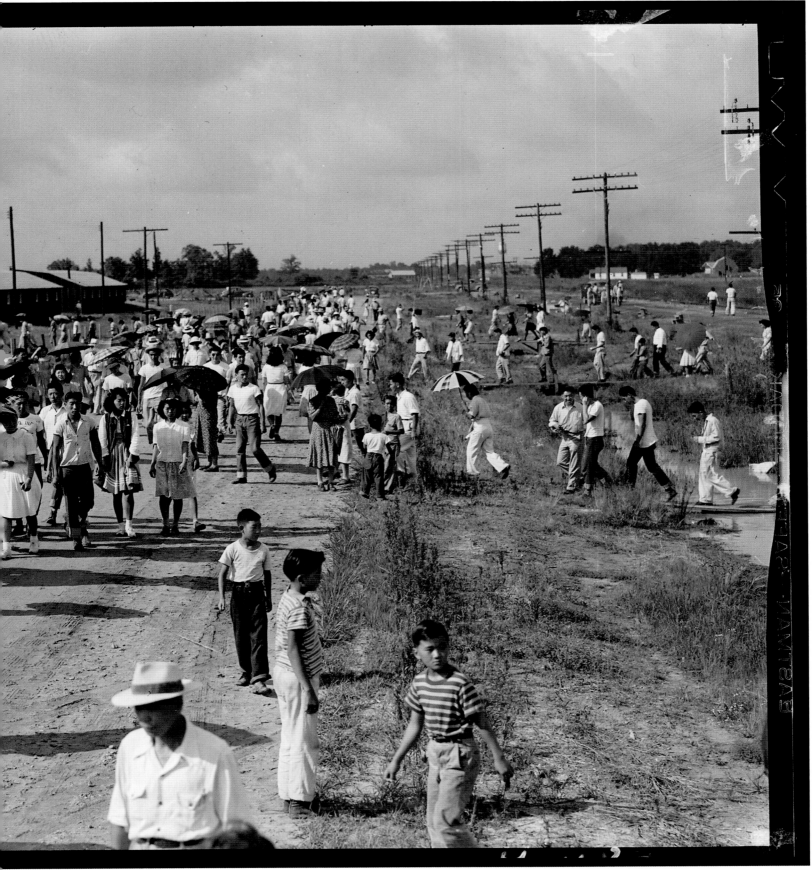

CHARLES MACE DENSON, ARKANSAS JUNE 22, 1944

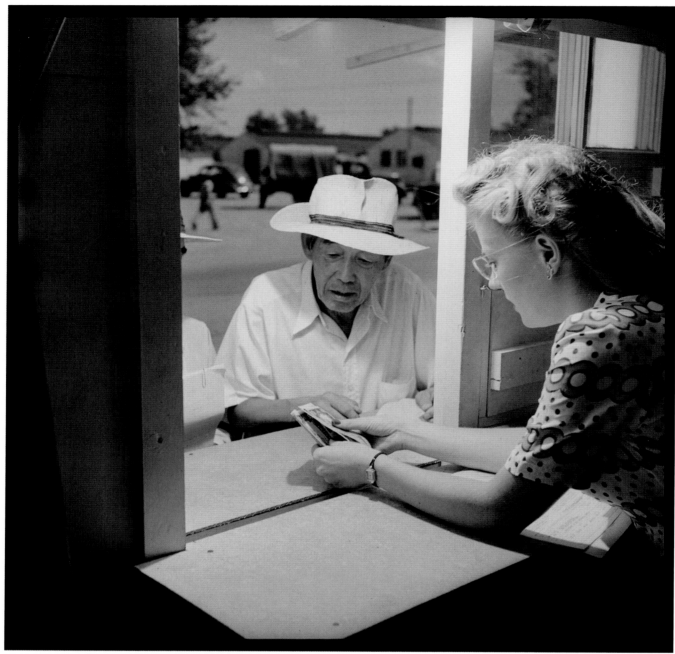

HIKARU CARL IWASAKI POSTEN, ARIZONA SEPTEMBER 1945

Upon leaving, all inmates, including this man at Gila River, received twenty-five dollars, a ticket back home, and modest travel expenses.

Right: Inmates file out of the camp at Poston. "Now that so many of their friends have gone out before them, it is with a feeling of anticipation rather than one of sorrow that the evacuees prepare to leave the place which for three years has been home to them," wrote photographer Iwasaki. His mother, Hisako, and younger sister, Akiko, were released from Heart Mountain in June 1945 and returned to their hometown of San Jose, California.

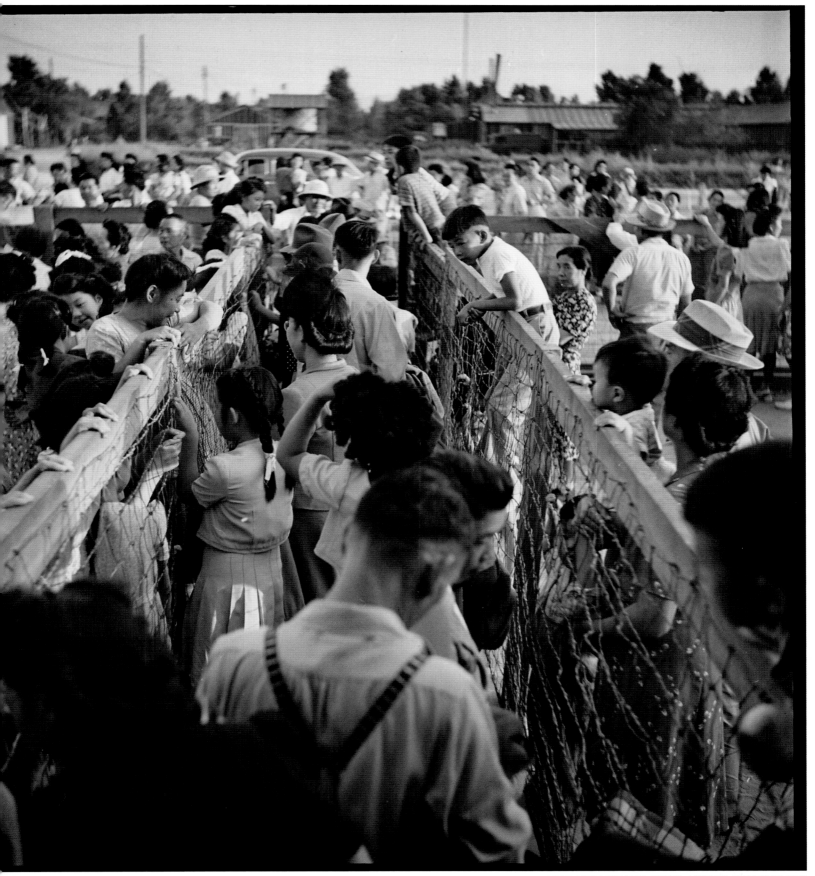

HIKARU CARL IWASAKI RIVERS, ARIZONA SEPTEMBER 1945

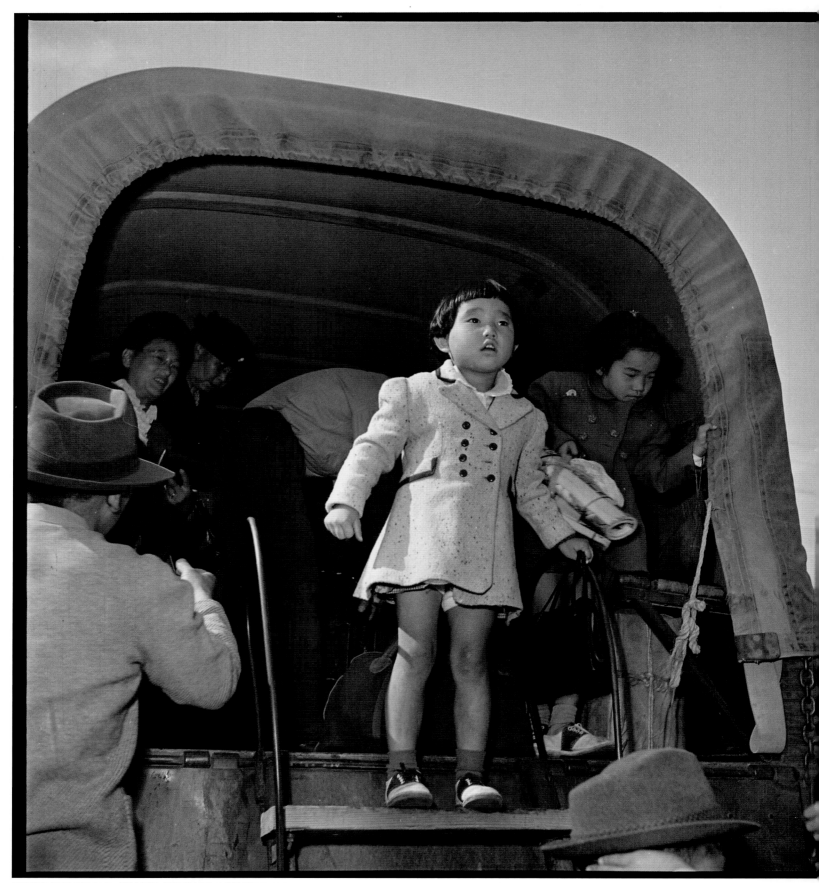

HIKARU CARL IWASAKI AMACHE, COLORADO OCTOBER 5, 1945

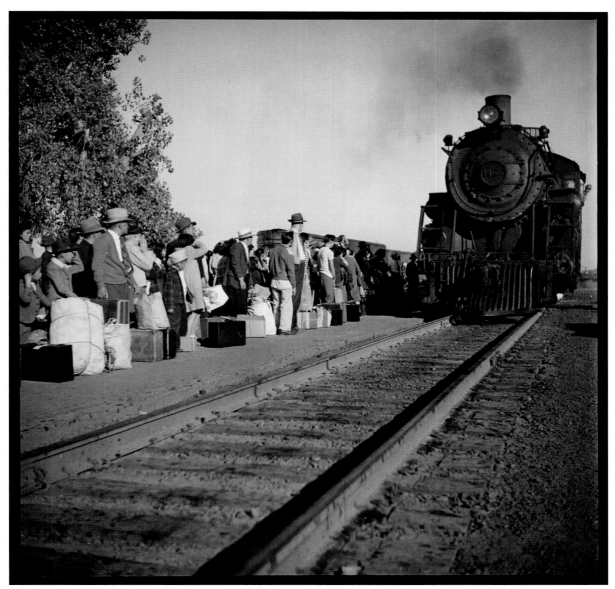

Left: Granada inmates arrive by truck at the Atchison, Topeka and Santa Fe railroad depot for the trip back to California.

Above: The last of the Granada inmates wait for the train that will take them to Sacramento and surrounding towns. Granada, the smallest of the ten camps, closed on the day this photo was taken. Two days later, the *Rocky Mountain News* columnist Lee Casey wrote that its closing marked the end of an incident for which "we should be thoroughly ashamed."

Returning to California from Poston was traumatic for 21-year-old Kiyo Sato. "My train heads west into what was the 'restricted zone' from where we were evicted," wrote Sato in her memoir, *Dandelion Through the Crack.* "Terrible thoughts keep crowding into my brain."

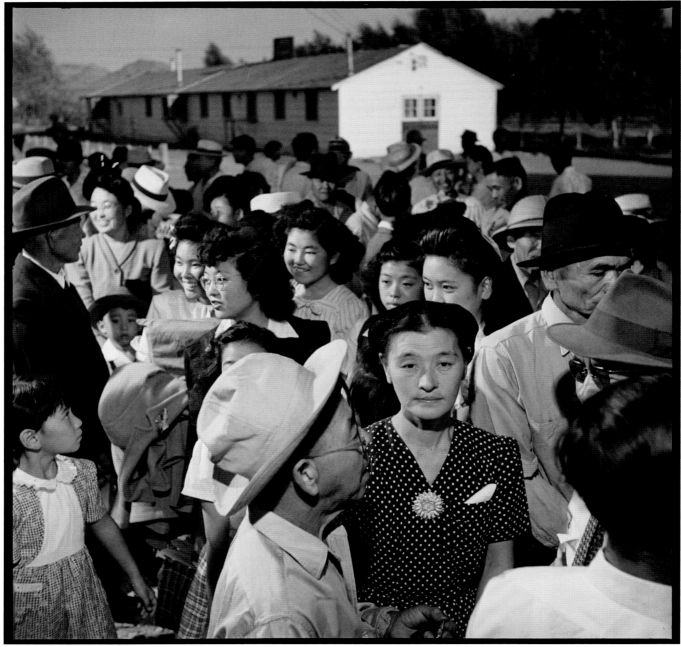

HIKARU CARL IWASAKI POSTON, ARIZONA SEPTEMBER 1945

Former Poston inmates on their way to the bus station line up to receive their cash grant and tickets. The camp consisted of three separate units, nicknamed Roasten, Toasten, and Dustin because of the heat and dust. Two of the units closed in September 1945. The third closed two months later.

Right: A woman—probably Ichi Tanaka, based on the original caption—takes the train home to Los Angeles from Poston. Tanaka, who immigrated in 1920 and became a U.S. citizen in 1954, was accompanied by her husband, Masaichi, and their daughter, Shieko, according to camp records.

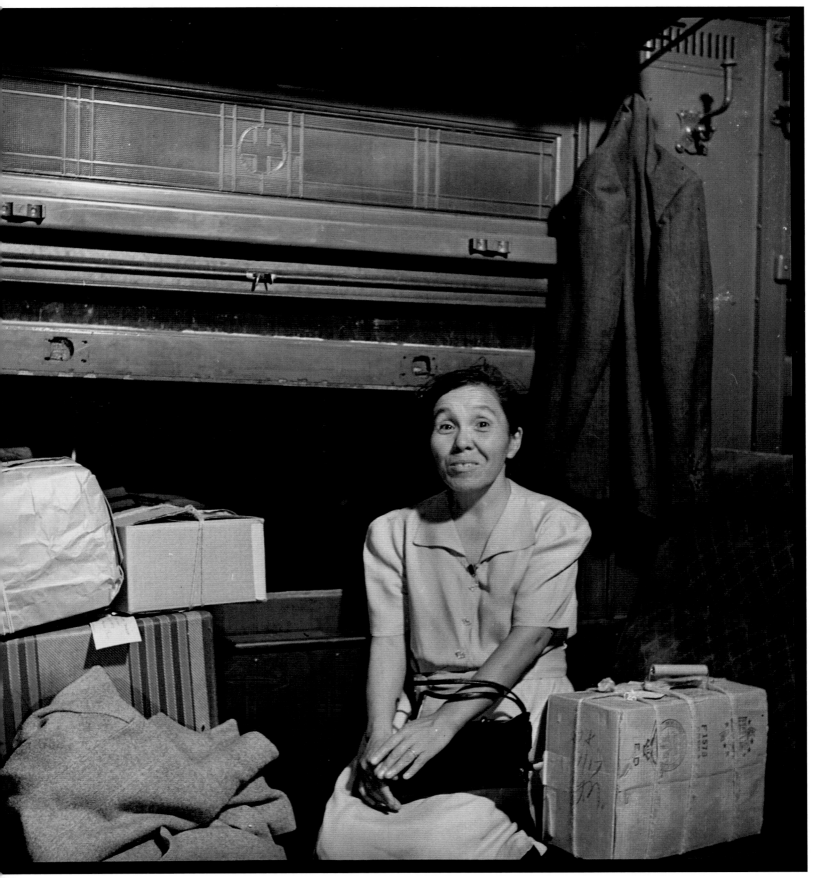

HIKARU CARL IWASAKI POSTON, ARIZONA SEPTEMBER 1945

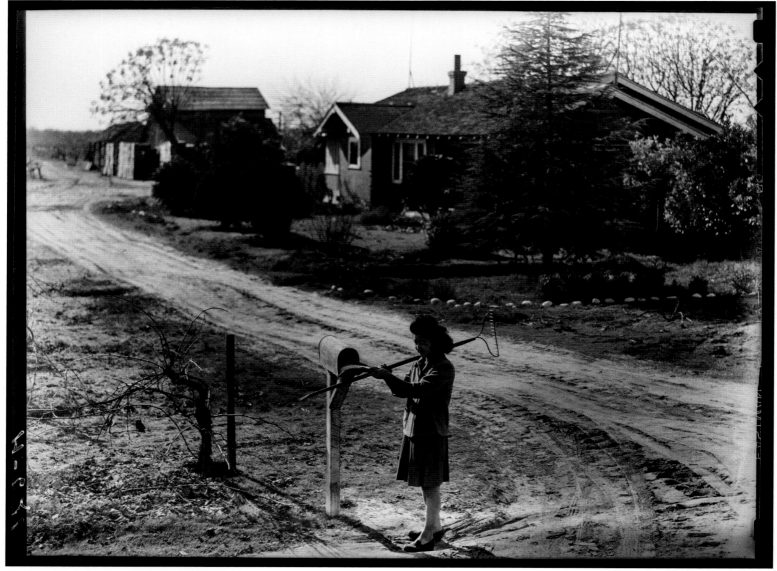

CHARLES MACE SELMA, CALIFORNIA JANUARY 19, 1945

Sixteen-year-old Priscilla Morishige returns to her family's vineyard near Selma, California. Recalling the day photographer Charles Mace knocked on their door, she said, "I'm not sure why he chose our family. Perhaps it was because we were so Americanized." She and her younger sister, Marlynne, were third-generation Japanese Americans. Before the war, their father, James, worked as an auto mechanic and bought his hundred-acre farm in parcels. He continued his work upon their return.

The family left Gila River on the last day of 1944. They'd heard reports that returning inmates were not being welcomed in California, but they didn't worry. "Things like that never entered our minds," Priscilla said. They had no problems. Their vineyard had been taken care of by friends. Priscilla later met and married Joseph Ishizaki, who had fought with the 442nd Regimental Combat Team. "He was a restaurant man, and we moved to San Francisco," she said. He started Yamato, one of the nation's first gourmet Japanese restaurants.

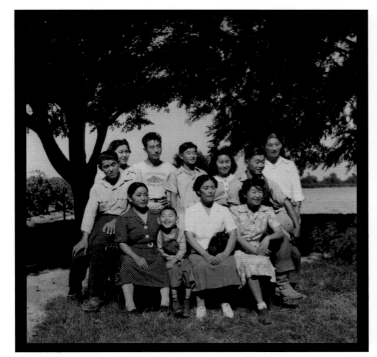

Top left: The homecoming experience was quite different for the extended Masada family (front row, from left: Nobuye, Tokio, Kyo, and Miyoko; back row, from left: Katsumi, Lily, Ted, Saburo, Aiko, Toshihiro, and Harold). Late one night about a month after the family's return to Caruthers, California, a group of vigilantes fired five or six gunshots into their home. Lily was reading at a table in the living room; a bullet struck the table leg, but she was not injured.

The shooting was one of thirty-six "terrorism incidents"—shootings, arson attempts, threatening visits, even an attempted dynamiting—reported by the War Relocation Authority against returning Japanese Americans in 1945. The violence wasn't always physical. The Masadas were invited to Easter services at a local church but were later told by the minister that his congregation would not attend if they showed up again. The family next tried a Methodist church. "They were not received warmly, but at least they were civil and didn't object to our coming," recalled Saburo, who was 15 at the time. A church board member refused to shake the hand of his sister Miyoko. "A few weeks later, his son, Dick, a classmate of Toshihiro back on furlough, came to the church and gave my brother a big hug. When he saw this, the board member went up to my sister and said, 'If my son in uniform could welcome you people like this, I have no right not to extend my hand to you.'"

Top right: Toshihiro checks the grapes in his vineyard. "The WRA took photos to show people in camp they would be welcome back on the West Coast," said Saburo, who became a Presbyterian minister. "That was not entirely the case. Thousands had nothing to come back to because we were forced to get rid of our homes in forty-eight hours." The agency's caption for this picture mentioned the shooting but concluded, "In spite of the incident, the family is glad to be home again."

HIKARU CARL IWASAKI SACRAMENTO, CALIFORNIA AUGUST 8, 1945

Rokutaro Nakamura, who left Granada in April 1945, returns to his furniture and hardware store in Sacramento, California. He also ran a store in nearby Woodland, which he boarded up when he and his family were sent to the Merced Assembly Center. He could not make the mortgage payments, but a local banker, Elmer Armfield, kept the store in his name. Nakamura Brothers is still in business, at 924 Main Street in Woodland, run by Rokutaro's grandson Alan.

Right: Neighbors join husband-and-wife physicians Toshio (second from right) and Tsutayo (right) Ichioka as they return to their clinic, where they worked with Tsutayo's sister, Satsuki Nakao (third from right), a pharmacist. They served the poor of East Los Angeles until 1975. "They had tremendous drive, then after retirement lived like frugal hermits," recalled nephew George Hori. The women established a trust that provides scholarships to University of Southern California medical and pharmacy students.

CHARLES MACE LOS ANGELES, CALIFORNIA MAY 22, 1945

TOM PARKER BURBANK, CALIFORNIA **NOVEMBER 1945**

After three years in the camps, thousands of Japanese Americans returned to the Los Angeles area with no money and no jobs. To provide them affordable housing, the War Relocation Authority erected temporary living quarters in Hawthorne, Santa Monica, El Segundo, Long Beach, Lomita, Sun Valley, and Burbank.

The converted army barracks at the Magnolia Housing Project, at Magnolia Boulevard and Lomita Street in Burbank, must have looked familiar to the residents. Thirty-five families from Heart Mountain moved into the tarpaper barracks in November 1945. Neighbors fought the housing project, but Paul Robertson, head of Los Angeles's WRA office, assured them that it would be short-lived. "The barracks will be partitioned into square rooms provided with no furniture except cots," he said. "These people will move as soon as they can find other homes and jobs."

But jobs were scarce and discrimination was rampant. Restrictive covenants ruled out many neighborhoods, and exclusionary loans made it challenging to finance homes. Magnolia closed in May 1946, but at least one housing project remained open for ten years.

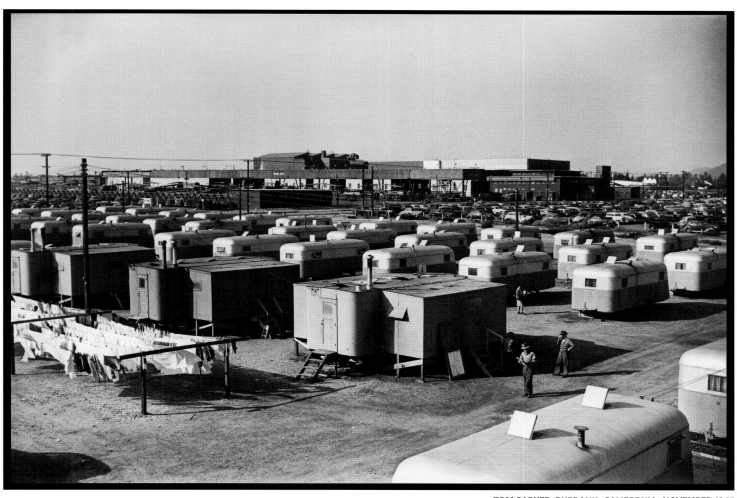

The trailer homes provided at the Winona Housing Project in Burbank had no electricity, gas, or plumbing. As they had been at the camps, toilet and shower facilities were shared. Unlike at the camps, there were no mess halls. And the newly returned faced another problem: They were often refused service at restaurants and stores. To help, the government set up soup kitchens. In addition, many Japanese Americans did the unthinkable and went on welfare.

Once again, newspapers blamed Japanese Americans. Wrote the *Los Angeles Times* in May 1946: "Japanese-Americans, maelstrom of problems during the war, yesterday created a headache for Los Angeles County after 513 of them, according to county officials, were taken to an unprepared camp at Burbank where no provision had been made for food."

Anthropologist Tom Sasaki wrote that 194 families occupied three hundred trailers in Burbank. (Large families were split up among the tiny trailers.) One year after the trailer park was opened, he wrote: "The camp is still a dismal place."

HIKARU CARL IWASAKI AMACHE, COLORADO OCTOBER 1945

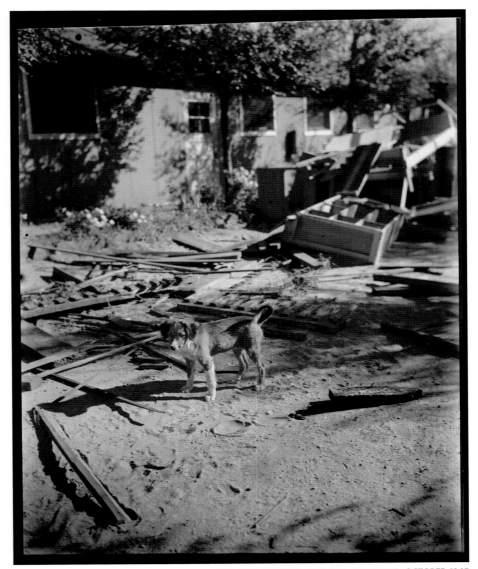

HIKARU CARL IWASAKI AMACHE, COLORADO OCTOBER 1945

Photographer Hikaru Carl Iwasaki surveyed Granada just after it closed. "Even this dog, which has spent many a happy hour playing with the children in the center, has a deserted and forlorn look as though he too realizes the end of his time, as well as that of the center, has come," he wrote. Although Japanese Americans were not allowed to bring pets, hundreds of dogs and cats roamed the camps.

Left: Items left behind included tables, benches, and chairs. "The trees were planted by the evacuees to provide shade on the sandy, sun baked soil," wrote Iwasaki, noting that temperatures reaching 120 degrees were not uncommon.

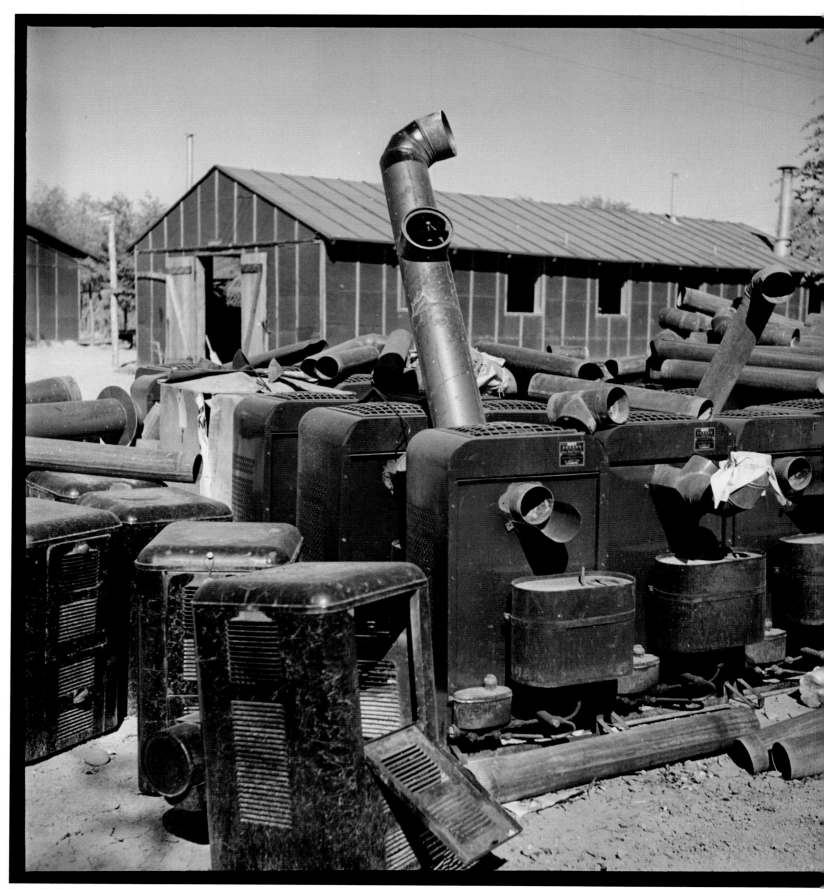

HIKARU CARL IWASAKI POSTON, ARIZONA SEPTEMBER 1945

HIKARU CARL IWASAKI POSTON, ARIZONA SEPTEMBER 1945

Sally Tunah was one of seventy-eight Hopis moved by the government to the Colorado River Indian Reservation in September 1945. During their last months at Poston, a welcoming committee of Japanese American inmates greeted them. "They moved into one of the blocks and seem to like it very much," Hikaru Carl Iwasaki wrote of the Hopis, who for the next several years lived in a few of the camp's old barracks and used the larger buildings for schools and offices. They also made use of the other improvements, including plumbing and electricity, roads and bridges, and a seventeen-mile irrigation canal.

Left: Stoves pile up at Poston as the camp closes. Although Native Americans kept some of its buildings, most of the incarceration camp was eventually razed. The road grid and building foundations are long gone. The tribal land on which the camp was located is now gated and locked, but the Poston Memorial Monument, built in 1992, can be visited.

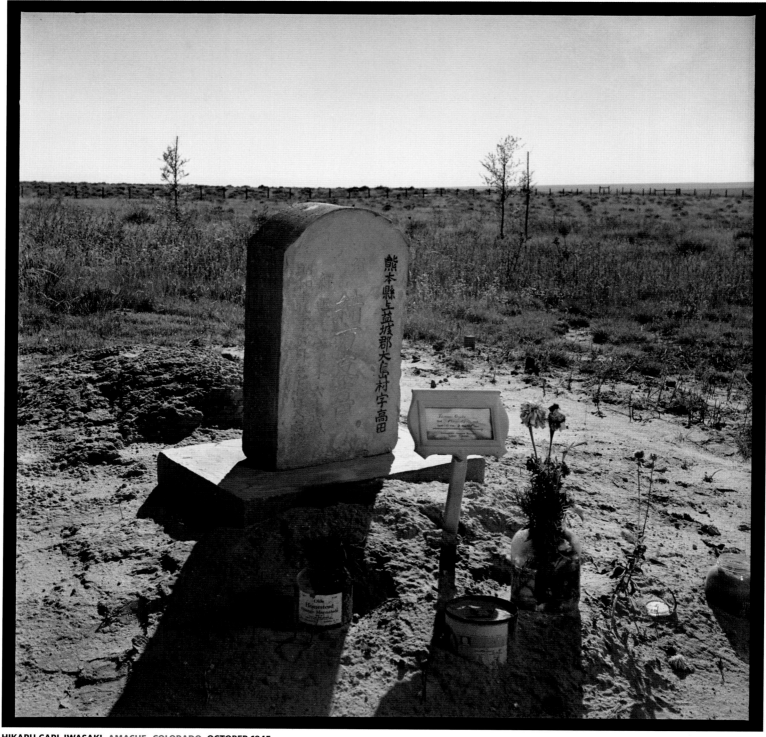

HIKARU CARL IWASAKI AMACHE, COLORADO OCTOBER 1945

Before leaving Granada, Hikaru Carl Iwasaki stopped to photograph the gravestone of Tomoki Ogata. Born in Japan in 1883, he was a bachelor who spent most of his life working as a farmhand in California, where he immigrated in 1897. As required by law, he registered for the Selective Service in 1918 and again in 1942. He was removed from Hughson, California, to the temporary detention center in Merced, California, and was later taken to Granada, where he died in 1944.

Epilogue

The War Relocation Authority was shut down in 1946. The photos taken by the photographers it hired were sent to the National Archives, where they remain today.

The experience took a toll on Dorothea Lange. She was upset by what she saw and—perhaps as a result—suffered severe stomach problems that sidelined her off and on for years. She considered her 1942 photographs a failure until she studied them at the National Archives years later. She died in 1965 at the age of 70.

Clem Albers, who worked only a month for the WRA, accepted a commission with the U.S. Maritime Service. He returned after the war to the *San Francisco Chronicle,* where he was a photographer until 1981. He died in 1990 at 87. Charles Mace worked as a commercial photographer in Denver until the 1960s. He died in 1973 at 83. Tom Parker, the sole WRA photographer to continue working for the government after the war, spent years as a State Department photographer. He died in 1976 at 68.

Francis Stewart opened a commercial studio in San Francisco, but his career was cut short by a neurological condition. "I think the work affected him greatly," said his son Gene of his father's abrupt departure from the WRA. Stewart never talked to his family about the work. He died in 1992 at 82.

Hikaru Carl Iwasaki's work for the WRA propelled him into a career shooting for magazines, mostly *Time, Life,* and *Sports Illustrated.* Born in 1923, Iwasaki, the only surviving WRA photographer, lives in Denver. "I think most Americans don't know anything about this," he said. "That is the sad part of it."

Ansel Adams, celebrated as the country's premier nature photographer, said his Manzanar work was the most important of his life. He died in 1984 at 82.

Sacred Ground

Tomoki Ogata's gravestone (pictured on page 220) three decades later in Grenada, Colorado.

ANSEL ADAMS UNDERSTOOD nature's cycles, and the photographer saw similar changes ahead for the camps. "When all the occupants of Manzanar have resumed their places in the stream of American life," he predicted, "these flimsy buildings will vanish, the greens and flowers brought in to make life more understandable will wither, the old orchards will grow older, remnants of paths, foundations and terracing will gradually blend into the stable texture of the desert."

Decades after he wrote that, another photographer, Joan Myers, traveled to the sites of each of the ten incarceration centers to see what was left. Her interest was sparked in 1981, when she stopped to visit the Manzanar National Historic Site. As she walked the grounds, she noticed the concrete footings of guard towers, the crumbling steps of barracks, a toy car buried in the sand. That day, she decided she would return with a large-format view camera to document the remains.

Over the next four years, Myers journeyed to forlorn areas of the West and Midwest. "Everywhere some trace remains: a sewage treatment plant at Jerome, Arkansas; the cemetery at Rohwer, Arkansas; a schoolhouse built by internees at Poston, Arizona," she wrote. Granada—where she found cottonwood trees that had been planted by inmates and Tomoki Ogata's gravestone tipped over in the cemetery—was "dark and full of stories." Like the inmates themselves, she confronted dust storms, snakes, and mosquitoes. The resulting photographs first appeared in the book *Whispered Silences*. A sampling is shown on the following eight pages and the one opposite.

Tule Lake closed in March 1946. Later that year, the Department of Justice's internment camp in Crystal City, Texas, where the last Japanese Americans were held, finally closed.

The incarceration was over, but its effects lingered.

Token payments for damages were sent to Japanese Americans a few years after the war ended. The Immigration and Nationality Act of 1952 made it possible for the first time for foreign-born Japanese to become U.S. citizens, and an estimated forty thousand Issei who had lived through the camps did so.

In 1976, President Gerald Ford rescinded—but offered no apology for—Executive Order 9066. Twelve years later, President Ronald Reagan signed the Civil Liberties Act of 1988, which acknowledged the "fundamental injustice" of the government's exclusion program—and offered a formal apology on behalf of the people of the United States. The act declared that the government's policies were "motivated largely by racial prejudice, wartime hysteria, and a failure of political leadership." More than eighty-two thousand Japanese Americans whose lives were disrupted were each given $20,000.

In 1992, on the fiftieth anniversary of the signing of Executive Order 9066, Manzanar was established as a national historic site. The National Park Service acquired Manzanar in 1997 and has since acquired Minidoka and Tule Lake. Local museums operate at Granada, Heart Mountain, Jerome, Rohwer, and Topaz. Access is limited at Gila River and Poston, which are both on American Indian reservations in Arizona.

Fewer artifacts remain now than when Joan Myers finished her work in 1985. Ansel Adams knew that the Manzanar gate and cemetery monument would one day be viewed as "desert ruins." He wrote in *Born Free and Equal* that the wind and snow and summer sun would struggle to repossess the site. "Yet we know that the human challenge of Manzanar will rise insistently over all of America—and America cannot deny its tremendous implications."

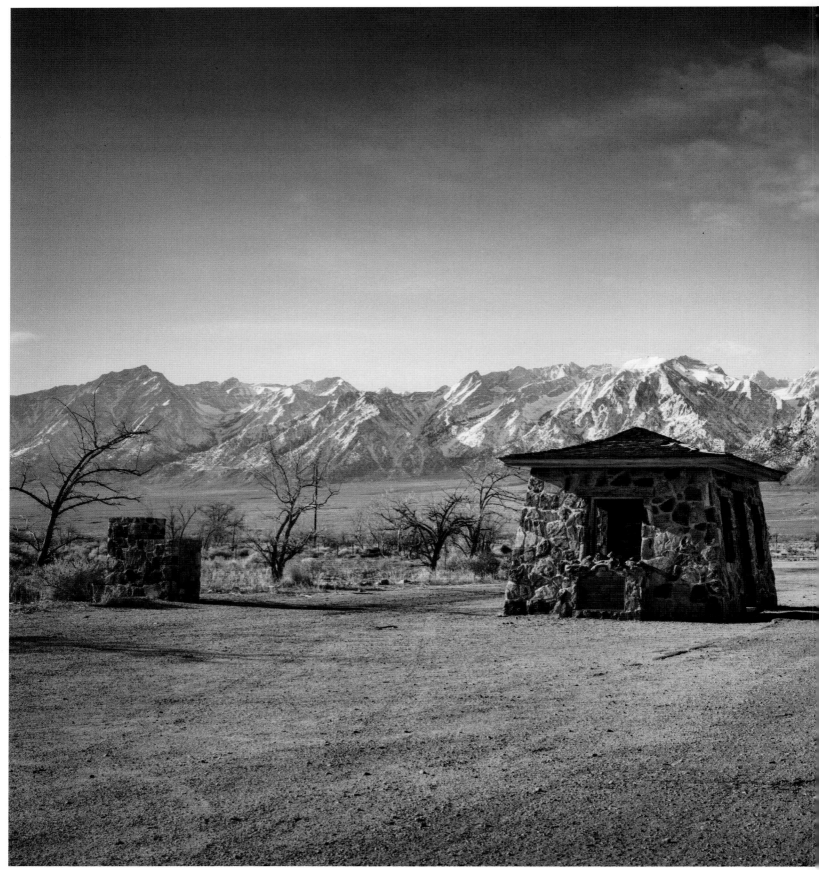

ENTRY STATION, MANZANAR, CALIFORNIA

ENTRANCE GUARD STATION, MINIDOKA, IDAHO

SPOON AND CHINA

POWER PLANT SMOKESTACK, JEROME, ARKANSAS

MEMORIAL TO CAMP SOLDIERS, GILA RIVER, ARIZONA

DEBRIS, HEART MOUNTAIN, WYOMING

STOVEPIPES, TOPAZ, UTAH

TULE LAKE, CALIFORNIA

BICYCLE SEAT

PET GRAVE, ROHWER, ARKANSAS

FLYSWATTER

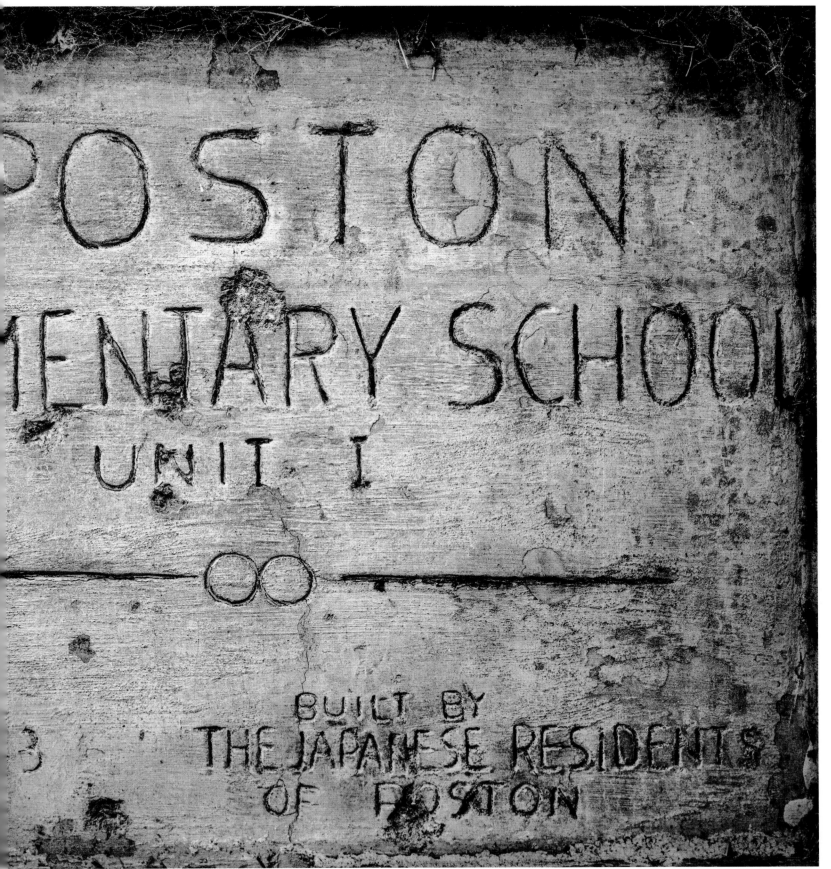

SCHOOL BUILDING PLAQUE, POSTON, ARIZONA

Backstory

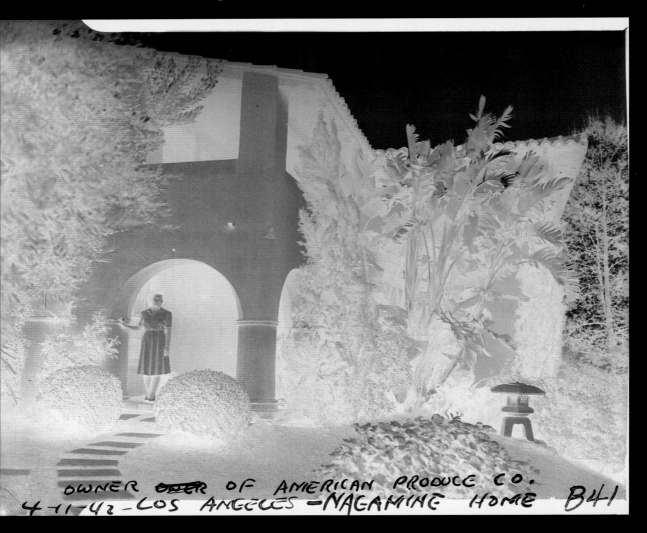

OWNER OF AMERICAN PRODUCE CO.
4-11-42-LOS ANGELES -NAGAMINE HOME B41

WAR RELOCATION AUTHORITY NO: /B-41
Midland Savings Bldg.
Denver, Colo. DATE: 4/11/42

PHOTO LOCATION: Los Angeles, California

DATA: The Nagamine residence prior to evacuation of people of Japanese ancestry from this area.

Photographer: CLEM ALBERS

A negative, original print, and caption. For the first time, the negatives have been shown full frame.

FINDING THESE PHOTOGRAPHS and the subjects of the photographs was a treasure hunt. We were aided by dozens of people who saw the importance of this project.

Our most valuable resources were records kept by the National Archive and Records Administration, particularly the Final Accountability Rosters of Evacuees at Relocation Centers and the Japanese-American Internee Data File, both available online. A huge selection of government photos of the incarceration can be searched online through the National Archives' Central Photographic File of the War Relocation Authority. High-resolution images of most of these photographs can be found on Wikimedia Commons. Original prints can be found in the Still Pictures Research Room of the National Archives in College Park, Maryland—one of our favorite places to work.

For basic caption information, we depended on the online War Relocation Authority photo and caption collection maintained by the University of California, Berkeley, which we accessed through the Online Archives of California. The collection is titled War Relocation Photographs of Japanese-American Evacuation and Resettlement. The Online Archives of California also has an extensive collection of textual material on the incarceration.

For data about the incarceration we relied on Densho: The Japanese American Legacy Project, an essential Seattle-based organization that offers a vast collection of digital interviews of camp survivors and a huge archive of scanned images and documents on its website Densho.org.

This project could not have been completed without the aid of the genealogical website Ancestry.com. It helped us track down basic information about the subjects of these photographs by providing us with federal census records through 1940, government records, high

school yearbooks, birth and death certificates, and death notices. These records led us to our subjects or their families. Telephone databases helped us make the final connections.

The following offers information about how we put together the introduction and many of the captions and adds supplemental facts.

FRONT MATTER:

Lawson Fusao Inada and his family were sent to the Fresno Assembly Center in California, and later to permanent incarceration centers in Jerome, Arkansas, and Granada, Colorado. His quote is from *Only What We Could Carry: The Japanese American Internment Experience* published by Heyday Books in 2000. He served as the poet laureate of Oregon from 2006 to 2010.

All of the photographs in this section along with the endpapers were taken by Ansel Adams at Manzanar Relocation Center in California in 1943 and 1944. He provided the identifications.

INTRODUCTION:

Page 20: Tamotsu Shibutani's observations are from "The Initial Impact of the War on the Japanese Communities in the San Francisco Bay Region," a paper he authored for the University of California, Berkeley, in 1942.

Page 21: The Justice Department's admission that it lacked evidence against the Japanese American community is from a May 1942 memo written by U.S. Attorney General Francis Biddle to President Franklin D. Roosevelt.

Page 23: Dorothea Lange's extended quotes are from oral interviews conducted in 1960 and 1961 by the Regional Oral History Office of the University of California, Berkeley, and in 1964 by the Smithsonian Institution's Archives of American Art.

Page 24: Christina Gardner's recollections are from a 1992 video interview housed at the Washington University Film and Media Archive.

Page 25: Edwin Bates's description of army accusations against Dorothea Lange is from a recently discovered letter in the possession of Gene Stewart, son of War Relocation Authority photographer Francis Stewart.

Page 26: A letter detailing photos to be impounded by the army by Captain H. C. Braden was discovered in the WRA text records at the National Archives in Washington, D.C.

Page 28: The War Relocation Authority's determination that the army could no longer censor its photographs is from an October 1942 opinion by WRA Solicitor Philip M. Glick. It is in the Claremont Colleges Library in Claremont, California.

Page 31: The shooting script was found in the WRA text records at the National Archives.

Page 31: Ansel Adams's extended quotes are from oral interviews conducted in 1972, 1974, and 1975, by the Regional Oral History Office of the University of California, Berkeley.

Page 36: Tom C. Clark's post-incarceration quote is from a preface that he wrote in *The Bamboo People,* published by Publisher's Inc. in 1976. His contemporary comments can be found in the February 23, 1942, transcript of the House Select Committee Investigating National Defense Migration.

Page 36: Excerpts of Earl Warren's attack on Japanese Americans were from the February 21, 1942, House Select Committee Investigating National Defense Migration. His later reflections are from *The Memoirs of Earl Warren,* published by Doubleday in 1977.

CHAPTER 1:

Page 38: Kiyo Sato's memoir *Dandelion Through The Crack* was published by Willow Valley Press in 2007. It was re-published as *Kiyo's Story* by Soho Press in 2009.

Page 41: Maremaro Shibuya was listed in the original caption furnished by photographer Dorothea Lange. We contacted him by phone and he told us about the day Lange took his family's photograph. Correspondence between Lange and his sister Masago Shibuya is in the Dorothea Lange Papers Relating to the Japanese-American Relocation. The collection is in the Bancroft Library of the University of California, Berkeley. The family's house, at 1430 Grant Road in Mountain View, California, was sold and moved so that a shopping center could be built. The house is now at 1271 Phyllis Avenue in Mountain View.

Page 42: Online business records filed in 1947 led us to Shizuko Sumi as the president of the Union Paper and Supply Company, the firm scratched on the negative by photographer Clem Albers. An obituary showed Sumi died in early 2016. Her daughter Kazuko Anderson led us to Shizuko Sumi's sister, Akiko Sumi Honda, who was the subject of the photograph. Honda and Anderson filled in family details. The house at 3043 Landa Street in Los Angeles still exists.

Page 45: Caretaker Mary Ogawa was identified in another photograph of the Nagamine residence taken by photographer Clem Albers. The 1940 census listed her as working for Haruyuki and Yone Nagamine. Google street views showed that the address in the census, 1921 Redcliff Street in Los Angeles,

was the same house in the photograph. FBI records stated that Haruyuki Nagamine was arrested on December 7, 1941. Records provided by Priscilla Wegars, of the University of Idaho's Asian American Comparative Collection, showed Haruyuki was an inmate at the Kooskia (Idaho) Internment Camp, run by the Immigration and Naturalization Service for the Department of Justice. Wegars provided us with his case file.

Page 48: Sam Mihara, a national lecturer on the incarceration, discussed his boyhood at Raphael Weill Elementary School in San Francisco.

Page 51: Dorothea Lange misspelled Rachel Kuruma's name in her original caption. The photograph is one of the iconic images of the incarceration, but Kuruma had never seen it before. After we identified her through alternate spellings, we met her in San Francisco and shared the photograph. We later sent her a copy. Hisashi John Kobayashi, identified by Sam Mihara, talked about the flag-raising ceremonies.

Page 54: The Mitarai family was identified in the caption by Dorothea Lange. Each of the four sisters is alive and was contacted by phone. Jeanette Misaka, the oldest, provided background about the family and recollections of the day the family was photographed.

Page 57: The Kubota farm was identified in another photograph, which showed the mailbox belonging to "K. Kubota, Rt. 1 Box 353 Mt. View." The 1940 census helped identify the family, and Candace Bowers of the Mountain View Public Library helped track down the house. We could never locate any family members. The quote "We're charged with wanting to get rid of the Japs" was confirmed by Joel Kotkin, who used it in *California, Inc.,* co-authored with Paul Grabowicz. It was published by Rawson, Wade in 1982.

CHAPTER 2:

Page 60: Peggie Nishimura Bain's 2004 quote is from the Densho Visual History Collection. All of the Densho filmed interviews are available online.

Page 65: Information about the farm laborers outside the Odd Fellows Hall in Byron, California, is from the Dorothea Lange Papers at the Bancroft Library.

Page 71: Correspondence between Lange and Dave Tatsuno were in the Dorothea Lange papers. Portions of Tatsuno's movie *Topaz* can be found online.

Page 72: San Francisco journalists first identified Ted Miyata in 1992. He served as a medic in the 442nd Regimental Combat Team and moved to Chicago after the war. He worked as a pharmacist and died in 2001.

Page 75: The comment by Joseph Yoshisuke Kurihara was from a manuscript reprinted in *The Spoilage* by Dorothy S. Thomas and Richard Nishimoto and published by University of California Press in 1946.

Page 77: Facts about the Wanto grocery store are from the Dorothea Lange papers. Yasuko Ito's remark is from 1981 testimony before the federal Commission on Wartime Relocation and Internment of Civilians.

Page 79: Ray Ogata identified his sisters, Shirley Mandarino and Margaret O'Neill, and mother Margaret Ogata in front of the family grocery store in Florin. The sisters provided background.

Page 80: Imelda "Mel" Russell, former coordinator of the Yolo County Archives, was our most helpful tour guide, taking us around Woodland in an effort to locate Dorothea Lange's subjects and find exactly where she photographed.

CHAPTER 3:

Page 82: James M. Omura was one of the most vocal early resisters to the government's plan to expel Japanese Americans from the West Coast. His comments can be found in the February 23, 1942, transcript of the House Select Committee Investigating National Defense Migration.

Page 85: The diary of Shizuko Ina was provided by her daughter, Satsuki Ina.

Page 86: We tracked down Shima Yoshino from the tiny family number on her luggage at the bottom right corner of the photograph. Her grandchildren, Paul Imazumi, Mike Imazumi, and Jane Yabu, confirmed her identity and provided recollections. The small gate enclosure through which San Francisco's residents passed to register with the Wartime Civil Control Administration still exists at 2031 Bush Street.

Page 89: Paul Kitagaki Jr., a Sacramento photojournalist who has done pathbreaking work tracking down the subjects of WRA photographs, identified Kimiko Kitagaki. She's his aunt. Paul began his work after learning that Dorothea Lange photographed Kimiko, his father Kiyoshi Kitagaki, and his grandparents Juki and Suyematsu Kitagaki in 1942. His aunt, whose married name was Kimiko Kitagaki Wong, returned to Oakland after the war and had two daughters. She worked for the Pacific Bell Telephone Company in Oakland. Paul uses period cameras to create vintage-style photographs of the WRA's original subjects (or their children). He often takes the new photographs in the same location as the original pictures. His exhibit, *Gambatte! Legacy of an Enduring Spirit,* which is touring the nation, pairs the original prints with his new photographs.

Page 90: Mitsunobu "Mits" Kojimoto was identified by Paul Kitagaki.

Page 93: Tomoe and Yoshino Otsu were identified by Paul Kitagaki. Amy Tomine, daughter of Tomoe Otsu Tomine, provided context for the photograph.

Page 94: Mamaru "Mamo" Takeuchi was found by tracking down the family identification number that he wore on the day he was forcibly removed. Nephew Michael Goro Takeuchi helped set up an interview with him.

Page 97: Accounts of the Japanese in Centerville by the *Township Register* were provided by Janet Cronbach of the local history and reference services at the Fremont Main Library in Fremont, California.

Page 99: We interviewed Ibuki Hibi Lee about her memories of "Evacuation Day" in Hayward, California, and talked with her about her artist parents Hisako and George Matsusaburo Hibi. Her identity was provided by Paul Kitagaki. The identity of the Takeuchi family was provided by Dorothea Lange on her captions. John Christian, of the Hayward Area Historical Association, sent local newspapers to supplement the caption. Hector Villasenor, librarian at the Hayward, California, Public Library, added historical tidbits about Hayward Park, where Japanese American families were picked up. The library, built in 1950, now occupies the center of the plaza. He also sent copies of the *Hayward Review.*

Page 100: We spoke to Kayoko Mochida Ikuma and Tooru "Mo" Mochida to find out more about the Mochida family. Jerry Aso shared memories of his grandfather, Sakutaro Aso.

Page 105: Milton Eisenhower's stated concerns about Japanese Americans are from the War Relocation Authority film *Japanese Relocation,* which is available online.

Pages 105 and 107: Yuri Kochiyama's memories of leaving San Pedro, California, in the convoy is from an interview conducted in 2009 in the Densho Visual History Collection.

Page 110: Michael Adams showed us the Woodland Southern Pacific Train Depot, which is undergoing restoration. The Sacramento Valley Historical Railways is using Dorothea Lange photographs to better understand the historical significance of the building.

Page 110 and 113: Joan Tuss, librarian at the Mary L. Stephens Davis Branch Library in Woodland, California, sent copies of the *Woodland Democrat.* Imelda Russell showed us the Yolo County Board of Supervisors resolution.

CHAPTER 4:

Page 114: The girl was quoted by *San Francisco Chronicle* columnist Herb Caen in 1942.

Page 116: The account of the Santa Anita Assembly Center is from the contemporary letters and diaries by Yamato Ichihashi from *Morning Glory, Evening Shadow,* published by Stanford University Press in 1997.

Page 119: Dorothea Lange's recollections of the first days at Tanforan are from the Lange papers in the Bancroft Library.

Page 122: Lily Okura's quote is from the book *Victory Without Swords: The Story of Pat and Lily Okura, Japanese American Citizens in 1941 America,* written by Robert B. Kugel and published by Eagle Editions in 2004.

Page 126: Niichi Tanaka's identification comes from the family tag that he is wearing.

Page 128: Elsie Inouye's quote about her arrival at the Turlock Assembly Center is from "Life in a Relocation Center in Arizona," a five-page manuscript available online.

Page 130: Teri Rodriguez provided historical background about the Salinas Assembly Center from the Salinas Public Library in California.

Page 131: Dorothea Lange's account of the Tanforan Assembly Center is from the Lange Papers.

Page 134: Richard Konda told us about his grandfather, Kumataro Konda, and aunt, Asako Takeda. Paul Kitagaki first made the identification. We found the identity of Akira Toya from Sandy Lydon's book *The Japanese in the Monterey Bay Region.* Information about Toya was provided by Jack Fujimoto, whose wife Grace Toya was Akira's sister.

CHAPTER 5:

Page 138: Frank S. Fujii's 1997 quote is from the Densho Visual History Collection.

Page 140: The daughter of Arajiro and Yone Hamachi, who prefered not to be identified, told us about the final days of her family's farm near Centerville, California.

Page 143: The good work by Bob Fletcher in Florin, California, was recounted in Fletcher's 2013 obituaries in *The New York Times* and *Washington Post.*

Page 145: Facts about the vandalism of property were found in *The Wartime Handling of Evacuee Property,* published by the U.S. Interior Department in 1945.

Page 146: Georgia Day Robertson's description of Parker, Arizona, is from her book *The Harvest of Hate,* part of the Japanese American Project of the Oral History Program at California State University, Fullerton.

Page 149: Helping us find out about property stored in the basement of the Tacoma Buddhist Church in Tacoma, Washington, were Ronald E. Magden, author of *Furusato: Tacoma-Pierce County Japanese, 1888-1977,* and Jean Fisher, Northwest Room librarian of Special Collections & Archives at the Tacoma Public Library. Fisher figured out the photograph was taken by Richards Studio in Tacoma as a freelance job for the War Relocation Authority.

CHAPTER 6:

Page 150: Joseph Yoshisuke Kurihara comments are from his manuscripts, which were made public in 1946.

Page 153: Facts about the speed of barrack construction is from Mike Mackey, author of the manuscript "A Brief History of the Heart Mountain Relocation Center and the Japanese American Experience."

Page 158: Sharon Tanagi Aburano's recollections of her family making straw mattresses are from a 2008 interview in the Densho Visual History Collection.

Page 160: Dorothea Lange's comments about education at Manzanar are from the Dorothea Lange Papers.

Page 162: We interviewed Bruce Tsurutani about his family's experience at Manzanar.

Page 165: Fred Tanaka told us about his parents, Shizuko and Kenichi Tanaka. Nicole Blechynden, archivist at the Heart Mountain Wyoming Foundation, helped us figure out the funeral picture by looking through the general information bulletins printed during the first weeks of the incarceration center.

Page 170: Photographer Andy Frazer called our attention to Karlene Koketsu, who was photographed by Ansel Adams and later interviewed by us.

Page 173: Bo Sakaguchi helped us learn the fate of his sister, Chiyeo "Chico" Sakaguchi. Letters between Dorothea Lange and Togo Tanaka's family can be found in the Dorothea Lange Papers. An account of Karl Yoneda's wartime experiences can be found in his autobiography *Ganbatte: Sixty-year Struggle of a Kibei Worker,* published by the University of California in 1983. Julia Tafel talked to us about her father, Frank Nobuo Hirosawa. She believes the incarceration actually benefited her father because he was able to receive attention for his scientific prowess.

Page 176: David Yonemitsu and Teri Chihara told us about their father, Robert Yonemitsu.

Page 180: Kerry Yo Nakagawa connected us to two baseball all-stars from the Butte High School Eagles—Kenso Howard

Zenimura and Tetsuo Furukawa—who explained the importance of baseball in the camps. Zenimura's family is depicted in the children's book *Barbed Wire Baseball* by Marisa Moss and Yuko Shimzu. Furukawa is the fictional subject of the children's book *A Diamond in the Desert* by Kathryn Fitzmaurice.

Page 183: Details about William Manjiro Katsuki and the gardens of Manzanar are from the 2015 National Park Service's Garden Management Plan by Jeffery F. Burton. The plan, available online, outlines the extensive effort by archeologists to tell the camp's history.

CHAPTER 7:

Page 190: The quote by Jeanne Wakatsuki Houston and James D. Houston is from their book *Farewell to Manzanar*.

Page 195: Robert H. Ross's view of the finals days at Tule Lake was found in his 1946 affidavit in the U.S. Court of Appeals lawsuit Clark vs. Inouye, which is available online.

Page 196: Satsuki Ina provided information about her father, Itaru Ina. We also checked the diaries kept by her mother, Shizuko, to determine what happened to the family in 1945.

Page 198: Raymond Hasegawa told us about his sister, Clara Hasegawa. Hikaru Carl Iwasaki confirmed that he was one of the people standing on the Jerome canal bridge.

Page 201: Betty Kagawa's valedictorian speech is available online from the digital collection of the University of Arkansas. Noel Murata told us about his parents, Kikuye and Kanichi Murata, who moved back to Hawaii after the war.

Page 202: Kay Roberts, curator of the WWII Japanese-American Internment Museum in McGehee, Arkansas, discussed what is left at the nearby Jerome incarceration camp.

Page 210: Priscilla Morishige Ishizaki talked about the day she was photographed by War Relocation Authority photographer Charles Mace. She became aware of the photograph when a relative sent it to her several years ago.

Page 211: Saburo Masada recounted the night his family was the target of a shooting, and also told us about the trials faced by family members after their return to California. He and his wife Marion give presentations about their experiences during World War II.

Page 212: We visited Rokutaro Nakamura's store, Nakamura Brothers Furniture, in downtown Woodland. George Hori told us about his aunts, Tsutayo Ichioka and Satsuki Nakao, and their contributions to the University of Southern California.

Pages 214 and 215: Background about the temporary housing provided to Japanese Americans in Burbank came from a manuscript titled "Burbank History (1975)" by Jackson Mayers and the City of Burbank Citywide Historic Context Report, made available in 2009.

Page 219: Ginger Scott, curator at the Colorado River Indian Tribes Museum, and native Mohave Gertrude Van Fleet discussed the last days of the incarceration camp and its impact on the reservation. Van Fleet, a tribal elder, traveled to San Diego in the early 1990s after being invited by former camp residents to visit them.

Page 220: Translation of the words on Tomoki Ogata's gravestone was provided by Noriko Sugano, a prolific gravestone reader, and Ryan Yokota, Legacy Center manager of the Japanese American Service Committee in Chicago.

The incarceration of Japanese Americans during World War II has produced a rich vein of books. Here are a few that were particularly helpful.

On photography:

Adams, Ansel. *Born Free and Equal: Photographs of the Loyal Japanese-Americans at Manzanar Relocation Center, Inyo County, California.* New York: U.S. Camera, 1945

Alinder, Jasmine. *Moving Images: Photography and the Japanese American Incarceration.* Urbana: U of Illinois, 2009.

Conrat, Maisie, Richard Conrat, and Dorothea Lange. *Executive Order 9066; the Internment of 110,000 Japanese Americans.* San Francisco: California Historical Society, 1972.

Creef, Elena Tajima. *Imaging Japanese America: The Visual Construction of Citizenship, Nation, and the Body.* New York: New York UP, 2004.

Gordon, Linda. *Dorothea Lange: A Life beyond Limits.* London: W.W. Norton, 2009.

Hirabayashi, Lane Ryo, Kenichiro Shimada, and Hikaru Iwasaki. *Japanese American Resettlement through the Lens: Hikaru Carl Iwasaki and the WRA's Photographic Section, 1943-1945.* Boulder, CO: U of Colorado, 2009.

Lange, Dorothea, Linda Gordon, and Gary Y. Okihiro. *Impounded: Dorothea Lange and the Censored Images of Japanese American Internment.* New York: W.W. Norton, 2006.

Meltzer, Milton. *Dorothea Lange: A Photographer's Life.* New York: Farrar Straus Giroux, 1978.

Okihiro, Gary Y., and Joan Myers. *Whispered Silences: Japanese Americans and World War II.* Seattle: U of Washington, 1996.

Robinson, Gerald H., Ansel Adams, Clem Albers, Dorothea Lange, and Toyo Miyatake. *Elusive Truth: Four Photographers at Manzanar.* Nevada City, CA: Carl Mautz, 2007.

On the incarceration:

Daniels, Roger, and Eric Foner. *Prisoners Without Trial: Japanese Americans in World War II.* New York: Hill and Wang, 1993.

Grodzins, Morton. *Americans Betrayed: Politics and the Japanese Evacuation.* Chicago: U of Chicago, 1949.

Muller, Eric L. *American Inquisition: The Hunt for Japanese American Disloyalty in World War II.* Chapel Hill: U of North Carolina, 2007.

Okihiro, Gary Y. *Encyclopedia of Japanese American Internment.* Santa Barbara, CA: Greenwood, 2013

Okubo, Miné. *Citizen 13660.* Seattle: U of Washington, 1983.

Reeves, Richard. *Infamy: The Shocking Story of the Japanese American Internment in World War II.* New York: Henry Holt, 2015.

Weglyn, Michi. *Years of Infamy: The Untold Story of America's Concentration Camps.* New York: Morrow, 1976.

Memoirs:

Egami, Hatsuye, and Claire Gorfinkel. *The Evacuation Diary of Hatsuye Egami.* Pasadena, CA: Intentional Productions, 1995.

Houston, Jeanne Wakatsuki, and James D. Houston. *Farewell to Manzanar; a True Story of Japanese American Experience during and after the World War II Internment.* Boston: Houghton Mifflin, 1973.

Sato, Kiyo. *Dandelion through the Crack: The Sato Family Quest for the American Dream.* Nevada City, CA: Willow Valley, 2007.

Uchida, Yoshiko. *Desert Exile: The Uprooting of a Japanese American Family.* Seattle: U of Washington, 1982.

Government publications:

California Incidents of Terrorism Involving Persons of Japanese Ancestry. Washington, D.C.: War Relocation Authority, 1945.

The Evacuated People: A Quantitative Description. Washington, DC: U.S. Government Print Office, 1946.

Final Report: Japanese Evacuation from the West Coast 1942. Washington, D.C.: Government Printing Office, 1943.

Personal Justice Denied. Washington, D.C.: Civil Liberties Public Education Fund, 1997.

The Wartime Handling of Evacuee Property. Washington, D.C.: U.S. G.P.O., 1946.

In addition, the authors would like to thank Elissa Cahan Burroughs, Maddie Burroughs, Glenn Cahan, Mary Anne Gibbons, Bill Healy, and Michael Healy for research; Karen Burke, Caleb Burroughs, Cate Cahan, Mark Jacob, Meribah Knight, Alex Kotlowitz, Sam Mihara, Amy Schroeder, and Frank Sugano for copy editing; Sharon Culley and Holly Reed at the National Archives; Eric Taylor, Cindy Jones, and Jared Stevens at Four Colour Print Group; Jeff Tegge and Sarah Armstrong at Legato Publishers Group; Bill Van Niekerken at the *San Francisco Chronicle;* Joe McCary at Photo Response; Peter Hanff at the Bancroft Library, and Tom Ikeda at Densho: The Japanese American Legacy Project.

Also offering help were Frank Abe, Douglas Din, Kristin Delaplane, Richard Alden Feldon, Mae Yanagi Ferral, Bob French, Elnina Geiger, Linda Gordon, Lane Ryo Hirabayashi, Robert Honda, Dana Hoshide, Will Kaku, Karen Kanemoto, Tanya Kato, Ken Light, Rosemary Masters, Joyce Morishita, David Rapaport, Richard Reeves, James Tanaka, Jerry Telfer, Rosalyn Tonai, and Marielle Tsukamoto.

Thank you, too, to Aaron, Claire, and Valerie Farnum Cahan; Millie Burroughs; Schuyler Smith; Chris, Caedan, and Daisy Jinks.

Special thanks to Paul Kitagaki, photographer Joan Myers, fiscal sponsor Tatsu Aoki of Asian Improv Arts Midwest, and Jonathan Logan of the Reva and David Logan Foundation, who helped make this book possible with financial support.

Index
of Names

To Cate and Karen

Published by CityFiles Press, Chicago, Illinois

cityfilespress.com

Produced and designed by Michael Williams

ISBN: 978-0-9915418-6-7

Published November 2016

First Edition

Printed in China

With funding assistance from:

THE
REVA & DAVID LOGAN
FOUNDATION